Géricault

# GÉRICAULT

*Lorenz Eitner*

Los Angeles County
Museum of Art
October 12-
December 12, 1971

The Detroit
Institute of Arts
January 23-
March 7, 1972

Philadelphia
Museum of Art
March 30-
May 14, 1972

Library of Congress
Catalog Card Number 70-173255

Copyrighted © 1971 by
Museum Associates of the
Los Angeles County Museum of Art

I.S.B.N. 87587-046-5

Published by the
Los Angeles County Museum of Art

## Acknowledgments

For the generous help they have given me in the organization of this exhibition and the compilation of the catalog, I should like to give my thanks in particular to Mr. Kenneth Donahue and Mrs. Jeanne Doyle of the Los Angeles County Museum of Art, to Professor Lee Johnson of Toronto University, to Dr. Frances S. Jowell, to Dr. Hans A. Lüthy of the Schweizerische Institut für Kunstwissenschaft of Zurich, and to Mr. Pierre Rosenberg of the Musée National du Louvre. I am grateful also for the kindness shown me by curators of French museums, in particular Miss Roselyne Bacou, Curator in the Department of Drawings, Louvre, and Miss Olga Popovitch, Curator of the Musées des Beaux-Arts of Rouen. The work which produced the exhibition and its catalog could not have been done without the assistance of the Carnegie Corporation and the Kress Foundation, to whose continued, enlightened support art-historical scholarship in America owes a great debt. I would also like to express my thanks to members of the staff of the Los Angeles County Museum of Art: to Mrs. Joanne Jaffe, Publications Associate; to Mrs. Lilli Cristin, Curatorial Aide in the Department of Exhibitions and Publications; and to the many other Museum staff members who cooperated in coordinating the exhibition.

This catalog is dedicated to Katherina M. Eitner.

## Committee of Honor

The Honorable Jacques Duhamel
*Minister of Cultural Affairs of France*

The Honorable Maurice Schumann
*Minister of Foreign Affairs of France*

The Honorable Charles Lucet
*Ambassador to the United States
from France*

The Honorable Arthur K. Watson
*Ambassador to France from the
United States*

The Honorable Hervé Alphand
*Secretary General to the Ministry of
Foreign Affairs of France*

Mr. Pierre Laurent
*Director General of Cultural, Scientific,
and Technical Relations of France*

Mr. Jean Chatelain
*Director of the Museums of France*

Mr. Jean Lecanuet
*Senator, Rouen*

Mr. Jean-Hervé Donnard
*Cultural Counselor to the French Embassy
in the United States*

The Honorable Jacques Dircks-Dilly
*Consul General of France, Detroit*

The Honorable Didier Raguenet
*Consul General of France, Los Angeles*

## Professional Committee

Roselyne Bacou
*Curator, Department of Drawings,
Musée National du Louvre*

Frederick J. Cummings
*Assistant Director, The Detroit Institute of Arts*

Kenneth Donahue
*Director,
Los Angeles County Museum of Art*

Jeanne Doyle
*Coordinator, Exhibitions and Publications,
Los Angeles County Museum of Art*

Michel Laclotte
*Chief Curator, Department of Paintings,
Musée National du Louvre*

Hans A. Lüthy
*Director, Schweizerisches Institut
für Kunstwissenschaft, Zurich*

Charles W. Millard
*Curator, Nineteenth-Century European Art,
Los Angeles County Museum of Art*

Olga Popovitch
*Curator, Musées des Beaux-Arts, Rouen*

Joseph Rishel
*Curator of Paintings before 1900,
Philadelphia Museum of Art*

Pierre Rosenberg
*Curator, Department of Paintings,
Musée National du Louvre*

Maurice Serullaz
*Curator, Department of Drawings,
Musée National du Louvre*

Evan H. Turner
*Director, Philadelphia Museum of Art*

Willis F. Woods
*Director, The Detroit Institute of Arts*

## Introduction

The careers of artists do not necessarily end with their lives: Géricault's posthumous fate exemplifies the way in which posterity, by its lapses and returns of memory, can transform their stature and the meaning of their work. When Géricault died in 1824 at the age of thirty-three, he was known to the public by some published lithographs and by only three paintings: the *Charging Chasseur* (1812), the *Wounded Cuirassier* (1814), and the *Raft of the Medusa* (1819). The *Medusa* had produced a sensation at the Salon of 1819 and established Géricault's reputation; it was the fame, or notoriety, of this one painting which caused his death to be mourned as that of the most promising French artist of his generation. Only his friends and disciples had personal knowledge of the rest of his work, though rumors of its originality and strength were widely current and had aroused great curiosity. When the contents of his studio were offered for sale ten months after his death, they were eagerly bought up. The sale abruptly dispersed some 220 paintings and sixteen large lots of drawings and watercolors which may have comprised (taking into account the sketchbooks that were later disassembled) some 1,600 to 1,800 individual sheets. Save for the pictures and drawings which he had casually given to friends and relatives, this constituted the bulk of his life's work. He had sold very little.

From the auction of his studio, the *Medusa* went to the Louvre, the *Chasseur* and the *Cuirassier* to the Galerie d'Orléans at the Palais Royal. The other hundreds of paintings and drawings were scattered among private collections where most of them remained for the next hundred years, inaccessible to all but a handful of connoisseurs and watchers of the art market. When some forty years later Charles Clément compiled his comprehensive *oeuvre* catalog, he located 191 paintings and 180 drawings; of these, only twelve paintings and four drawings were to be seen in public museums, specifically in the Louvre and the museum of Rouen.

This neglect of Géricault's work by the museums did not reflect a general lack of appreciation. His drawings and paintings continued to be sought after by private collectors and consistently reached high prices at auction. It was something in their format and function, rather than their quality, that closed the museums to them. Every period has its own notion of what constitutes an exhibitable work of art. Museum curators of the nineteenth century regarded the majority of Géricault's paintings as "cabinet" rather than "museum pieces" because to their eyes they seemed incomplete. Their experimental, sketch-like character did not diminish their value; as precious autographs, fragmentary utterances of genius, they deserved the closest study, but they were believed to be unsuitable for display on the walls of public galleries.

The dispersal of most of his work among a multitude of private collections had the effect of making it impossible to survey it as a whole or to form a coherent idea of its range and development. As long as the bulk of it remained out of sight, the very few exhibited paintings were bound to take on a disproportionate prominence; Géricault came to be thought of simply as *le peintre de la Méduse*. As an artist he had become famous, even popular, without being at all well known. The inaccessibility of his work did not diminish his reputation. Legend flourished where the complicated truth would merely have confused his willing admirers. For the youth of the period the Byronic paradoxes in his life and personality, or what were seen as such,

had an irresistible attraction. His shy and melancholic temper, the fire and gentleness in him, the power and irregularity of his talent, his impatience with school routine, his bursts of activity and spells of languor perfectly matched the popular image of the Artist. That he had been unhappy, had suffered, and died very young by no means lessened the interest in him, and the hint of something uncanny and hidden in his death-haunted existence made this fascination complete. The stories told of him showed him defying his teachers, mastering spirited horses, studying the faces of the dead at the morgue, being crucified by spiteful critics, and slowly dying from a horrible disease. Though not a very good likeness, the anecdotal portrait of Géricault — as genius, athlete, martyr, and romantic ghoul — became embedded in a cult centered on his person rather than on his art. In the typical artist's studio of the 1830s and 1840s, a cast of Géricault's death mask hung in a place of honor.

In 1841 Géricault's friends and admirers subscribed to a memorial to be erected on his tomb. The moment seemed opportune for an attempt to gather together what remained of authentic information about his life. The popular *Revue Pittoresque* published a biographical sketch to mark the occasion, and in 1842 there appeared in the *Revue du dix-neuvième siècle* the first detailed life of Géricault, by Louis Batissier. Based on the reminiscences of his surviving friends and incorporating fragments of his own writings, it is still worth reading. But about the work of Géricault, Batissier had little to offer: "One may say," he wrote, "that he spent the greater part of his time in study. The number of his paintings therefore is not considerable."

With the advent of the Realist movement in the late 1840s, Géricault once again became a figure of controversy. All parties now claimed him as their champion: the battered rearguard of Neoclassicism tried to take cover behind him, invoking his debt to Guérin and David; the Romantics, now in their cross and defensive middle age, held fast to him as a relic of their heroic past; while the Realists, with the arrogance of youth, simply annexed him to their movement as its forerunner and prophet. Only Ingres, to his credit, made no concessions: "I wish they would take that picture of the *Medusa* and its acolytes, those two big *Dragoons,* out of the Louvre, and put the one into some corner of the Ministry of the Navy and the other two into the Ministry of War, so they won't corrupt the taste of the public which must only be conditioned to the Beautiful...I don't want any part of the *Medusa* and those other pictures of the dissecting room which show man as a cadaver, which show only the Ugly, the Hideous. No! I don't want them! Art must be nothing but Beauty and teach us nothing but Beauty."

The polemic about Géricault's place in the modern French tradition continued intermittently for more than a decade without shedding any new light on his work. The disputants, not bothering to look beyond the Louvre, argued in a vacuum. Their articles, less pithy than Ingres' outburst, were equally narrow in their factual base. Gustave Planche, a critical luminary of the day, managed to fill thirty pages of the *Revue des Deux Mondes* with a wordy assessment of Géricault's art, confining himself entirely to the *Medusa* and the "two big *Dragoons*" and giving no reason for supposing that he had seen any other works. Meanwhile, it was in the portfolios of collectors and in the auction rooms that the actual character and variety of Géricault's art manifested itself. The number of his paintings and drawings which passed

under the hammer year after year, beginning with a very few in the 1830s and gradually swelling into a great volume in the 1850s and 1860s, should have disabused those who still believed he had produced little in his short life. There were some amateurs who carefully followed the sales, to pluck from them a painting here, a drawing there, and who sharply competed with one another over the larger lots that occasionally came on the market — the two big sketchbooks in Sir Thomas Lawrence's sale in 1830; eighteen drawings and two sketchbooks in the de Musigny sale in 1845; four paintings and 155 drawings in the Marcille sale in 1857; nine paintings and six lots of drawings, including an album, in the Scheffer sale in 1859; twelve drawings in the Walferdin sale in 1860; five paintings in Lord Seymour's sale in 1860; nineteen paintings and three drawings in the Delacroix sale in 1864. Important collections of Géricault's works were being composed with discrimination and skill by collectors such as His de La Salle, a part of whose enormous collection eventually went to the Louvre; the dealer Coutan, whose collection was dispersed; the painter Jean Gigoux, who later gave a choice from his collection to the museum of Besançon, and by the painter Leon Bonnat who endowed the museum of Bayonne. These passionate and experienced searchers developed the expertise necessary for spotting the authentic works among the flotsam of the auctions, and they learned to distinguish between the work of Géricault and that of his copyists and imitators. With acquisition in mind they followed the movements of key paintings from collection to collection. They had the knowledge that the critics lacked.

None knew this better than Charles Clément who wrote his exemplary monograph, *Géricault, étude biographique et critique,* in the 1860s and first published it in 1867. He wisely dispensed with the opinions of the professional critics and scholars who had preceded him — Michelet, Planche, Blanc, Chesneau — and instead drew his information from the collectors, the surviving friends of Géricault, and the work itself. He told as much of Géricault's life as he thought necessary, dismantling the myth with great tact, but he gave his main attention to the work. His is the earliest and still the best general account of Géricault as an *artist.* The critical catalog which he appended to the life was compiled with the help of men who had known Géricault and remembered the contents of his studio. Though incomplete by present standards, it remains unsurpassed for reliability. To locate and describe nearly 400 scattered works, unaided by records or photographs, was a task of staggering difficulty which Clément could never have accomplished had he not been able to fall back on the detailed information gathered by a generation of collectors and dealers and on his own long familiarity with the auction houses and the world of collectors. While he appears not to have made a single error of attribution — an unmatched record — he was less confident in arranging the work in chronological order. With characteristic reserve he refrained from insisting on precise dates when he was not sure of the facts. On Clément's book all subsequent studies have had to be based; from it, many have acquired a tinge of his pragmatism.

The immediate effect of its publication was to stimulate the further resurrection of Géricault's work. This continued to be, for the time being, a task for amateurs rather than scholars. Practical collectors, with money at stake, knew how to tell right from wrong among the tangled attributions to Géricault, but their interest in histori-

cal interpretation was slight. Historians were late in entering the field. It may be that the obvious excellence of Clément's book discouraged, or at least postponed, further publication. At any rate the attention given Géricault in print declined during the last decades of the century. The figure of Géricault, once so glamorous, had by this time gathered considerable patina. He seemed old-fashioned. The generation which was coming to terms with Impressionism found him less interesting than had the followers of Realism. By way of compensation his paintings and drawings entered the museums in large numbers during the 1880s and 1890s, benefiting from a more tolerant attitude toward work of unconventional subject matter and free execution. The great collections which had been formed in the middle decades of the century were meanwhile dissolving, their contents going to museums or passing into the ownership of a new generation of collectors: Vollon, Chéramy, Dollfus, Foinard, Goetz, and Ackermann.

Shortly after 1900 the interest in Géricault suddenly quickened. His work won ardent new friends in and outside France and particularly in Germany. The Post-Impressionist reaction vindicated him; he seemed once again a precursor of modern art, and his expressive energy found favor with the rising avant-garde. In 1907 the first one-man exhibition ever given him opened at the Salon Gurlitt in Berlin accompanied by a catalog for which Meier-Graefe had written the preface. From this time on exhibitions were to be the chief instrument for the rediscovery and critical study of his work. He figured prominently in several international exhibitions of modern French art on the eve of World War I. In keeping with his new reputation his first American showing, at the Brooklyn Museum in 1921, was in an exhibition entitled *The Post-Impressionists and their Precursors.*

In France where the anniversary of his birth, 1891, had been allowed to pass unobserved, the centenary of his death in 1924 was marked by an exhibition on the grandest scale. Organized by two enthusiastic collectors, the Duc de Trévise and Pierre Dubaut, it was intended to crown Clément's enterprise by putting on view all the extant works that could be assembled. Many private collectors and a few museums lent some eighty paintings and about 175 drawings or watercolors either by Géricault or ascribed to him. For the first time since his death a large part of his work could be seen under one roof, making it possible to comprehend in a glance what it had taken Clément years of strenuous search to discover: the actual variety, depth, and coherence of Géricault's art. Visitors could observe its range of styles and techniques, they could follow the stages of its development, trace the different strands of subject matter that run through it, and relate the profusion of individual sketches to the main projects. Above all, their eyes were opened to an artistic individuality of terrifying impact, to a painter who bore little resemblance to the schoolbook cliché of Romanticism. The occasion had something of the drama of archaeological discovery. A treasure had suddenly been brought to light, rich beyond expectation, bewildering in its complexity.

Not all of the many new attributions exposed to critical examination at the Centenary ultimately withstood the test, but the exhibition did result in a very marked expansion and clarification of the acceptable *oeuvre.* It also stimulated a rush of articles and books, including the perceptive essay by Regamey, Oprescu's excellent

biography, and Delteil's catalog of the lithographs. None of these, however, represented a clear advance over Clément or the Centenary. The real initiative remained for some time after with the arrangers of exhibitions, the collectors, and the *marchands-amateurs*. Throughout the period of rediscovery, which continued for thirty years, from 1924 to 1953, the personalities of the Duc de Trévise and Pierre Dubaut strongly dominated the field. Together, they organized a second important exhibition in 1937 (Galerie Bernheim-Jeune); alone, Dubaut lent his formidable energy and expertise to the selection of the exhibitions held in 1950 (Galerie Bignou), in 1952 (Marlborough Ltd., London), and in 1953 (Kunstmuseum, Winterthur). In 1935, Maurice Gobin showed an important group of drawings and watercolors at his own gallery.

In assessing the results of this activity it may suffice to note that by 1953 the number of works known to be — or claimed to be — by Géricault had risen from Clément's original four hundred to about five times this number, either directly in consequence of the exhibitions or indirectly through their effect on the art market. The initial situation had thus been neatly reversed. From an artist who was known only by a very small number of works, Géricault had become an all too prolific and extremely visible artist.

Not all of this increase was a clear gain. Few painters, it was discovered, had been copied, imitated, or forged more often and more deceptively than Géricault. Several of his pupils and followers, unremarkable in their own right, had acquired disconcerting skill in mimicking his manner. As the number of attributions to him increased, so did the problem of separating the Jamars, Montforts, Lehoux, Volmars, and Champmartins from the Géricaults. In this connection, too, the exhibitions performed an important service. They drew attention to the problem and provided occasions for dealing with it. It was proper that, instead of limiting themselves to the completely safe and fully explored work, they should function as laboratories for the testing of new attributions. But the sheer number of speculative attributions included in them finally grew so large — especially in the area of Géricault's youthful exercises (1808-1812) where undocumented ascriptions can be little more than acts of faith — that it threatened to blur the contours of the authentic work. The proportion of academic life studies, compositional essays, and copies after the masters — charitably classified as *oeuvres de jeunesse* — grew beyond all probability, while the really important new discoveries became rarer. The large exhibition in Winterthur, which climaxed the series of exploratory exhibitions in 1953, presented 122 paintings in all; of these no fewer than fifty-three were assigned to the period of 1808-1812.

It is impossible to overstate the contribution which the collectors, the amateurs, the lovers of Géricault's work have made to its physical recovery and its presentation to the public. All the important exhibitions held before 1963 were organized by private enthusiasts, and there can be no doubt that it was these exhibitions, rather than the researches and publications of scholars, which uncovered the broad range of his achievement. The role of the museums and the professional historians, by comparison, was initially quite small. Discovery far outstripped study and interpretation. One of the early attempts to relate Géricault to the larger art-historical context was made by Léon Rosenthal in his monograph of 1905. A second, faint start

occurred in Germany just before the First World War when J. Meier-Graefe and O. Grautoff turned their attention to Géricault. These attempts were followed by the historical studies of H. Focillon (1925, 1927), Walter Friedlaender (1930), and F. Antal (1940) which, though excellent in their various ways, were handicapped by their authors' incomplete knowledge of the *oeuvre.*

The period of discovery has meanwhile come to an end. Since the late 1930s Géricault's work has steadily gravitated from private into public ownership. The bulk of it is now well known. Though important finds are still being made,[1] their effect on the whole is fairly marginal. The future is not likely to bring total surprises. The main obstacles to an understanding of Géricault are no longer the scarceness and inaccessibility of his work, but its ravelled state and its difficulty. The effort has begun to bring order and meaning into the vast accumulation which the collecting zeal of earlier generations had brought together. The monographs by Klaus Berger (1946 and 1952) were among the first to benefit from the recent increase of the *oeuvre,* and to suffer from its inflation. The biography by Denise Aimé-Azam (1956) contributed valuable new information, including documents which suggest that Géricault suffered a breakdown after the completion of the *Medusa.* The publication of the collection of Hans E. Buehler (Winterthur) by Pierre Dubaut, who had helped to form it, gave visibility to the largest group of works by Géricault still in private hands (1956). It was followed by Maurice Gobin's publication of his own rich collection (1958). Two further monographs, by A. del Guercino (Milan, 1963) and V. N. Prokofiev (Moscow, 1963), added little that was new. The still unpublished archival researches of LePesant of the Archives Nationales have solved some of the deepest riddles in Géricault's personal life.[2] The forthcoming biography by Anita Brookner is expected to sum up these recent inquiries. Particular studies of individual works, groups of works, or whole phases in Géricault's development (see Bibliography) have meanwhile brought some clarity into stretches of his career that had been obscure. But much remains to be done. The figure of Géricault, now that it has become more distinct, is more difficult than ever to accommodate in the schemes of classification used to describe the art of the early nineteenth century. He does not fit, yet he is clearly the crucial artist in the interval between David and Delacroix in those years from 1810 to 1824 when, except for him, art in France stood still. It is probable that a considerable revision of the history of Classicism and Romanticism will be among the consequences of his resurrection.

Now once again we can see Géricault as he was seen by his pupils and friends — as an artist full of contradictions, and yet of very marked individuality. His teacher, Pierre Guérin, once said of him that he had "the stuff of three or four painters in him." That seems quite literally true; by singling out certain traits in his work, it is not difficult to make him a classicist, a romantic, a realist. The alternating predominance of one or the other of these tendencies in him determined his frequent, often abrupt shifts of style. The progress of his art, when traced in his few finished paintings and main projects, describes an odd, zig-zag course — from the Baroque dash and color of his youthful *Charging Chasseur* (1812), to the somber monumentality of the *Wounded Cuirassier* (1814), to the classical serenity of some of the studies for the *Race of the Barberi Horses* (1817), to the grandiose melodrama of the *Raft of*

the *Medusa* (1819), the hard modernity of the *Epsom Downs Race* (1821), and the tragic realism of the *Portraits of the Insane* (ca. 1822) — and yet their discontinuity barely hints at the even greater variety of the work that surrounds them. Throughout most of his life Géricault worked on two different levels. On the one, he composed with deliberate intent, on the other, he casually expressed intimate feeling and experience. In his more formal manner he dealt with artistic problems and reacted to artistic influence. In his private manner he drew or painted spontaneously with little conscious effort at style. Each had its own development, the one more rapid and abrupt, the other more gradual. At any time Géricault was able to shift from one to the other, confounding any attempt at establishing a simple chronology of his stylistic evolution.

Most of his work was experimental. Since his wealth exempted him from having to paint for a living, he could afford to indulge his taste for improvisation, his habit of intermittent work, his dislike for long-sustained effort. His large, finished paintings, the *Chasseur,* the *Cuirassier,* and the *Medusa,* on which most assessments of his style have been based, are in fact quite exceptional achievements; and of these three, the *Chasseur* and the *Cuirassier* can actually be considered as oversize improvisations, carried off in short bursts of effort, but not fully worked out. Only in the *Medusa,* completed in eighteen months of concentrated labor, did he succeed in uniting the different strands of his talent and in bringing all his energies to bear on the realization of a project. The majority of his works, considered by themselves, are fragmentary. Many of them are studies from life, loosely connected with one or the other of his larger enterprises or carried out for their own sake. In either case they are likely to form series of related pieces. When attempting to compose a particular subject, he often developed it in a sequence of images. Much of his work clusters in families or forms lines of connected designs which progressively spell out their meaning if their course is followed out: the landscape of his art consists of rivers rather than peaks. This gradualness of expression, whether deliberate or stemming from difficulties with pictorial invention, is one of the puzzling aspects of his work and comes as a surprise in an artist who was capable of producing pictures of powerful immediacy. Like certain artists of the twentieth century, he seems on occasion to have been interested in the process rather than the product of composition. This is one of the reasons why matters of dating and of sequence take on a special importance in the reconstruction of his work. Like the wind-scattered pages of a text, the individual pieces must be put in the right order before they can again be "read."

The great diversity of subject matter which animates his work is yet another aspect of its experimental nature, as baffling to interpretation as its stylistic variety. The range is wider than that of any other artist of his time. It extends from erotic fantasies on the one side to studies of cadavers on the other. The unconventionality and privacy of his interests reflected his personal independence and the fact that he could pursue his studies with little thought of flattering anyone's taste. The quality common to all his subjects, whether they be dramatic compositions or simple observations, is the steady emphasis on the concrete and material. Géricault was more vividly stirred by tangible reality than by sentiments or abstract ideas. His imagination responded to the shock of physical experience, to the sensations of body, weight,

energy, and motion. His fantasy in its freest, most unfettered moments gave birth to sculptural forms rather than ethereal visions. Moreover, he found it difficult to invent situations or tell stories. Past and distance in themselves had no romantic charms for him; he did not share the taste of his time for Antiquity or the Middle Ages, and the exotic appealed to him only in the tangible shape of the turbaned Mamelukes who posed for him in his studio. Most of his subjects are "modern" in the sense that they are taken from direct experience and therefore deal with actuality in some form. Totally unburdened by any idealist aesthetic, such as both the classicists and the romantics professed, he saw reality as object or action. A large part of his work has the character of still-life, of matter at rest, even when it deals with men or animals. With unflagging objectivity he painted lions, tigers, soldiers, children, stabled horses, and severed heads, but in their stillness these studies have an intensity of physical presence which is more moving, or disturbing, than any mere expression of sentiment. When he represented action, he usually gave it the form of physical conflict, often of a struggle between men and animals — soldiers on rearing horses, grooms restraining horses at the start of a race, butchers struggling with cattle, lions springing at their prey, men in battle. In the *Raft of the Medusa* he pitted men against the force of nature itself. It is possible to take these scenes for what they are or to see in them the symbolic expression of larger conflicts — psychological, social, or elemental — as various critics have suggested. Géricault gave no clue to his intention, but the persistence of the theme in his work leaves no doubt about its importance.

Géricault was one of the first painters in the nineteenth century to give sympathetic attention to actual human or animal suffering in his work; to deal objectively with sickness, death, and insanity; and to describe poverty and crime not as picturesque *motifs,* but as facts. His *Raft of the Medusa* concerned a naval disaster caused by criminal negligence and followed by political scandal. Toward the end of his life he projected large paintings on the subjects of the *Liberation of the Prisoners of the Inquisition* and the *African Slave Trade.* Inevitably he has been hailed as a precursor of "social realism." Courbet's friend, the Socialist thinker Proudhon, who formulated the theory of art's social function, linked the *Medusa* with David's *Death of Marat* as one of the beacons indicating the future direction of art. It is a fact that Géricault lived for years among men of strong political views. But the politics of this milieu were Bonapartist and by present standards rabidly chauvinistic rather than liberal or humanitarian. The political spokesmen of the circle to which Géricault belonged, by ties of friendship rather than of party, were the poet Béranger and the painter Vernet, neither of them socially-conscious in our sense. Géricault's own political views are as difficult to determine as his religious beliefs since he never expressed either in his work. His art reflects experience rather than ideology. It makes no comment, but it is expressive of an impartial humanity open to all forms of existence. While this may have unfitted his art for any particular political use, it has preserved it from obsolescence: it moves us still.

*Footnotes*

1. In the 1950s, when it seemed that every attic had been scoured, three very large and highly finished landscape panels came to light and added a new, rather unexpected dimension to the knowledge of Géricault's work. Since then, nothing of comparable importance has been discovered, though some very interesting discoveries have been made, sometimes in unexpected places. The searches of Dr. Hans Luethy, of the Swiss Institute for Art History, not long ago turned up a sketchbook by Géricault, the finest known, which had lain undetected on the shelves of the Zurich Kunsthaus for about ninety years. Still more recently, three separate lots of drawings, two of them of outstanding quality, were cast up on the London art market in 1968, 1970, and 1971.

2. Including that of the identity of Géricault's mistress who bore him a son in 1818. She turns out to have been Mme. Alexandrine-Modeste Caruel de Saint Martin, the wife of Géricault's maternal uncle, a woman only slightly older than he. Since it helps to explain why this episode, only hinted at by Clément, had a very serious effect on Géricault's personal life, and indirectly on his art, LePesant's discovery is important.

Youth and Apprenticeship 1808-1812

1791   Jean-Louis-André-Théodore Géricault was born on September 26, 1791 in Rouen of prosperous parents. His father, Georges-Nicolas, owned considerable real estate and was active in the tobacco business; his mother, Louise-Jeanne-Marie, née Caruel, was descended from a well-to-do Norman family.

ca. 1796   Géricault moved to Paris with his family.

1806-08   He attended the Lycée Imperial in Paris, finishing his studies in 1808. He was a mediocre student. In 1808, his mother died. Fond of his father, Géricault was to live the rest of his life in close companionship with him. A comfortable annuity assured his financial independence.

1808-10   With the connivance of his uncle, Jean-Baptiste Caruel, and against his father's wishes, Géricault — having decided to become an artist — entered the studio of Carle Vernet, a well-known painter and graphic artist who specialized in fashionably modern subjects. Vernet belonged to an eighteenth-century tradition of elegant genre strongly under English influence and very little touched by French neo-classicism. He seems not to have given Géricault any formal training; he simply allowed him the freedom of his studio, to observe, draw, and copy as he pleased.

    Some of Géricault's earliest preserved studies of horses, riders, and military subjects date from the time of his stay with Vernet. Many of them show the rather brittle mannerism of his master. He may also have painted the early, freely brushed *Self Portrait* (Aimé-Azam Coll.) during these months.

1810-11   Feeling the need for more regular work and stricter discipline, Géricault changed to the studio of Pierre Guérin, an orthodox classicist addicted to melodramatic subject matter. Here Géricault received regular instruction in figure composition, painted and drew models, and studied casts of antique sculpture. From Guérin he received — not without offering some resistance — indoctrination in the ideology and practice of Davidian neo-classicism, then at the height of its prestige and the beginning of its rapid decline. Géricault stayed with Guérin for only eleven months but continued to paint occasional life studies at the studio of his former teacher in the following years.

*The preserved work of Géricault's apprenticeship under Guérin includes compositional exercises on classical themes (in various collections) and some academic studies of the nude (Rouen; Bayonne, etc.)*

ca. 1811   As he gradually withdrew from regular training, Géricault set himself a program of independent study. This consisted in part of copying the works of the masters at the Louvre, known at that time as the Musée Napoléon and filled with the art-loot of the campaigns in Italy, Flanders, Germany, and Spain. Géricault's choice of models expressed his discontent with classicism; he strongly favored Rubens, Van Dyck, Titian, Veronese, Caravaggio, Rembrandt, and Velásquez.

For years he continued to paint copies after the masters, some extremely faithful, many very free. The number of preserved copies is large; the majority probably dates from ca. 1812-16.

1811-12    Among the artists of his own time Géricault particularly admired Gros, whose example encouraged him to try his hand at modern, military subjects. Under the combined influence of Gros and the Baroque masters he formed a casual, realist manner in which he sketched military and equine subjects. These small pictures, fresh in color and free in handling, are the first clear expression of his artistic personality.

First Independent Works 1812-1814

1812    Having decided to submit a large painting to the Salon of 1812, Géricault transformed a simple genre motif — suggested to him by the sight of a bolting carriage horse — into a monumental and highly dramatic equestrian portrait.

The Charging Chasseur, *improvised in the course of a few weeks, had some success at the Salon. The picture is strongly influenced by Gros but also owes something to Rubens.*

*Numerous sketches for it survive (Louvre; Rouen; Nathan Coll.; Aimé-Azam Coll., etc.).*

1812-14    *The* Chasseur *marks the high point of Géricault's early style. Something of its warmth of color, its sense of motion, its lively execution also appears in various smaller military compositions which evidently date from about this time. A sketchbook fragment in Chicago gives an index to the subjects which then occupied him. He painted*

*and drew stabled horses (de Noailles Coll.; Buehler Coll., etc.),* Polish Lancers, Mounted Trumpeters *(ex-Trévise Coll.; Niarchos Coll.; Glasgow, etc.), a* Cavalry Battle, *landscapes, and animal studies. Many of these works are of quite small size, of casually naturalist conception, and of very refined execution.*

There is some evidence that toward the end of this period Géricault's style underwent a gradual change in the direction of a more compact definition of form, darker tones, harsher contours.

1814    The defeat of the Napoleonic armies and the occupation of Paris by the Allies interrupted Géricault's work. He was caught unprepared by the royal government's decision to hold a regular Salon in 1814 in spite of the presence of foreign troops in the city. He resolved, nevertheless, to participate.

*His* Wounded Cuirassier Leaving the Battlefield, *executed in great haste, caused disappointment at the Salon. In improvising it, Géricault may have made use of a slightly earlier composition, the* Signboard of a Blacksmith *(painting in Zurich, sketches in the Chicago Album). Some preparatory*

*studies for the* Cuirassier *survive (drawings in the Aimé-Azam Coll. and Louvre; painted studies at the Louvre, in Brooklyn, etc.). The picture was conceived as a pendant to the* Chasseur *of 1812. While the one had expressed confidence in victory on the eve of the Russian campaign, the other reflected*

*the French defeats of 1813-14. As a pair, they are the first instance in Géricault's work of a veiled allusion to contemporary events. The somber, ponderous Cuirassier at the same time offers a sharp stylistic contrast to the earlier picture. It shows Géricault sacrificing his former spontaneity, dynamism, and color brilliance in favor of an emphatically monumental and expressive style.*

1814-15    *Several military portraits and equestrian subjects of roughly the same date echo the Cuirassier's tragic note, among them the* Mounted Hussar Trumpeter *(Williamstown) and the two versions of the* Portrait of a Carabinier *(Louvre and Rouen).*

Both the life and the work of Géricault in these years hint at stress. In late 1814 or early 1815 he impulsively enlisted in the Royal Household Cavalry and shortly afterwards found himself among the troops escorting the king on his escape to Belgium. At about this time, too, he entered into a love affair with Alexandrine-Modeste Caruel, the young wife of his maternal uncle. The affair was to have a disastrous effect on his emotional life and hence an influence on his art.

New Directions 1814-1816

The *Cuirassier* marked a reversal in Géricault's development. Dissatisfied with his precocious facility and determined to gain greater expressive power, he put himself through a painful course of re-training. The new manner which emerged from this effort was in many ways the opposite of his earlier and more spontaneous one. Wholly artificial, based on clichés borrowed from Michelangelo and classicism, it emphasized sculptural bulk, heavy contour, harsh light-dark contrast, and drab color. The subjects which he treated in this manner were more often conventionally "antique" than modern, but the spirit in which he conceived them was closer to romantic exaltation than classical serenity.

1814    *The fairly crude beginnings of the "antique" manner are illustrated by the compositional exercises of the* Zoubaloff Sketchbook *(Louvre) which also contains studies for the* Cuirassier.

1815-16    *Related to these exercises are free fantasies in a bizarre, quasi-Michelangelesque vein which concern scenes of love or cruelty — nymphs in love-struggle with satyrs, executioners strangling their victims, Ugolino in the Pisan tower — executed in a rugged, discordant pen-and-wash technique and marked by vehement exaggerations of body types and gestures (Bayonne; Louvre; Buehler Coll., etc.). In a calmer style Géricault explored such classical themes as* Mars and Hercules *(Lille; Marcille Coll.) and projected a* Battle of Gods and Giants *of which scattered traces remain.*

*The group of three* Heroic Landscape Compositions *(Petit Palais; Chrysler Coll.; ex-Huntington Hartford Coll.; drawings at the Fogg Museum and in the Dubaut Coll.) which Géricault painted in free imitation of the manner of French masters of the seventeenth century are the culminating expression of his romantic classicism of this period. The* Deluge *(Louvre) is closely related to them.*

1816    In March, Géricault competed for the Prix de Rome of the Ecole des Beaux-Arts.

*The competition theme,* The Dying Paris Rejected by Oenone, *suited his "antique" manner. The surviving studies (Buehler Coll.; Rouen; Bayonne; Orléans; Munich)* *show to what degree he had by this time purged his new style of its original crudity and exaggeration.*

He failed to win the prize and resolved to go to Rome at his own expense.

Italian Journey 1816-1817

1816    In September or October of 1816, Géricault left for Italy, intending to stay two years. His purpose was in part deeply personal, a desire to escape from his troubled love. He also wanted to study the remains of antiquity and the works of the Italian masters.

*On his way to Rome he stopped in Florence where he drew studies after Michelangelo's* *Medici Tombs (Ecole des Beaux-Arts; Bayonne).*

In Rome he was most strongly impressed by Michelangelo's frescoes in the Sistine Chapel: he "trembled" before the *Last Judgment.* As echoes in his later works show, he also came under the spell of Raphael and the painters of the Baroque.

*A record of his travel impressions is preserved in the Zurich Sketchbook (Kunsthaus).*

1816-17  While in Italy he drew in both his casual "modern" and in his grander "antique" vein. In the one he noted his observations of Roman street life, in the other he composed mythological themes.

What has sometimes been called his "Italian Manner" is actually only the final maturity of his "antique" manner which had had its beginnings two years earlier. This accounts for the promptness with which he was able to achieve his great series of wash-and-gouache drawings of classical themes after only a short stay in Italy.

*Among the finest of these drawings are* Leda and the Swan *(Louvre; Ecole des Beaux-Arts; Alençon),* Silenus and his Retinue *(Orléans; Marcille Coll.),* Centaur Abducting a Woman *(Louvre; Rouen; Jowell Coll.),* Satyr and Nymph *(Louvre), and* Stag Hunt *(Louvre).*

*In a more casual style he observed and recorded picturesque scenes of Italian life. In these works he was following his personal bent and possibly was influenced by* *the then fashionable vedutists and genre specialists, such as Pinelli. The faint traces of more ambitious genre compositions appear among these drawings:* Worshippers at the Portal of a Church *(Lyon; Ecole des Beaux-Arts),* an Italian Family *(painted version in Stuttgart; drawings in various collections),* a series recording an Execution in Rome *(Ecole des Beaux-Arts; Jowell Coll.), and many studies of* Italian Peasants *(Gobin Coll.; Buehler Coll., etc.).*

1817    During the Roman Carnival in February of 1817, Géricault witnessed the traditional race of riderless Barberi horses in the Corso. The spectacle fascinated him as a lover

of horses, as an observer of modern life, and as a painter in search of a grand subject. It inspired him to attempt a fusion of his "modern" and his "antique" manners in a work of large scale which would translate an observed event into timeless and monumental forms.

*He spent the remainder of his Italian stay developing the composition of the* Race of the Barberi Horses. *Of the many studies which he painted and drew, only a fraction is preserved. They form a progressive sequence, dissecting the race into its different aspects: the start in the Piazza del Popolo, the race itself, and the capture of the horses at the finish. Starting with a realistic, "picturesque" description of these various phases, he gradually divested them of all modern detail, transforming the Carnival scene into an elemental struggle between men and animals. Initially he wavered between the dramatic capture (drawings in Truro; Marcille Coll.; painting in Lille) and the suspenseful start (drawing in Buehler Coll.; painting in Walters Art Gallery, Baltimore). Having selected the episode of the Start as his subject, he gave it an Arcadian setting (Rouen) or a background of classical architecture (drawing in Fogg Museum, paintings in the Buehler Coll., Louvre, Daber Coll.) and placed the figures in frieze-like arrangements of grandly monumental effect. The groups of men restraining horses resume a theme which he had treated earlier, in the* Signboard of a Blacksmith *and the* Wounded Cuirassier. *In the most developed version of the composition (Louvre), the main figures are curiously reminiscent of French Baroque rather than Roman sources — they resemble Coustou's* Horsetamers of Marly.*

It was Géricault's plan to execute the *Race of the Barberi Horses* in life-size, a bold idea, since the composition lacked a proper subject — historical or mythical — such as was conventionally expected of monumental or "history" painting.

Driven by personal reasons, Géricault abruptly abandoned the project in an unfinished state and hurriedly returned to France at the end of September 1817, one year earlier than he had planned.

Return to France 1817-1818

1817     The domestic setting to which Géricault returned in the fall of 1817 was that of his father's house in the Rue des Martyrs, located in a newly-established quarter, popularly known as "Nouvelle Athenes," in the northern outskirts of Paris. The neighborhood in which he lived was largely inhabited by professional men, artists, politicians, and young veterans of the Napoleonic wars. His studio closely adjoined that of his friend, Horace Vernet. Vernet's studio was a lively center of political discussions and Bonapartist agitation.

Géricault's personal life rapidly approached a crisis. During November his mistress conceived a child by him. He knew that the relationship between his young aunt and himself could not be hidden much longer, and the thought of the approaching scandal must have weighed heavily on him.

As he was determined to exhibit at the next Salon (1819), he continued to search for a subject.

1817-18 *The project of a* Cattle Market *(Fogg Museum) which occupied him for a time recalls that of the* Barberi *in its inspiration and development. In it Géricault attempted a synthesis of motifs from classical sources (the drawings of* Hercules Killing the Bull *and* Antique Sacrifice, *both in the Louvre) with Italian genre scenes (*Roman Herdsmen, *Fogg) and observations gathered in the slaughter-houses of Paris. One of his earliest lithographs,* Roman Butchers *(1817, Delteil 2) was a by-product of this project, which he abandoned only after having made many studies for it.*

*He also projected a* Battle Scene, *alternately in "antique" and in modern versions (Bayonne; Ecole des Beaux-Arts; Louvre). The painting* Artillery Train Passing a Ravine *(Munich) and the lithograph* Artillerie à cheval changeant de position *(1819, Delteil 16) may have come out of these essays.*

Influenced by his friends, many of whom were politically active, his interests once again turned to contemporary events and his search began to center around modern subjects. Horace Vernet introduced him to the new technique of lithography, then at the height of its fashion and much used for political polemic. Géricault rapidly achieved great mastery in this medium.

1817-19 His early lithographs (1817-19) dealt mostly with the heroism and suffering of French soldiers caught in the military disasters of 1812-15; they recall thus the *Wounded Cuirassier.* Despite their modest format, he achieved in them a remarkable blend of objective realism and stylistic grandeur.

*A sketchbook fragment in Chicago records the considerable preparatory work that went into these lithographs, and so do many other studies for them, as well as such related, finished drawings as* Kléber at St. Jean d'Acre *(Rouen), or even paintings such as* Cart Loaded with Wounded Soldiers *(Cambridge).*

1818 *The then recent, atrocious murder of Fualdès, ex-magistrate of Rodez, a case much debated at the time because of its political repercussions, tempted Géricault to explore various phases of the crime in a series of compositions in the "antique" manner (drawings in Rouen; Lille; Aubry Coll.; ex-Trévise Coll.). This was his first use of a sensational, contemporary event as subject for a monumentally conceived composition.*

Though modest in themselves, these essays are important as proof of Géricault's ability to combine stylistic discipline and modern realism; this was the final result of the effort at greater control and expressive energy which he had begun in 1814. It was also the immediate preparation for the *Medusa,* the great enterprise of his life.

The Raft of the Medusa 1818-1819

The shipwreck of the *Medusa* in July of 1816 and the loss of 135 of its crew and passengers — abandoned on a make-shift raft by the captain — vehemently agitated public opinion, for reasons both humanitarian and political, at the time of Géricault's return to France in 1817. An account by two survivors, Corréard and Savigny, was published in November 1817 and gave Géricault the idea of using this event as the subject for a very large painting which he intended to submit to the Salon of 1819.

21

| 1818 | On the eve of this undertaking the scandal of his liaison erupted and shattered his family. His natural son, born on August 21, was declared to be "of parents unknown" but was supported by Géricault's father. The final separation from his mistress must have occurred some time in the spring of 1818. It is likely that these troubles strengthened Géricault's decision to shut himself off in an enterprise of long duration. |
|---|---|
| April-May | Work on the *Medusa* started some time in the late spring of 1818. As he had done in previous projects, Géricault began by exploring the successive episodes which constituted the event. Of several, he drew detailed compositions: the *Mutiny* of the crew, the outbreak of *Cannibalism* after the battles on the raft, the inconclusive *Sighting* of the rescue vessel on the thirteenth day of the raft's voyage, the *Approach of a Rowboat* to the raft, and the final *Rescue* of the survivors. It is significant that he did not treat the scenes that were politically the most controversial, e.g., the desertion of the raft by the Medusa's aristocratic captain. |

*Compositions for the* Mutiny *are in the Rouen, Amsterdam, and Fogg museums. A drawing of the scene of* Cannibalism *is in the Gobin Collection. A painted study of the* Approach of a Rowboat *perished in 1944; drawings exist in the Rouen and Poitiers museums, and the Marcille Collection. Drawings of the* Rescue *are in the Dubaut and Granville Collections.*

Having decided to use the episode of the *Sighting* for his picture, he very gradually constructed its composition, literally building its pyramid of bodies from the base upward, by piling figure on figure.

*The successive stages in this process of construction are well documented by a chain of compositional drawings and painted studies in the museums of Besançon, Rouen, Lille, and the Louvre, and in the Aubry and Buehler Collections. Each of the figures of the composition had its own gradual development, traceable in the very numerous preserved studies. The* Zurich *Sketchbook, in addition, preserves several drawings from life for the* Medusa.

The composition which Géricault gradually evolved is of the highest originality. From a foreground filled with cadavers and the motionless figures of despairing men, groups of striving, signalling men rise as with one motion, their gestures converging on the point in the far distance which marks the scarcely visible sail of the rescue vessel. The raft is so turned and the men on it so arranged as to place the viewer in close involvement with the action, compelling his empathetic participation and, at the same time, giving him a vivid experience of the elemental forces which oppose and frustrate the men. Rather than through explanatory narrative, the composition delivers its meaning directly by its very structure.

| 1818-19 | By November of 1818 the completed composition was ready to be transferred to the canvas. Géricault moved to a larger studio where he secluded himself during the eight months it took him to execute the painting. |
|---|---|

*He painted the figures of his composition directly from life, setting them side by side on the bare canvas on which he had traced his composition in outline. To assist in the execution of his picture, he painted and drew separate life and portrait studies (sev-*

*eral of these now in the museums of Alen-
çon, Besançon, and Rouen, and in the Baker,
Buehler, and Dubaut Colls.).*

*A special group of studies associated
with the* Medusa *represents dead or dying
men (paintings in Chicago and Hohelohe
Coll.; drawings in Bayonne and Gobin
Coll.), severed heads (paintings in Stock-
holm and Dubaut Coll.; drawings in Besan-
çon and Dubaut Coll.), and dissected limbs*

*(paintings in Montpellier, Louvre, and
Lebel Coll.). Executed with sober realism
and totally devoid of any romantic grave-
yard morbidity, these studies served no
direct, practical purpose. Géricault prob-
ably painted them to sharpen his awareness
of the physical and emotional reality of his
subject and to maintain himself in a state
of alert tension during the long drudgery
of his work.*

The *Raft of the Medusa* combined two sides of Géricault's art, its realist tendencies
and its monumental, heroic aspirations. It represents on every level, the formal as
well as the thematic, a complicated fusion of naturalism and stylization, of factual
truth and symbolic allusion. It remains one of the very few works in modern art
which raises an actual event to the level of grand style and timeless significance.

1819    The Salon opened on August 25, 1819. Badly hung, the *Medusa* received a mixed
critical reaction. Much of the discussion which it stirred reflected artistically irrele-
vant, political issues.

        Profoundly exhausted by his long labor, Géricault passed through a time of
physical and emotional sickness.

English Journey 1820-1821

1820    As he had done four years earlier, Géricault sought relief in travel. He seized on a
chance to have the *Medusa* exhibited in London at the "Egyptian Hall," operated by
the showman William Bullock, and left for England on April 10, 1820. The exhi-
bition of his picture opened in London on June 12 and continued until December 30,
1820, after which the *Medusa* was shown in Dublin. The exhibition was a popular
success. More than 50,000 paid admissions are said to have netted Géricault between
17,000 and 20,000 francs. He remained in England for nearly two years, interrupt-
ing his stay in November 1820 to visit the painter Louis David in his Brussels exile.

1821    While in London he associated with English artists, even attending a Royal Academy
dinner at the invitation of Sir Thomas Lawrence, and absorbed the influence of
English sporting, genre, and landscape painting. His English work did not center
around major projects. After the *Medusa,* he had renounced heroic subject matter
and grand style, content to devote himself to the description of common life. He
drew a great deal, painted in watercolors, but rarely used oils.

        The bulk of his English work is of small format and casual character. It shows
a marked drop in emotional temperature and often seems overcast by melancholy
or lassitude. Instead of the former energy, there is a new lightness and refinement of
touch, a greater attention to nuances of color, tone, and atmosphere.

1821     *Many of the drawings and watercolors which can be dated in the English years are connected with the series of lithographs which Géricault drew for English publishers. Some of these are concerned with the lives of the poor and show a keenness of social observation which goes beyond that of his studies of Roman popular life. The wash drawing of a* Public Hanging *(Rouen) and the studies related to the lithographs of* the Piper *(Delteil 30) and the* Paralytic Woman *(Delteil 38) document aspects of London low life with hard realism. Even when representing horses he shows a preference for heavy work animals, often setting them in the bleakness of wharves and coalyards, as in the many studies for* Adelphi Wharf *(Delteil 40) and the* Coal Wagon *(Delteil 36).*

Some of the English work is concerned with the more elegant aspects of horsemanship and sport. In the watercolors of these subjects Géricault developed a brilliance of color and intricacy of finish reminiscent of some of his early military paintings. It is possible that not all of the very numerous drawings and watercolors of grooms, officers, and "amazons" actually date from his English stay and that some of them were executed after his return to France.

*Influenced by English animal painters (Stubbs, Ward, Landseer) and inspired by visits to a London zoo, he drew and painted many studies of lions, tigers, and panthers,* *often showing these animals in dramatic conflict with one another, or attacking horses (Louvre; Ecole des Beaux-Arts; Rouen; Rotterdam, etc.).*

Among the few paintings in oil which Géricault executed in England are several small studies and one large, highly finished picture of horse racing, the English counterparts of his Roman *Race of the Barberi Horses.*

1821     *The* Epsom Downs Race *(Louvre), said to have been painted for his landlord, the horse-dealer Elmore, was preceded by smaller studies (Bayonne and Louvre) all of which show tightly-massed groups of horses plunging forward and flitting past blurrily-* *indicated landscapes. The execution is dry, hard, bright in the figures, subtly atmospheric in the skies and landscapes. The break with Géricault's earlier sculptural and monumental style seems absolute.*

Last Years 1822-1824

1822     Géricault returned to Paris in failing health and bad spirits. Within a short time he suffered a series of riding accidents which broke what was left of his health. He gambled away part of his fortune in financial speculations and reckless expenditures. He was bed-ridden for some time in 1822 but recovered in the late months of the year and resumed his work. His abilities were unimpaired but, instead of focusing them on major works, he spent them in enterprises of small scale and short duration.

He continued to draw lithographs and to compose genre scenes — most of them concerned with stabled horses, farriers, and postillions — in a style so close to that of his English work that it is difficult to distinguish between the pictures he did in France and those he did in England.

*Most of the versions in oil of English genre subjects seem to belong to the years of 1822-23, for example, the* Postillion at the Door of an Inn *(Fogg Museum).*

*The* Lime Kiln *(Louvre), though painted in Montmartre ca. 1822, is the culmination of his English suburban, industrial genres.* *It shows draught horses waiting in a bleak terrain, topped by the ugly, impressive monolith of a factory. The romantic poignancy of the pictures derives not from any extraordinary features, but from the intensity of its realism. Its seemingly grey monochromy is, in fact, a blend of many colors.*

1822-23    The same intensity of realism, raised to its highest, expressive power, appears in the *Portraits of the Insane* which Géricault painted on commission for an acquaintance, Dr. Georget, an alienist engaged in the study of morbid obsessions, or "monomanias." The exact date of this series of portraits of actual mental patients is not known. It was most likely painted in the winter of 1822-23.

*Only five of the ten portraits are known: the* "Gambler" *(Louvre),* "Envy" *(Lyon),* "Kidnapper" *(Springfield),* "Kleptomaniac" *(Ghent), and* "Delusion of Military Rank" *(Reinhart Coll.). They are histori-* *cally remarkable as objective studies of insanity, painted at a time when artists treated insanity sensationally or sentimentally.*

Géricault shared the interest of many of his contemporaries in the cause of Greek independence and followed the war of Greek national liberation with interest. It is possible that he planned to paint a picture on this theme.

*The large number of portraits of Orientals, costume studies, and genres (such as the painting traditionally known as the* Plague *at Missolunghi, in the Virginia Museum), may be related to such an intention.*

1823    At the very end of his life Géricault returned to his old ambition: to cast a significant contemporary subject in monumental form.

*Fragmentary remnants indicate that he considered the subjects of the* Liberation of the Prisoners of the Spanish Inquisition by French Troops *(drawings in the Dubaut Coll.) and the* African Slave Trade *(drawings in Ecole des Beaux-Arts and Dubaut* *Coll.). The former was a memory of the Napoleonic Wars in the Peninsula, stirred by the recent Bourbon invasion of Spain, and the latter a cause then much under discussion.*

1823    In the late spring or the summer of 1823 Géricault's fatal illness, a form of tubercular decay of the spine, became acute. He underwent several operations and was bedridden throughout the latter half of the year. On November 30 he made his last will with the intention of leaving all his property to his natural son.

1824    On January 26 Géricault died.

The contents of his studio were dispersed at auction on November 2-3. The sale was well attended and realized an unexpectedly large sum. Géricault's close friend Dedreux-Dorcy bought the *Medusa* and sold it to the Louvre on November 12, 1824.

# Chronological Bibliography

*m* monographs
*b* the most important bibliographic sources
*s* special studies of aspects of Géricault's work
*c* catalogs of museums or private collections

*A Concise Description of M. Jerricault's* (sic) *Great Picture, Representing the Surviving Crew of the Medusa, French Frigate,* at the Roman Gallery, Egyptian Hall, Piccadilly, London, 1820.

A. Corréard and H. Savigny, *Naufrage de la frégate la Méduse* (4th ed.), Paris, 1821.

b "M. Géricault," *La Pandore* (Paris, January 29, 1824); cf. P. Courthion, *Géricault raconté par lui même et par ses amis.* Vézenas-Geneva, 1947, p. 273.

c *Catalogue de la vente aprés décés de Géricault,* Hotel Bullion, Paris, November 2-3, 1824; cf. *Gazette des Beaux-Arts,* VI period, Vol. LIII, p. 115 ff.

*Fac-similes extraits des livres de croquis de Géricault,* Paris, 1825.

b Letter of Th. Lebrun of 1836, cf. M. Tourneux. "Particularités intimes sur la vie et l'oeuvre de Géricault," *Bulletin de la Société de l'Histoire de l'Art Français* (1912), p. 56 ff.

b L. Batissier, "Biographie de Géricault," *Revue du XIX siècle* (Paris, 1842); cf. Courthion, *op. cit.,* p. 23.

b "Tombeau de Géricault, par M. Etex," *Magasin Pittoresque* (1841), p. 108.

E. Coquatrix, *Aux Rouennais: Géricault,* Rouen, n.d. (1842).

Lucien-Elie, *Eloge de Géricault,* Rouen, 1842.

C. Blanc, *Histoire des peintres français au XIX siècle,* I, Paris, 1845, p. 439.

J. Michelet, "David, Géricault; Souvenirs du College de France, 1846," *Revue des Deux Mondes,* LXVI (1896), p. 237.

T. Thoré, *Salon de 1846,* Paris, 1846, p. 30 ff.

T. Thoré, *Salon de 1847,* Paris, 1847, p. 77 ff.

J. Michelet, "Cinquième leçon non-professée," *Cours professées au Collège de France, 1847-48* (Paris, 1848); cf. Klingender in *Burlington Magazine,* LXXXI (1942), p. 254.

G. Planche, "Géricault," *Revue des Deux Mondes,* XXI (1851), p. 502.

H. de Chennevières, *Archives de l'art français,* I, Paris, 1852, p. 71 ff.

A. Dumas, *Mes mémoires,* Brussels, 1852.

T. Silvestre, *Les Artistes Français; I. Romantiques,* 1856 (re-issued by the Bibliothèque Dionysienne, Paris, 1926, Vol. I, p. 52 ff).

b de la Garenne, "Géricault," *Biographie Universelle* (Paris, 1856).

E. Delécluze, *Louis David, son école et ses élèves,* Paris, 1855, p. 381 ff.

L. Véron, *Mémoires d'un bourgeois de Paris,* I, Paris, 1856, p. 269 ff.

b Col. LaCombe, *Charlet,* Paris, 1856, p. 17 ff.

E. Chesneau, "Le mouvement moderne en peinture," *Revue Européenne,* XVII (1861), p. 483 ff. (re-published in 1862 under the title *Les chefs d'école*).

C. Blanc, *Histoire des peintres; Ecole Française,* III, Paris, 1863, p. 3.

A. Durande, *Joseph, Carle et Horace Vernet,* Paris, 1864.

Piron (ed.), *Eugène Delacroix, sa vie et son oeuvre,* Paris, 1865, p. 61.

m C. Clément, *Géricault, étude biographique et critique,* Paris, 1867 (3rd ed., enlarged, 1879).

T. Couture, *Méthodes et entretiens d'atelier,* Paris, 1867.

J. B. Delestre, *Gros, sa vie et ses ouvrages,* Paris, 1867.

b H. Lachèvre, *Details intimes sur Géricault,* Rouen, 1870 (excerpts republished by P. Courthion in *Géricault, raconté par lui-méme et par ses amis,* Vézenas-Geneva, 1947).

E. Fromentin, *Les maîtres d'autrefois,* Paris, 1876.

A. Jal, *Souvenirs d'un homme de lettres,* Paris, 1877, p. 405 ff.

Barbey d'Aurevilly, *Les oeuvres et les hommes,* Paris, 1879.

J. Tripier Le Franc, *Histoire de la vie et de la mort du baron Gros,* Paris, 1880, p. 406 ff.

H. Houssaye, "Un maitre de l'école française: Géricault," *Revue des Deux Mondes,* XXXVI (1879), p. 374 ff.

b M. du Camp, *Souvenirs littéraires,* II, Paris, 1883, p. 295 ff.

b A. Etex, *Les trois tombeaux de Géricault,* Paris, 1885.

A. Etex, *Les souvenirs d'un artiste,* Paris, n.d.

J. Gigoux, *Causeries sur les artistes de mon temps,* Paris, 1885.

M. Hamal, "Portraits de fous," *Gazette des Beaux-Arts,* XXXV (1887), p. 256 ff.

E. de Lalaing, *Les Vernet, Géricault, et Delaroche,* Lille, 1888.

E. Michel, *L'école française de David à Delacroix, chefs d'oeuvre de l'art au XIX siècle,* Paris, 1891.

A. Tréal, "Dessins anatomiques de Géricault," *Chronique des Arts* (1893), p. 44.

C. de Beaulieu, *Peintres du XIX siècle,* Paris, 1894.

F. Benoit, *L'art français sous la Révolution et l'Empire,* Paris, 1897.

s E. Cuyer, "Notes sur quelques dessins anatomiques de Géricault," *Chronique des Arts* (1898), p. 236.

C. Blanc, *Les trois Vernet,* Paris, 1898.

A. Dayot, *Les Vernet,* Paris, 1898.

J. Breton, *Nos peintres du siècle,* Paris, 1900.

L. Rosenthal, *La peinture romantique,* Paris, 1900.

m L. Rosenthal, *Géricault,* Paris, 1905.

C. J. Holmes, "The Passage of the Ravine by Géricault," *Burlington Magazine,* VIII (1908), p. 209.

*c* J. Meier-Graefe and E. Klossowski, *La collection Chéramy, Munich,* 1908, p. 76 ff.

*b* Boyer d'Agen, *Ingres d'après une correspondance inédite,* Paris, 1909, pp. 28, 166.

*c* Guiffrey and Marcel, *Inventaire général des dessins du Musée du Louvre, Ecole Française,* V, Paris, 1910, p. 120 ff.

P. Huet, *Notes et correspondances,* Paris, 1911.

P. André-Lemoisne, *Eugène Lami, 1800-1890,* Paris, 1912, p. 15 ff.

P. Fechter, "Géricault," *Kunst und Künstler,* XI (1913), p. 267.

J. Meier-Graefe, *Delacroix und Géricault* (Mappen der Maresgesellschaft XIV), Munich, n.d. (ca. 1914).

*b* L. Bro de Comères, *Mémoires,* Paris, 1914, Chap. VII.

L. Dimier, *Histoire de la peinture française au* XIX *siècle,* Paris, 1914.

E. Waldmann, "Notizen zur Franzosen-Ausstellung in Dresden," *Kunst und Künstler,* XIII (1914), p. 389.

G. Vauthier, "Le comte de Forbin et le Radeau de la Méduse," *Bulletin de la Société de l'Histoire de l'Art Français,* (1915-17), p. 170 ff.

M. G., "A propos de Géricault," *Le Progrès Medical* (Paris, 1920), no. 20.

K. Scheffler, "Géricault," *Kunst und Künstler* (1920), p. 188.

*b* H. Vollmer, "Géricault," Thieme-Becker, *Allgemeines Lexikon der bildenden Künstler,* XIII (Leipzig, 1920), p. 458 ff.

O. Grautoff, "Géricault," *Die Kunst,* XXXIX (1923-24), p. 129 ff.

R. Regamey, "Hommage à Géricault," *Les cahiers du mois,* III (July 1924).

R. Sizéranne, "Géricault et la découverte du cheval," *Revue des Deux Mondes* (May 1, 1924; reprinted in P. Courthion, *op. cit.).*

L. Rosenthal, "Géricault et notre temps," *Amour de l'art* (1924), p. 9 ff. and p. 203 ff.

L. Rosenthal, "Centenaire de Géricault," *Revue de l'art ancien et moderne,* XLIX (1924), p. 53 ff. and p. 225 ff.

Duc de Trévise, "Géricault, peintre d'actualités," *Revue d'art ancien et modern,* XLIX (1924), p. 102 ff.

R. Rey, "Géricault," *Art et artistes* (1924), p. 257 ff.

*s* L. Delteil, *Géricault (Le peintre-graveur illustré,)* XVIII, Paris, 1924.

L. M. Vaucelles, "La méthode et la leçon de Géricault," *L'Art d'aujourd'hui,* I (1924), p. 28 ff.

F. Guey, "Centenaire de Géricault," *Renaissance de l'Art Français* (1924), p. 95 ff.

A. Michel, *Histoire de l'Art,* VIII, 1st part, Paris, 1925, p. 119 ff.

*c* *Les Dessins de la Collection Léon Bonnat au Musée de Bayonne,* I-III, Bayonne, 1925-26.

H. Foçillon, *La peinture du XIX siècle à nos jours,* Paris, 1925.

L. Rosenthal, "Géricault et Delacroix, élèves au Lycée Imperial," *Bulletin de la Société de l'Histoire de l'Art Français* (1925), p. 85 ff.

*m* R. Régamey, *Géricault,* Paris, 1926.

Braun et Cie., *Un choix de dessins de Géricault, Gleyre, Fromentin,* Paris, 1927.

*m* G. Oprescu, *Géricault,* Paris, 1927.

H. Foçillon, *La peinture au XIX siècle,* I, Paris, 1927.

Duc de Trévise, "Géricault," *The Arts,* XII (1927), p. 183 ff.

R. Rey, "Gros-Géricault," *Le romantisme et l'art* (Paris, 1928), p. 74 ff.

*s* C. Martine, *Cinquante-sept dessins de Théodore Géricault,* Paris, 1928.

P. Lavallée, "1930, Centenaire du romantisme; le dessin romantique," *Revue de l'art ancien et moderne,* LVIII (1930), p. 219 ff.

W. Friedlaender, *Hauptströmungen der französischen Malerei von David bis Delacroix,* Berlin, 1930 (English translation by Robert Goldwater, *David to Delacroix,* Cambridge, 1952).

*s* R. Huyghe, "La génèse du cuirassier blessé," *Amour de l'art* (1931), p. 65 ff.

L. Réau, *L'art romantique,* Paris, 1930.

W. T. Whitley, *Art in England, 1821-37,* Cambridge, 1930, p. 6.

*Thomas Couture, sa vie, son oeuvre ... par lui-même et par son petit-fils,* Paris, 1932, p. 143 ff.

*s* G. Bazin, "La course des chevaux libres," *Amour de l'art* (1932), p. 217 ff.

R. Fry, *Characteristics of French Art,* London, 1932.

A. Joubin (ed.), *Journal d'Eugène Delacroix,* Paris, 1932.

J. D. Maublanc, *Etapes: David, Géricault, Delacroix,* Paris, 1934.

*c* P. Lavallée, *David, Ingres, Géricault et leur temps,* Paris, 1934.

J. de Laprade, "Dessins de Géricault, Galerie Gobin," *Beaux-Arts* (December 13, 1935), p. 1.

M. Gauthier, *Géricault,* Paris, 1935.

M. Davidson, "American Debut of Géricault," *Art News,* XXXV (1936), p. 8.

J. de Laprade, "Une magnifique exposition d'oeuvres de Géricault," *Beaux-Arts* (May 14, 1937), p. 8.

M. Kolb, *Ary Scheffer et son temps,* Paris, 1937.

H. Francis, "Exhibition of the Work of Géricault," *Cleveland Museum Bulletin,* XXIV (1937), p. 24 ff.

*Collection du Duc de Trévise,* Galerie Jean Charpentier, Paris, 1938, p. 12 ff.

M. Florisoone, "La folle de Géricault," *Bulletin des Musées de France,* X, no. 6 (1938).

J. J. Sweeney, "Three Romantics, Gros, Géricault, Delacroix," *Parnassus,* X (December, 1938), p. 12.

s N. Wynne, "Géricault's Riderless Racers," *Magazine of Art,* XXXI (1938), p. 209 ff.

A. Frankfurter, "Apostles of Romanticism: Gros, Géricault, Delacroix," *Art News,* XXXVII (1938), p. 8.

R. Goldwater, "Gros, Géricault, Delacroix," *Art in America,* XXVII (1939), p. 36.

P. Courthion, *David, Ingres, Gros, Géricault,* Paris, 1940.

J. Knowlton, "The Style of Géricault's Raft of the Medusa," *Art News* (March, 1940), p. 14 ff.

L. Dimier, "Le rôle de Géricault dans nôtre école," *Beaux-Arts,* XXXVI, no. 7 (1941), p. 9 ff.

s M. Miller, "Géricault's Portraits of the Insane," *Journal of the Warburg and Courtauld Institute,* IV (1941), p. 152 ff.

F. Antal, "Reflections on Classicism and Romanticism," *Burlington Magazine,* LXXVII (1940), p. 72 ff. and p. 188 ff.; LXXVIII, p. 14 ff.

R. Escholier, *"La peinture française au XIX siècle, de David à Géricault,* Paris, 1941.

s J. Knowlton, "The Stylistic Origins of Géricault's Raft of the Medusa," *Marsyas,* II (1942), p. 125 ff.

O. Benesch, "From Neo-Classicism to Romanticism: David, Ingres, Géricault," *Art News,* XLII (1944), p. 20 ff.

W. Pach, "Géricault in America," *Gazette des Beaux-Arts,* XXVII (1945), p. 235 ff.

s K. Berger, *Géricault, Drawings and Watercolors,* New York, 1946.

K. Berger, "David and the Development of Géricault's Art," *Gazette des Beaux-Arts,* XXX (1946), p. 41 ff.

b P. Courthion, *Géricault raconté par lui-même et par ses amis,* Vézenas-Geneva, 1947.

E. J. Delécluze, *La vie parisienne sous la Restauration,* Paris, 1948.

R. Huyghe, *Le dessin français au XIX siècle,* Lausanne, 1948.

C. C. Cunningham, "Village Forge by J. A. L. Théodore Géricault," *Wadsworth Atheneum Bulletin,* series 2, no. 12 (Dec., 1949).

H. Wegener, "A Study of Géricault," *Brooklyn Museum Bulletin,* XI, no. 2 (1950) p. 11 ff.

R. Huyghe, "The Louvre Museum and the Problem of Cleaning Old Pictures," *Museum,* III (1950), p. 191 ff.

m K. Berger, *Géricault und sein Werk,* Vienna, 1952 (French translation published in 1953; reviewed by G. Seligman, *Art Bulletin,* September 1953; further remarks by L. Eitner, *Art Bulletin,* June 1954).

W. Friedlaender, "Géricault, Romantic Realist," *Magazine of Art,* XLV (1952), p. 260 ff.

A. Blunt, "Géricault at the Marlborough Gallery," *Burlington Magazine,* XCV (1953), p. 24 ff.

L. Eitner, "Deux oeuvres inconnues de Géricault au Musée d'Art Moderne," *Bulletin, Musées Royaux des Beaux-Arts* (Brussels, June 1953), p. 55 ff.

A. Dupont (ed.), *Eugène Delacroix, lettres intimes,* Paris, 1954.

D. Aimé-Azam, "Le tragique sécret de Théodore Géricault," *Journal de l'amateur de l'art,* VII (1954), p. 5 ff.

s L. Eitner, "Two Re-Discovered Landscapes by Géricault and the Chronology of his Early Work," *Art Bulletin,* XXXVI (1954), p. 131 ff.

s M. Huggler, "Two Unknown Landscapes by Géricault," *Burlington Magazine,* XCVI (1954), p. 234 ff.

s L. Eitner, "Géricault's Wounded Cuirassier," *Burlington Magazine,* XCVI (1954), p. 237 ff.

s B. Nicolson, "The Raft from the Point of View of Subject Matter," *Burlington Magazine,* XCVI (1954), p. 241 ff.

s L. Johnson, "The Raft of the Medusa in Great Britain," *Burlington Magazine,* XCVI (1954), p. 249 ff.

L. Eitner, "Géricault at Winterthur," *Burlington Magazine,* XCVI (1954), p. 254 ff.

s L. Johnson, "Some Unknown Sketches for the Wounded Cuirassier and a Subject Identified," *Burlington Magazine,* XCVII (1955), p. 78 ff.

J. W. Fowle, "Batissier's Géricault," *Burlington Magazine,* XCVII (1955), p. 81.

c P. Dubaut (ed.), *Sammlung Hans E. Buehler,* Winterthur, 1956.

m D. Aimé-Azam, *Mazeppa, Géricault et son temps,* Paris, 1956.

M. Florisoone, "Moratin, Inspirer of Géricault and Delacroix," *Burlington Magazine,* XCIX (1957), p. 302 ff.

L. Aragon, *La semaine sainte,* Paris, 1958.

s L. Eitner, "The Sale of Géricault's Studio in 1824," *Gazette des Beaux-Arts,* VI period, Vol. LIII (1959), p. 115 ff.

c M. Gobin, *Géricault dans la collection d'un amateur,* Paris, 1959.

c C. Sterling and H. Adhemar, *La peinture au Musée du Louvre, Ecole Française,* I, Paris, 1959, p. 35 ff.

s L. Eitner, *Géricault, an Album of Drawings in the Art Institute of Chicago,* Chicago, 1960.

s R. Lebel, "Géricault, ses ambitions monumentales et l'inspiration italienne," *L'Arte,* n.s. XXV (1960), p. 327 ff.

J. Q. van Regteren Altena, "Het vlot van de Medusa," *Openbaar Kunstbezit,* V, no. 10 (1961).

G. Oprescu, "Oeuvres inédites de Géricault en Roumanie," *Art de France,* I (1961), p. 368 ff.

G. Testori, "Un Géricault ritrovato," *Arte Antica e Moderna,* no. 13/16, p. 462 ff.

E. Cameron, "The Space Composition of Géricault's Lime Kiln," *Leeds Art Calendar* (1962), p. 6 ff.

F. H. Lem, "Le thème du nègre dans l'oeuvre de Géricault," *L'Arte, n.s.* XXVII (1962), p. 19 ff.

F. H. Lem, "Le séjour de Géricault en Italie," *L'Arte,* n.s. XXVII (1962), p. 189 ff.

m  N. V. Prokofiev, *Géricault,* Moscow, 1963.

F. H. Lem, "Géricault portraitiste," *L'Arte,* n.s. XXVIII (1963), p. 59 ff.

s  L. Eitner, "Géricault's 'Dying Paris' and the Meaning of his Romantic Classicism," *Master Drawings,* I (1963), p. 21 ff.

m  A. del Guercino, *Géricault,* Milan, 1963.

W. Wells, "Géricault in the Burrell Collection," *Scottish Art Review,* IX (1964), p. 13 ff.

N. Wallis, "Géricault—the Great Unknown," *Connoisseur,* CLVIII (1965), p. 16 ff.

s  S. Lodge, "Géricault in England," *Burlington Magazine,* CVII (1965), p. 616 ff.

M. A. Tippetts, *Les marines des peintres, vues par les littérateurs de Diderot aux Goncourt,* Paris, 1966, p. 65 ff.

A. del Guercino, "Géricault e Caravaggio," *Paragone,* XVII (1966), p. 70 ff.

A. Jouan, "Notes sur quelques radiographies," *Bulletin du laboratoire du Louvre,* XI (1966), p. 17 ff.

R. Jullian, "Géricault et l'Italie," *Arte in Europa, Scritti di storia dell'arte in onore di Edoardo Arslan,* I (1966), p. 697 ff.

H. A. Lüthy, "Géricault's Zürcher Skizzenbuch," *Neue Zürcher Zeitung,* (September 18, 1966), p. 4.

s  L. Eitner, "Reversals of Direction in Géricault's Compositional Projects," *Stil und Ueberlieferung in der Kunst des Abendlandes* (Akten des 21. Internationalen Kongresses für Kunstgeschichte in Bonn), III (Berlin, 1967), p. 126 ff.

Th. Brachert, "Beobachtung an einem Gemälde von Th. Géricault," *Maltechnik,* LXXIII (1967), p. 33 ff.

s  G. Busch, "Kopien von Géricault nach alten Meistern," *Pantheon,* XXV (1967), p. 176 ff.

s  L. Eitner, "Géricault's 'La Tempête'," *Museum Studies,* II (Chicago, 1967), p. 7 ff.

R. Hoetink, *Franse teekeningen uit de 19e Euw,* Rotterdam, 1968.

P. Granville, "L'une des sources de Géricault révélée par l'identification radiographique," *Revue du Louvre et des Musées de France,* XVIII (1968), p. 139 ff.

s  H. A. Lüthy, "Géricault und Joseph Volmar," *Jahrbuch* 1968/9, Schweizerisches Institut für Kunstwissenschaft (Zurich, 1969), p. 25 ff.

s  K. H. Spencer, *The Graphic Art of Géricault,* New Haven, 1969.

m  D. Aimé-Azam, *La passion de Géricault,* Paris, 1970 (a re-publication of *Mazeppa,* 1956).

s  L. Johnson, "A Copy after Van Dyck by Géricault," *Burlington Magazine,* CXII (1970), p. 793 ff.

s  H. A. Lüthy, "Zur Ikonographie der Skizzenbücher von Géricault," *Beiträge zur Motivkunde des 19. Jahrhunderts* (Munich, 1970), p. 245 ff.

s  M. Huggler, "Die Bemühung Géricault's um die Erneuerung der Wandmalerei," *Wallraf-Richartz-Jahrbuch,* XXXII (1970), p. 151 ff.

L. Johnson, "Géricault and Delacroix Seen by Cockerell," *Burlington Magazine* (September, 1971).

s  L. Eitner, "Dessins de Géricault d'après Rubens: la genèse du Radeau de la Méduse," *Revue de l'Art* (1971).

The abbreviations used in this catalog for the most important of these exhibitions are indicated by a † and precede the exhibition titles. Nearly all the exhibitions listed were accompanied by a catalog.

"Cent chefs-d'oeuvre des collections parisiennes," George Petit, Paris, 1883.

"Exposition Universelle Internationale," Paris, 1889.

"Géricault," Salon Gurlitt, Berlin (catalog preface by J. Meier-Graefe).

"Französische Kunst des neunzehnten Jahrhunderts," Galerie Heinemann, Munich, 1913.

"Französische Maler des neunzehnten Jahrhunderts," Galerie Arnold, Dresden, 1914.

"Paintings by Modern French Masters Representing the Post-Impressionists and their Predecessors," Brooklyn Museum, New York, 1921.

"Pictures, Drawings, and Sculptures of the French School of the Last Hundred Years," Burlington Fine Arts Club, London, 1922.

"Nineteenth Century French Painters," Knoedler & Co., London, 1923.

† *(Centenary)* "Exposition Géricault," Hotel Jean Charpentier, Paris, April-May 1924 (catalog by the Duc de Trévise and Pierre Dubaut; the exhibition was also shown at the Rouen Museum).

"De David à Manet," Galerie Balzac, Paris, 1924.

"La jeunesse des romantiques," Maison Victor Hugo, Paris, 1927.

"Peintres normands de Nicolas Poussin à nos jours," Galerie Hodebert, Paris, 1928.

"Géricault," Smith College Museum of Art, Northampton, 1929.

"Ein Jahrhundert französischer Zeichnung," Galerie P. Cassirer, Berlin, 1929-30.

"Le decor de la vie à l'epoque romantique, 1820-1848," Pavillon de Marsan, Palais du Louvre, Paris, April-May 1930.

"Les aquarellistes français de Géricault à nos jours," Galerie Georges Bernheim, Paris, 1930.

"French Art, 1200-1900," Royal Academy, London, 1932.

"Les chefs d'oeuvre des musées de province," Musée Carnavalet, Paris, 1933.

"David, Ingres, Géricault et leur temps," Ecole des Beaux-Arts, Paris, 1934 (catalog by P. Lavallée).

"Cent ans de portraits français," Galerie Bernheim-Jeune, Paris, 1934.

† *(Gobin)* "Dessins, aquarelles et gouaches par Géricault," Maurice Gobin, Paris, 1935.

"Tentoonstellung van teekeningen van Ingres, Delacroix, Géricault," Boymans-van Beuningen Museum, Rotterdam, 1936.

"First Exhibition in America of Géricault," Marie Sterner Galleries, New York, 1936.

"Gros, ses amis et ses élèves," Petit Palais, Paris, 1936 (catalog preface by Raymond Escholier).

"Chefs-d'oeuvre de l'art français," Palais National des Arts, Paris, 1937.

"Zeichnungen französischer Meister von David zu Millet," Kunsthaus, Zurich, 1937 (catalog preface by Paul Jamot).

† *(Bernheim-Jeune)* "Exposition Géricault," Galerie Bernheim-Jeune, Paris, May 1937 (catalog by Pierre Dubaut).

"Künstlerkopien," Kunsthalle, Basel, 1937.

"Gros, Géricault, Delacroix," Knoedler Galleries, New York, 1938.

"French Romantic Artists," Museum of Art, San Francisco, 1939.

"European and American Painting, 1500-1900," World's Fair, New York, May-October 1940 (catalog by W. Pach).

"Master Drawings," Golden Gate International Exposition, San Francisco, 1940.

"Between the Empires: Géricault, Delacroix, Chasseriau," Fogg Museum of Art, April-June 1946.

"Exposition de portraits français," Hotel Charpentier, Paris, 1945.

"Delacroix et les compagnons de sa jeunesse," Atelier Delacroix, Paris, 1947.

† *(Bignou)* "Géricault...cet inconnu," Galerie Bignou, Paris, May-June 1950 (catalog by Pierre Dubaut).

† *(Marlborough)* "Théodore Géricault," Marlborough Fine Arts Ltd., London, October-November 1952 (catalog by Pierre Dubaut).

"The Romantic Circle," Wadsworth Atheneum, Hartford, 1952.

"French Drawings," Washington, Cleveland, St. Louis, Fogg, Metropolitan Museum, 1952-53.

† *(Winterthur)* "Théodore Géricault," Kunstmuseum, Winterthur, 1953.

"Gros, Géricault, Delacroix," Galerie Bernheim-Jeune, Paris, 1954.

"Cent chefs-d'oeuvre de l'art français," Hotel Charpentier, Paris, 1957.

"Französische Zeichnungen," Hamburg, Cologne, Stuttgart museums, 1958.

"Idee und Vollendung," Städtische Kunsthalle, Recklinghausen, 1962.

† *(Rouen and Charleroi)* "Géricault, un réaliste romantique," Musée des Beaux-Arts, Rouen, 1963 (also shown at Charleroi).

"Delacroix, ses maîtres, ses amis, ses élèves," Musée des Beaux-Arts, Bordeaux, 1963.

† *(Aubry)* "Géricault dans les collections privées françaises," Galerie Claude Aubry, Paris, 1964 (catalog by Pierre Dubaut).

"Exposition d'oeuvres originales de Théodore Géricault," Musée Bonnat, Bayonne, 1964.

"Géricault to Courbet," Roland, Browse and Delbanco, London, 1965.

"Franse teekeningen uit de 19e Eeuw," Boymans-van Beuninger Museum, Rotterdam, 1968.

"Exhibition of Early Drawings," Christopher Powney, London, 1968.

"Berlioz and the Romantic Imagination," The Arts Council of Great Britain, Victoria and Albert Museum, London, 1969.

"The Graphic Art of Géricault," Yale University Art Gallery, New Haven, 1969 (catalog by K. H. Spencer).

"Rendez-vous à cheval," Schloss Jegenstorf, 1970.

"Dessins et aquarelles du XIX siècle," Galerie l'Oeil, Paris, 1970.

*Catalog
and
Plates*

**I**

## Self-portrait

Oil on paper
8¼ x 5½ in. (210 x 140 mm.)
Collections: Henri and Felix Moulin;
René Moulin; Henri Moulin,
Mortain (Normandy);
Denise Aimé-Azam, Paris.

The rapidly dashed-off portrait shows the young artist at the age of about eighteen, i.e., as he appeared in 1808-09 when he began his studies with Carle Vernet. The execution is enthusiastically amateurish, but it already gives a foretaste of Géricault's expressive impasto. Very fashionably turned out, Géricault has chosen to present himself holding a cluster of brushes, doubtless to proclaim — perhaps in jest — his newly discovered artistic avocation. The portrait remained in the possession of descendants of Géricault's maternal family until 1958.

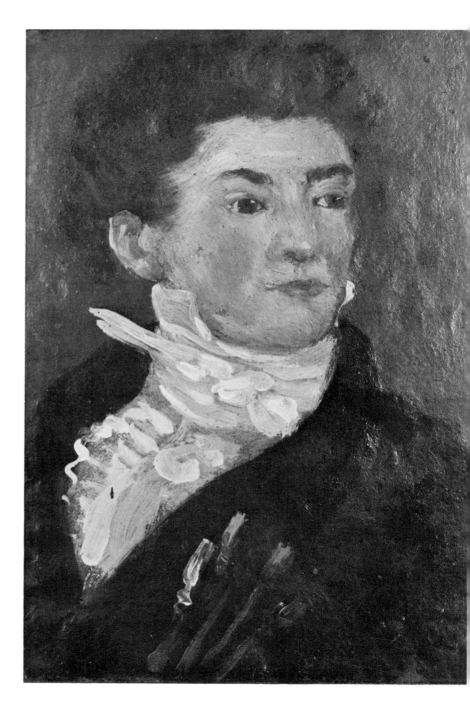

*Portrait of*
*Simeon Bonnesoeur*
*de la Bourginière*

Oil on canvas
15⅞ x 12⅞ in. (403 x 327 mm.)
Collections: Henri Moulin, Mortain;
anonymous sale, Hôtel Drouot, Paris,
December 22, 1922; Duc de Trévise;
The Minneapolis Institute of Arts
(acc. no. 65.38; The John R. Van Derlip
and William Hood Dunwoody Funds).

The sitter, a former deputy to the Constitu-
ent Assembly during the Revolution and
ex-president of the Tribunal of Mortain,
was an uncle of Géricault. Clément believed
that this portrait was painted about 1815,
but its lightness of handling, thinness and
freshness of color, and timidity of execution
suggest an earlier date, perhaps 1811-12.

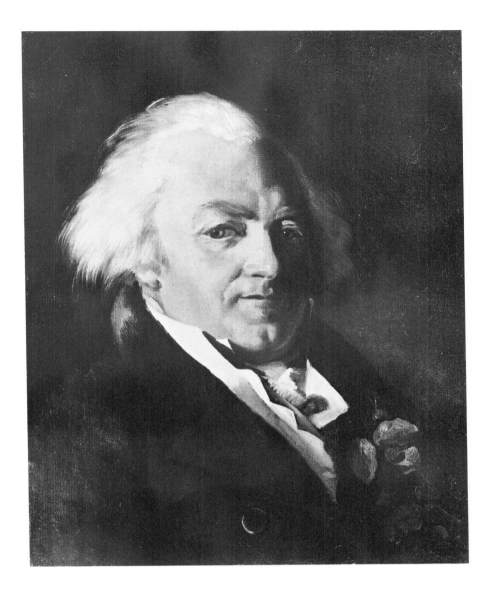

**3**

## Portrait of a Gentleman

Oil on canvas
25⅝ x 21¼ in. (651 x 540 mm.)
Collections: Christie; Le Bohélec, Paris;
sale, Galerie Charpentier, Paris,
June 16, 1955; Dr. Fritz Nathan
and Dr. Peter Nathan, Zurich;
The Armand Hammer Foundation,
Los Angeles.

Signed "T.G." at the lower left, this picture
was traditionally supposed to be a portrait
of the composer F. A. Boïeldieu (1775-
1834) although it does not bear any very
pronounced resemblance to his known por-
traits. Of unusually tight and careful finish,
the portrait is to be considered one of Géri-
cault's master copies, executed probably
about 1810-12, after a slightly earlier work
by a portraitist in the vicinity of Boilly or
the elder Isabey. Other, equally deceptive
copies by him are known (e.g., the copy
after H. Rigaud's *Portrait of the Mother of
the Artist,* private coll., Paris).

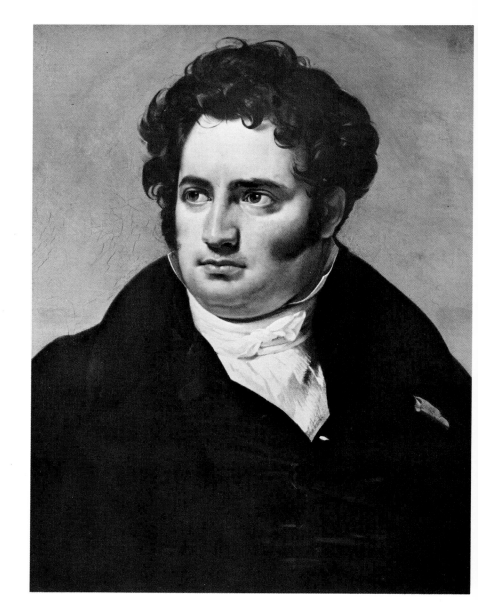

## St. Martin
## Dividing His Coat
## (after Van Dyck)

Oil on canvas
18⅛ x 14¹⁵⁄₁₆ in. (460 x 380 mm.)
Collections: Eugène Delacroix
(sale, 1864); Van Cuyck; L. Mancino
(sale, 1872); Musées Royaux des
Beaux-Arts de Belgique, Brussels.

The picture copies a Van Dyck altarpiece
from the church of Saventhem. Until 1815
the altarpiece was exhibited at the Louvre
as part of Napoleon's art loot. During his
apprenticeship under the rigorous classicist
Guérin, Géricault developed the habit of
studying and copying the works of the mas-
ters at the Louvre. The surviving or re-
corded copies indicate his strong partiality
to the colorists (Titian, Rubens, Van Dyck,
and Velásquez) and to the masters of dra-
matic illumination (Caravaggio, Rem-
brandt, Ribera, and Jouvenet). In a whole
series of copies, chiefly after Rubens and
Van Dyck, it is apparent that his interest
was centered on the ample splendors of the
Baroque horse, with its swelling muscula-
ture and flowing mane. His work as a copy-
ist acted as a strong antidote to his classicist
training and had a decisive influence on the
formation of his personal style. Among his
fellow-pupils in the studio of Guérin, his
love of heavy paint applied with a flourish,
earned Géricault the nicknames of "pastry
cook" and *"cuisinier de Rubens."* The copies
range from close imitations executed with
an astonishing power of stylistic mimicry
to vehement improvisations. At the post-
humous sale of Géricault's studio, the young
Delacroix bought a large number of these
copies.

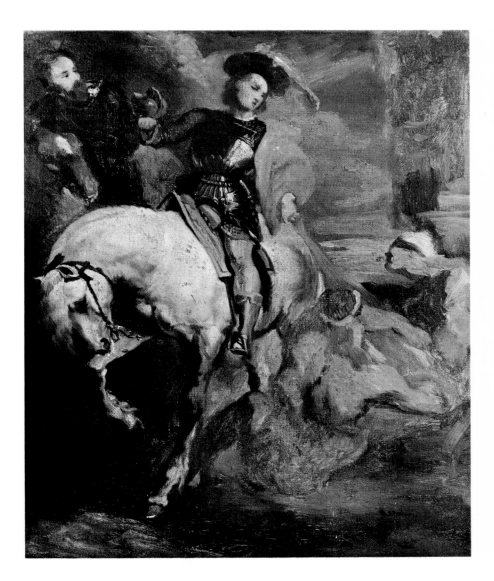

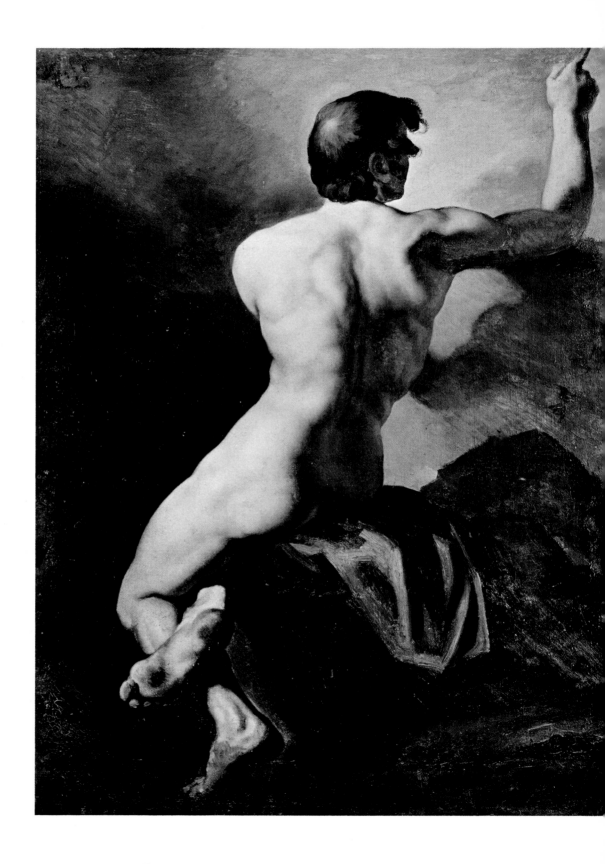

## Study of
## a Nude Model
## in Back View

Oil on canvas
34⅝ x 24⅜ in. (880 x 629 mm.)
Collections: Harry Schleisinger (1945);
Musées Royaux des Beaux-Arts
de Belgique, Brussels.

The painting of studies from life was an important part of Géricault's training under Pierre Guérin (1810-11), but it is known that he continued in the years following to attend occasional life classes in the studio of his former teacher. The posthumous sale of his works in 1824 included some fifty painted *academies*. Most of these were probably the products of his apprenticeship years, but some evidently date later and appear to be the by-products of that arduous course of self-training which Géricault administered to himself around 1814-1815. Especially in these later studies he often achieved a monumentality and sense of drama not usually found in academic exercises. Michelangelesque poses, strongly accentuated contours, a sharp concentration of light and shadow, and a vigorously expressive brushwork underlining every salience of the musculature, characterize these nudes and link them with drawings of a similarly expressive and quasi-sculptural style which can also be dated ca. 1814-1815 (see nos. 25, 26, 28 of this catalog). A drawing resembling the Brussels *Nude in Back View* in pose and style is in the British Museum (inv. 1920-2-16-2).

**8**

*Sketch for the
Charging Chasseur*

Pen and ink on tracing paper
7⅞ x 9⅛ in. (197 x 232 mm.)
Collections: Duc de Trévise;
Denise Aimé-Azam, Paris.

For the Salon of 1812 Géricault—then only twenty-one years old—painted a dramatic equestrian portrait of Lieutenant Dieudonné, a young officer of the elite *guides de l'Empereur*. The picture is, in fact, a monumental allegory rather than a simple portrait; it embodies the spirit of military adventure which animated France on the eve of the Russian campaign. Géricault conceived it as a vision of battle and victory. The first idea came to him by accident. A magnificent carriage horse, rearing in a cloud of dust on the road to St. Cloud, gave him the original image (cf. the painted sketch in the Glasgow Art Gallery) which he developed into a military subject by combining it with the figure of an officer. The first version of the picture had the horse rearing to the left. The rapid pen sketch in the Aimé-Azam Collection is for this version. It is one of the very early drawings for the project (another, more complete, is in the Musée Bonnat, Bayonne, inv. 703). The tempestuous *brio* of this drawing, the speed and energy of its handwriting, make it a document of Géricault's earliest, distinctive graphic style, a style against which he was later to react in an attempt to achieve greater formal discipline.

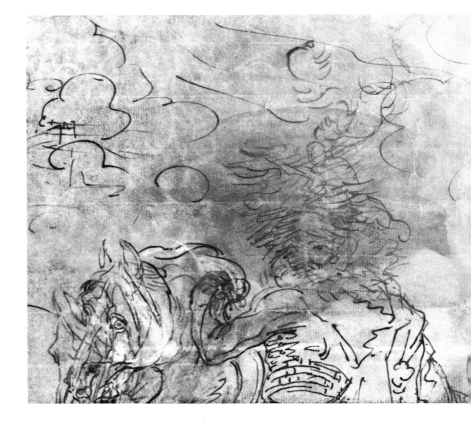

**9**

*Charging Chasseur*
*(sketch)*

Oil on paper, mounted on canvas
20¹¹⁄₁₆ x 15¾ in. (525 x 400 mm.)
Collections: His de La Salle
(gift, 1878);
Musée du Louvre (RF 210), Paris.

This *Charging Chasseur* is a sketch for the
early version of Géricault's Salon entry of
1812, *Portrait équestre de M. D.* (see the
preceding drawing). In his very rapid de-
velopment of the composition — the large
picture was completed in no more than
eight to twelve weeks — Géricault drew on
reminiscences of David's Napoleon *Cross-
ing the St. Bernard* and Gros' figure of
Murat in the *Battle of Eylau*. But his chief
inspiration was the rampaging horses in
the battle and hunting pictures of Rubens
(cf. his free copy after the *Hunt of Wolves
and Foxes* by Rubens, in the Hansen
Collection, Ordrupsgard, Denmark). The
painted sketch of the *Chasseur* preserves
much of the spontaneity and verve of the
preceding drawings. Its loose brushwork
and warm color harmonies are characteris-
tic of Géricault's early, *Rubéniste* manner.

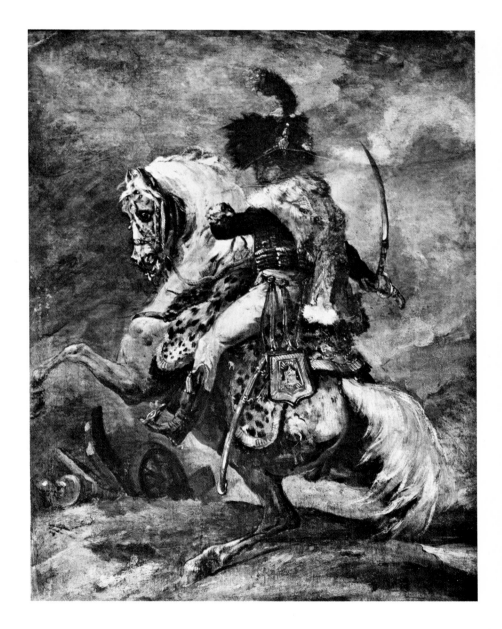

## Charging Chasseur
## (sketch)

This is another sketch for the early version of Géricault's Salon entry of 1812, *Portrait équestre de M. D.* (see nos. 8 and 9 of this catalog). It is a slightly smaller repetition of the sketch in the Louvre, corresponding to it in all but the most minute details; another, very similar sketch is in the Musée Bonnat, Bayonne, inv. 75. The compositional defects of this version — the horse's uncertain stance, the officer's limp posture, the unclear foreshortening of his sword arm — caused Géricault to abandon it for a more dynamic and legible design.

## The Charging Chasseur
## (sketch)

Oil on canvas
18⅛ x 15 in. (463 x 381 mm.)
Collections: de la Rosière;
Dr. Peter Nathan, Zurich.

Oil on paper, mounted on canvas
17 x 14 in. (432 x 356 mm.)
Collections: Coutan (1830);
Hauguet (1838); A. Hauguet (1860);
Coutan-Hauguet (sale, 1889);
P. A. Chéramy (sale, 1908, no. 95);
Musée des Beaux-Arts, Rouen (cat. 1366).

A sketch for the definitive version of Géricault's Salon entry of 1812, *Portrait équestre de M. D.* (see nos. 8-10 of this catalog), this work corresponds in general to the large, final canvas at the Louvre. A flag appears in the background at the left. To remedy the shortcomings of the earlier version, Géricault has reversed the composition, bringing the officer's sword arm clearly into view. Like a taut steel spring, the supporting rear leg of the horse, now fully visible, propels the animal and its rider obliquely into the picture. One contour circumscribes the entire group; it fuses the horse's head, the bearskin cap, the fluttering dolman, the extended arm, and the curving sword into one silhouette.

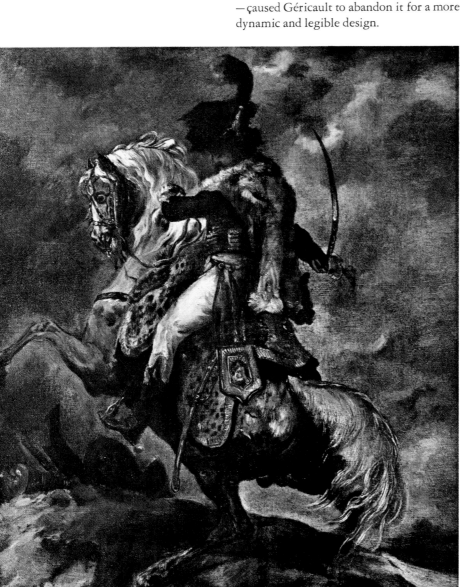

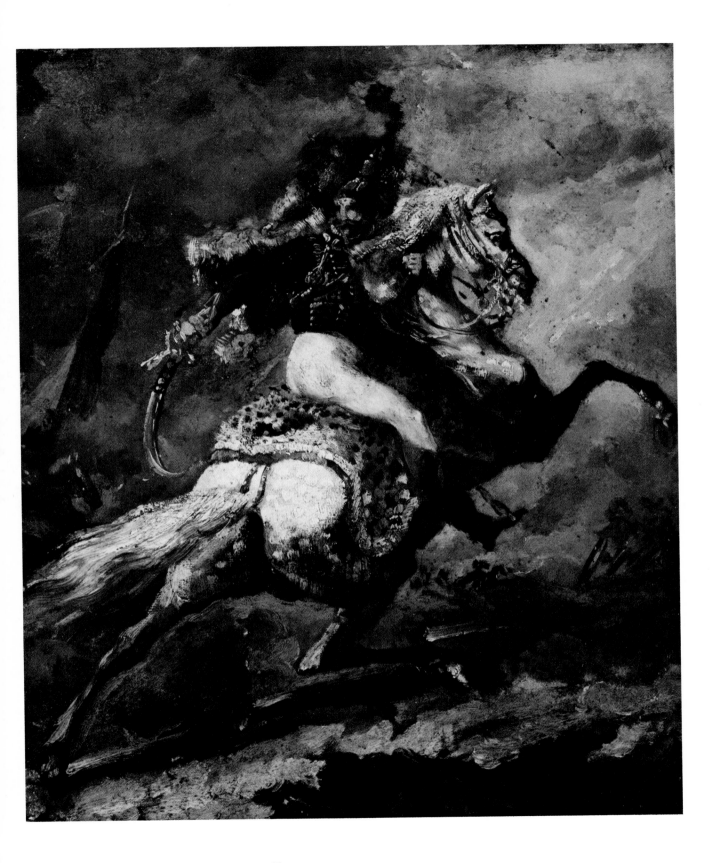

45

## *"The Horse of Napoleon"*

Oil on canvas
14³⁄₁₆ x 17¾ in. (360 x 451 mm.)
Collections: Clouard, Mortain;
private collection, France; Mr. and
Mrs. John Hay Whitney, New York.

This picture remained for a long time in the possession of descendants of maternal relatives of Géricault and was believed by them to represent one of Napoleon's horses. According to a family tradition, the Empress Marie-Louise rewarded Géricault with a gold medal for it. Both Batissier, Géricault's earliest biographer, and Clément report that Géricault painted horses in the Imperial stables of Versailles in 1813. This may quite possibly be the date of the study in the Whitney Collection; the date of 1815, which Clément suggests in his description of it, conflicts with the family traditions, which he also reports, and may simply be an error or misprint.

Géricault painted many studies of horses, particularly of stabled horses; the majority of them date from ca. 1811-1815. They are literal portraits of individual animals rendered with a careful regard for their physiognomic peculiarities and with deep feeling for the twilight atmosphere of the stables in which the horses are seen. Their execution tends to be refined and sometimes minute. These studies from life lack the impetuosity of Géricault's roughly contemporary studies after the masters. It is apparent in them that the excitement he felt in the presence of works of art gave way, in the presence of nature, to the equally intense quiet of patient observation.

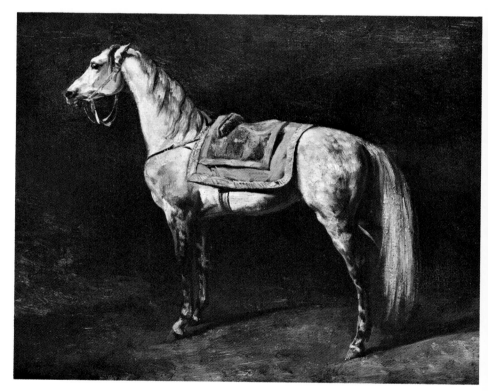

**13**

## Sketchbook Page

Pencil, pen and ink, wash on paper
6¾ x 9 in. (172 x 228 mm.)
Collections: Ary Scheffer (sale, 1859);
A. Hulot (1892); Baron Vitta;
The Art Institute of Chicago (Tiffany
and Margaret Blake Bequest).

This page is folio 54 recto of the Chicago Album which combines fragments from two sketchbooks, one of them (including this page) dating from about 1813-1814, the other (see nos. 66 and 67 of this catalog) from 1818-1819. The page contains four casual expression studies of a woman's head and the sketch of a parade in the Champ-de-Mars before King Louis XVIII and his court. Several other drawings of this scene are known (Buehler Coll., Winterthur; Musée de Lyon, X-1029/21-22, Clément, Dessins, 49; and Louvre, RF 1396, Clément, Dessins, 48). What may have been a version in oil passed through the R. Goetz sale in 1922 (no. 134). The rapid sketch in the Chicago Album appears to be a first record of the scene, penciled in haste and later gone over in ink. The accompanying list of the troops in the parade doubtless served as a memory guide in the later elaboration of the composition. The sketch is datable on firm historical grounds in 1814.

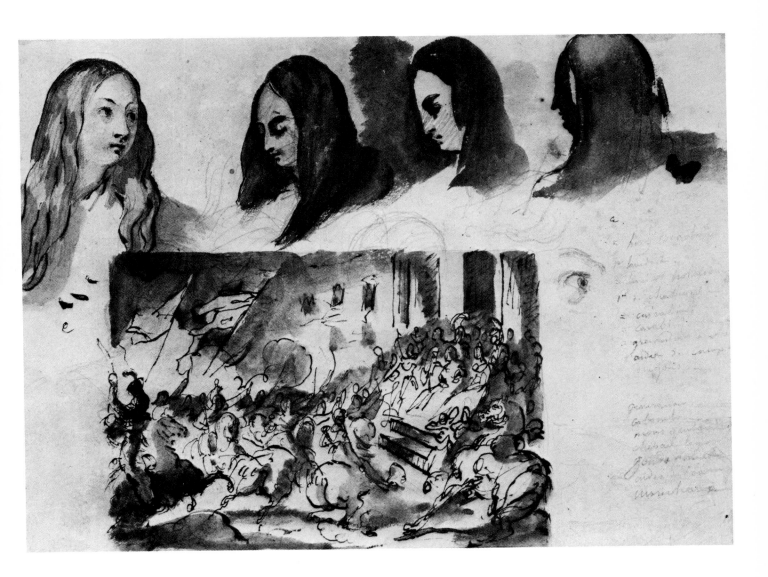

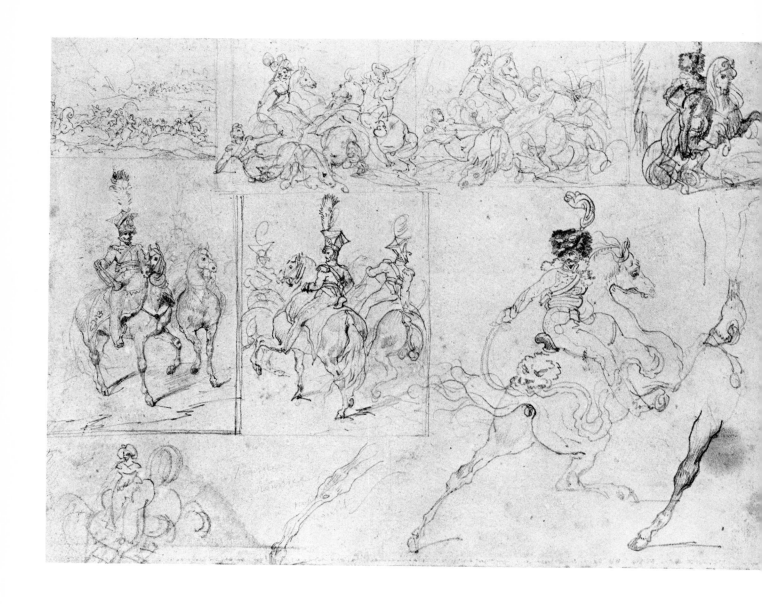

**14**

## *Sketchbook Page*

Pencil on paper
6¾ x 9 in. (172 x 228 mm.)
Collections: Ary Scheffer (sale, 1859);
A. Hulot (1892); Baron Vitta;
The Art Institute of Chicago (Tiffany
and Margaret Blake Bequest).

This, like the foregoing, is a page from the Chicago Album — folio 57 recto — a fragment from a sketchbook which Géricault used about 1813-1814 (see nos. 66 and 67 of this catalog for further, later drawings from this Album). The sketches on this page give an insight into the projects which occupied Géricault in the interval between his *Charging Chasseur* of 1812 and the *Wounded Cuirassier* of 1814. One of these projects was of a many-figured battle composition. The Chicago Album contains more than thirty sketches for this battle scene — two of them at the top center of the exhibited page — which illustrate Géricault's laborious compositional method and suggest that he intended to use the subject for a major painting. Two separate drawings for the project exist (Ecole des Beaux-Arts, Paris, 2894, and Louvre, RF 834, Clément, Dessins, 40). Clément doubtfully described one of them as *Episode de la guerre de Madagascar,* but it is evident that the engagement is between French and Russian troops and may represent an episode of the retreat from Russia. While in the *Charging Chasseur* Géricault had limited himself to a single, monumental group, he attempted in the battle composition to combine four such groups in an intricate structure. The problem which he strove to solve was that of reconciling vehement motion with the stability of monumental design. Had he carried out this ambitious project, it might have become the culminating work of his early period. The sketch of the *Charging Chasseur* at the lower right of the page is after, rather than for, the painting of 1812.

Géricault intended to integrate the figure in his battle composition. The remaining sketches, of a hussar trumpeter, of trumpeters of the lancers, and of mounted lancers refer to various military genres which then occupied Géricault, including the painting of *Three Trumpeters of the Lancers,* formerly in the collection of the Duc de Trévise. The sprightly execution and miniature refinement of these pencil sketches exemplify the manner in which Géricault treated modern subjects at this time: it is his "little" manner, which he was soon to turn against in an effort to attain a grander style.

## Lancer Standing
## Beside His Horse

Pen and ink, pencil on blue-grey paper
8 3/16 x 11 7/8 (208 x 302 mm.)
Collections: Bro de Comères; Baudin;
anonymous sale, Paris, Drouot,
February 13, 1939; Winslow Ames
(Lugt, Suppl. 2602a);
City Art Museum of St. Louis.

The soldier shown is a member of an élite cavalry unit of the Napoleonic armies, the so-called Polish Lancers. During ca. 1813-1814 Géricault drew and painted many military genre subjects involving Polish Lancers, possibly in connection with some unrealized project. The sketchbook fragments in the Chicago Art Institute (see nos. 13 and 14 of this catalog) contain a number of these compositions. The painting of a *Lancer Standing Beside his Horse* in the collection of Elie de Rothschild, Paris (Clément, *Peintures*, 62) is the closest relative to the drawing in St. Louis among this group of works. Since, after his return from Italy in 1817, Géricault resumed his preoccupation with military genre subjects and took up again some of the very motifs which he had treated about 1814, it is not always possible to date drawings such as this with absolute precision; 1814 seems most probable, 1817 possible. The inscription in the upper right corner of the sheet: "Croquis de Géricault, donné à mon ami l'amiral Baudin, le 18 Janvier, 1843, Gal. Bro." is by Géricault's close friend, the General Bro de Comères. A tenant of the Géricaults in the Rue des Martyrs, Bro de Comères (in his *Mémoires,* Paris, 1914) left an interesting account of the milieu in which Géricault lived during 1813-1816 and 1817-1820.

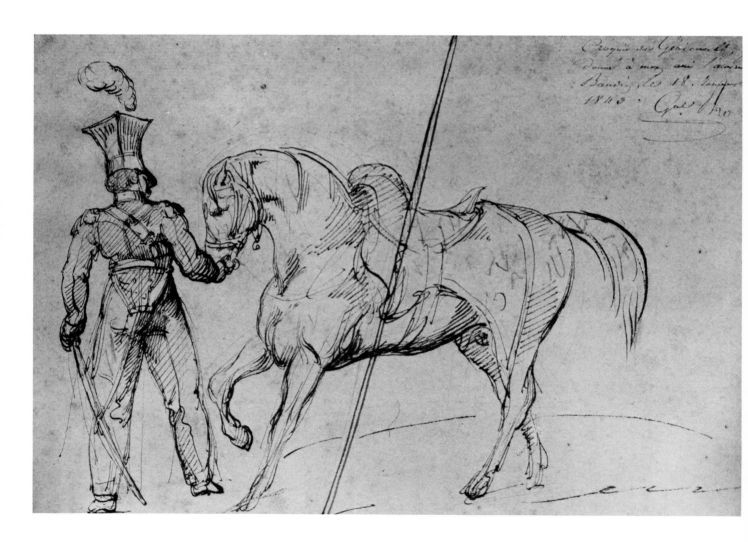

## *Wounded Cuirassier*

Oil on canvas
18⅛ x 14¹⁵⁄₁₆ in. (463 x 380 mm.)
Collections: His de La Salle
(gift, 1878);
Musée du Louvre (RF 211).

This painting is an early idea for the picture which Géricault exhibited at the Salon of 1814, *Wounded Cuirassier Leaving the Field of Battle* (Louvre). Géricault developed this composition in a very short time. His first thought was to represent a soldier, seated in an attitude of dejection and defeat, meditating or holding a child in his arms (cf. the drawings in the collection of Denise Aimé-Azam, Paris, published by Professor Johnson).

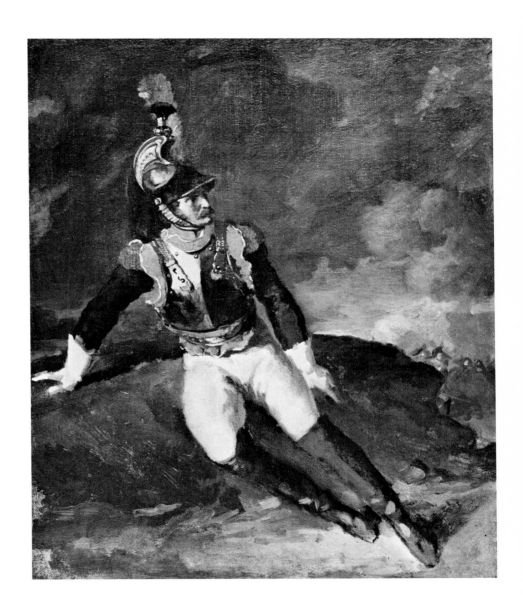

## Wounded Cuirassier

Oil on canvas
21$^{11}$/$_{16}$ x 18$^1$/$_8$ in. (551 x 460 mm.)
Collections: James-Nathaniel
Rothschild, Paris;
Martin Birnbaum; private collection;
The Brooklyn Museum.

This painting is a fully developed study for the final version of Géricault's Salon entry of 1814, *Wounded Cuirassier Leaving the Field of Battle* (Louvre). After a false start (see the preceding sketch), Géricault treated the subject as an equestrian composition and as a pendant to his earlier *Charging Chasseur* (see nos. 8-11 of this catalog). The motif of the massive figure restraining a restless horse was probably adapted from an earlier work, the *Signboard of a Blacksmith* (Kunsthaus, Zurich), for which Géricault drew many sketches during 1813-1814. The development of the *Wounded Cuirassier* is recorded by a series of pencil drawings in the so-called Zoubaloff Sketchbook at the Louvre. The painted sketch in Brooklyn differs from the final work in the draping of the mantle, which in the sketch hangs in heavy, vertical folds, while in the finished picture it is swept back and drags on the ground. Though conceived as a counterpart to the *Chasseur,* and to symbolize the recent defeat of France, as the earlier picture had symbolized the spirit of victory, the *Wounded Cuirassier* is carried out in a markedly different style. The figures loom larger and heavier, their forms have sculptural solidity; sharp contrasts of light and shadow emphasize the firm materiality of the bodies. All motion is stilled, the colors have turned somber, and the very strokes of the brush have lost their former playful dash. While the *Chasseur* could still be seen as a portrait, the *Wounded Cuirassier* does not fit into any of the categories of subject matter recognized at the time. Géricault had the temerity to give a monumental format to a subject that his contemporaries considered mere genre. What would have been one of a dozen episodic details in a battle picture by Gros is raised in the *Wounded Cuirassier* to central significance. The fall of the Empire is summed up in the single, anonymous figure of a soldier in distress. The picture in the Brooklyn Museum is virtually the only known authentic sketch for the final version of the *Wounded Cuirassier,* an indication of the great speed with which Géricault carried out this work. The large canvas is said to have been finished in the space of two weeks.

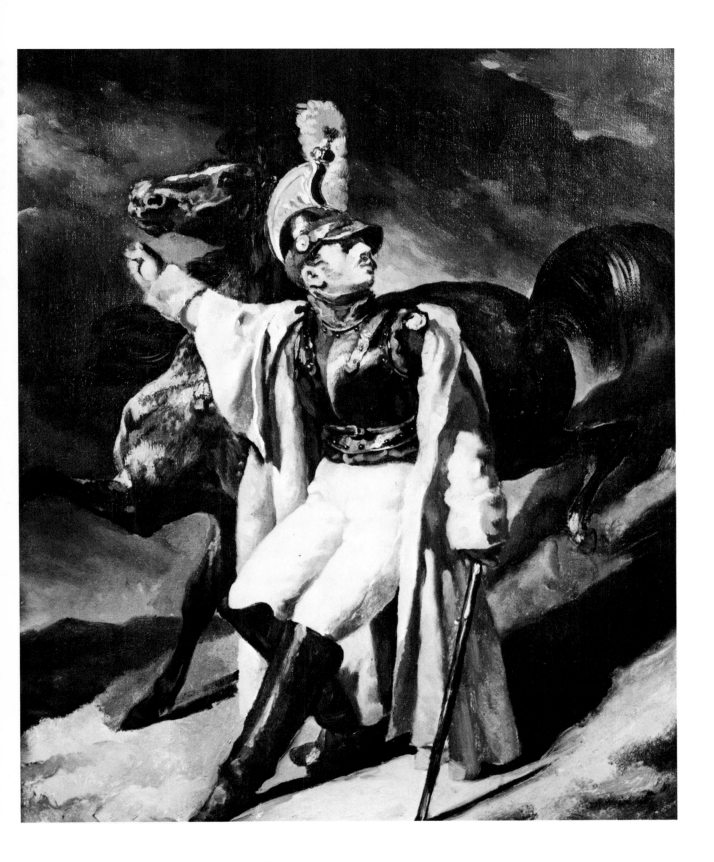

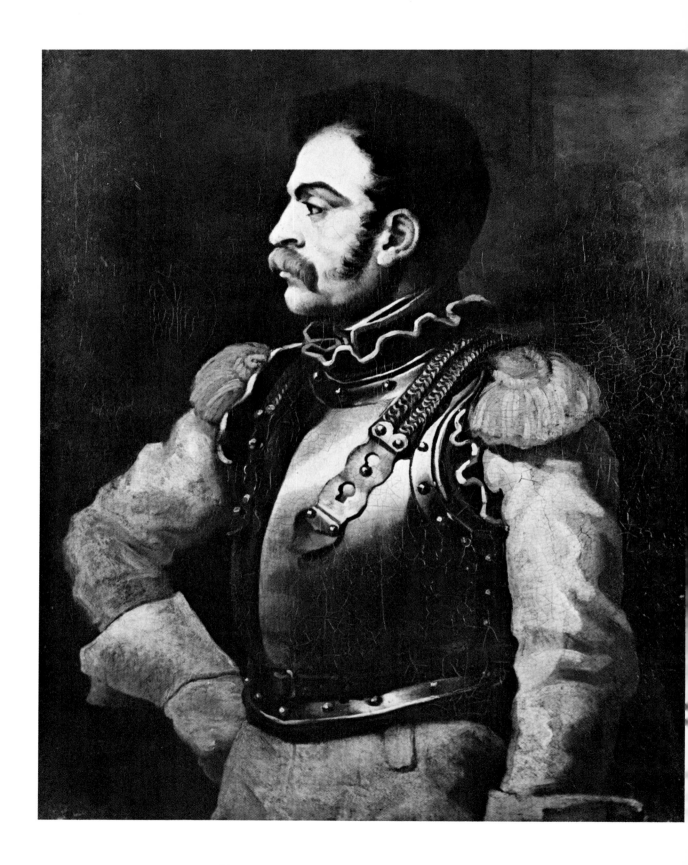

54

## *Portrait of a Carabinier*

Oil on canvas
39⁷⁄₁₆ x 33½ in. (1001 x 851 mm.)
Collections: Vandermaren (1849);
Stevens (sale, 1851);
Musée du Louvre (inv. 4887), Paris.

The half-length *Portrait of a Carabinier* in the Louvre has a counterpart in the bust-length *Carabinier and His Horse* in the Rouen Museum; the same model posed for both. Related drawings occur in the Chicago Album (folios 34 recto and 51 verso). Their style places these portraits in the immediate vicinity of the *Wounded Cuirassier*. It is a style which is characterized by a powerful stress on the weighty mass of the figure, achieved in part by abrupt contrasts of light and dark which give strong salience to the forms. Large areas of light color, laid directly on the dark, summarize the main features, the sleeve of a uniform, or even an entire profile. The portraits have a tragic seriousness which is in total contrast to the vivacity and easy brilliance of Géricault's earlier military genres and portraits. Movement and color have been sacrificed to a severe concentration on the dramatic impact of the figure, which is as much a matter of its brooding immobility as of actual expression in face and posture. In these elegaic portraits, suggestive of fallen power, Géricault came as close as he ever did to romantic sentiment. It was to one of them that Delacroix referred in his diary entry of December 30, 1823, after a visit to the dying artist: "I recall that I returned full of enthusiasm for his paintings, especially a study for the head of a Carabinier. Remember it. It is a landmark. What beautiful studies! What firmness! What superiority!"

A number of replicas, of various sizes, are known. None of them appears to be by the hand of Géricault.

## Head of a White Horse

Oil on canvas
25¾ x 21⅞ in. (654 x 544 mm.)
Collections: Julienne de Turmenine;
M. and Mme. Julienne-Montini
(gift, 1889);
Musée du Louvre (RF 544), Paris.

More than an ordinary study, this painting is in effect the portrait of a horse. It bears a remarkable resemblance, in conception as well as style, to Géricault's heroic military portraits of ca. 1814-1815. The firm modeling of the head by means of patches of light and dark and the looming nearness and bigness of the animal's face give it something of the tragic intensity of material presence that is a striking trait of Géricault's paintings at this time.

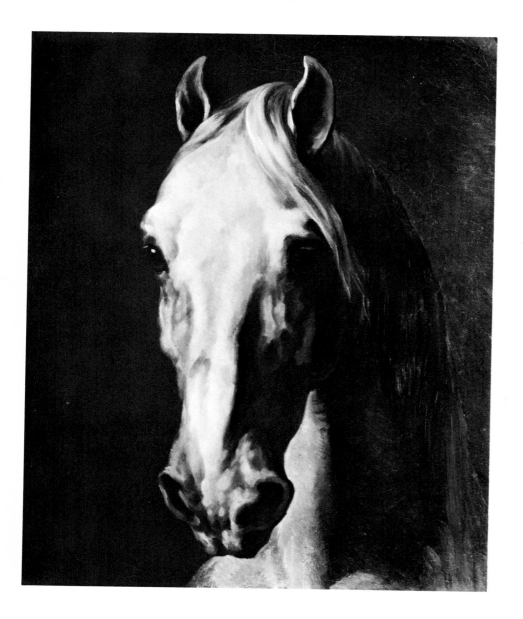

## Trumpeter
## of the Hussars

Oil on Canvas
37 13/16 x 28⅜ in. (960 x 721 mm.)
Collections: Monjean; Crabbe, Brussels
(1883); Baron Ury de Gunzbourg;
Defoer, Paris (sale, 1886);
G. Lutz (sale, 1902); Herman Schaus,
New York; Elizabeth S. Clark;
F. Ambrose Clark; R. S. Clark;
Sterling and Francine Clark Art Institute,
Williamstown, Massachusetts.

This is one of a group of military compositions related in style and spirit to the *Wounded Cuirassier* and the portraits of Carabiniers and datable in 1814-1815. Neither conventional portraits nor ordinary genres, and entirely devoid of narrative content, they might be termed "heroic genres." They mark an attempt by Géricault to treat aspects of modern reality in a grand style. Among the closest relatives of the Williamstown *Hussar* are the *Seated Trumpeter* in the Vienna Moderne Galerie and the *Mounted Trumpeter of the Chasseurs* in the Niarchos Collection, London. In all of them, the heavy figures are set against the emptiness of an overcast sky or bare wall, with the point of view kept so low that men and the animals loom high above the beholder. The very immobility of the soldiers and their horses has an expressive value; it suggests an involuntary stillness, the defiant passivity which follows defeat.

Géricault was the child of a military age. He had grown up among the veterans of the Revolutionary and Napoleonic Wars. His upbringing had conditioned him to admire the martial and heroic. It was his misfortune, and that of his entire generation, that the collapse of the Empire frustrated the ambitions to which he had been raised. In 1814-1815, when he painted these pictures, he lived among veterans of the Napoleonic campaigns who were reduced to half-pension and to resentful inactivity. Sometime in 1814 or early in 1815, Géricault, following an impulse, enrolled in the Royal Musketeers for a brief enlistment which ended when Napoleon returned from Elba in March of 1815. His preoccupation with military subjects at the time thus expressed personal experience and, beyond that, reflected sentiments and attitudes which he shared with other young Frenchmen. The peculiarly romantic flavor of his military compositions, their spirit of melancholy and nostalgia, derived from social and political stresses of his period.

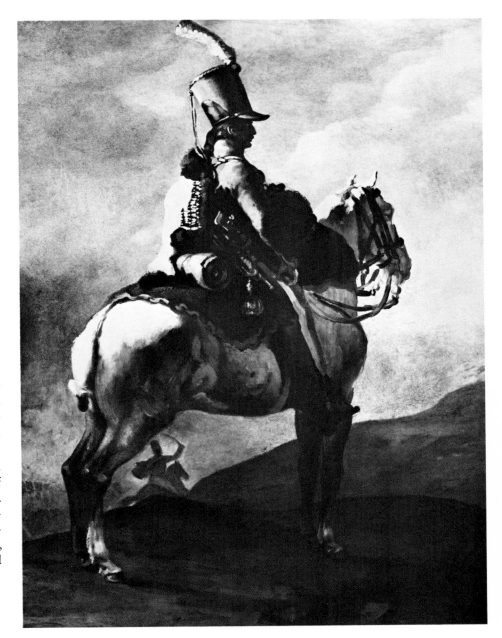

*Portrait*
*of an Adolescent*

The identity of the sitter is not known.
The style suggests a date about 1815-1816.

Oil on canvas
18⅛ x 14⁹⁄₁₆ in. (460 x 370 mm.)
Collections: Walferdin (sale, 1880); Dollfus
(sale, 1912); Mme. Jules Ferry (sale, 1921);
Pierre Dubaut; private collection, Paris.

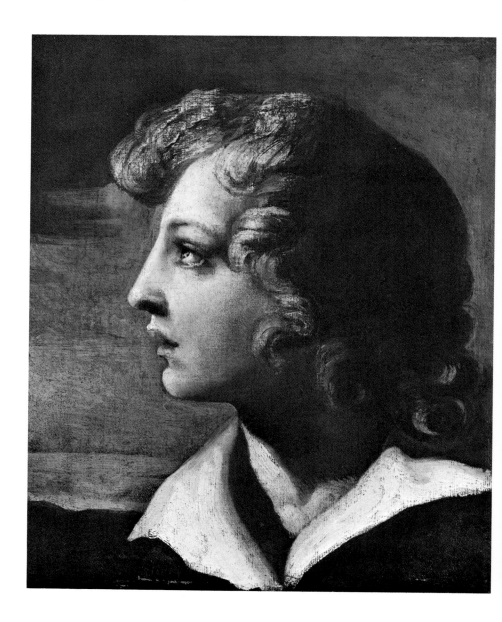

*Portrait of a
Young Woman*

Oil on canvas
18⅛ x 15 in. (460 x 381 mm.)
Collections: Walferdin (sale, 1880);
Musée des Beaux-Arts, Béziers
(acquired between 1893 and 1900).

According to Clément, the sitter was a model residing in the Rue de la Lune and called "la grosse Suzanne." The catalog of the Walferdin Collection speaks of her as "the artist's mistress." Sketches of a young woman of somewhat similar appearance, similarly dressed, occur in the Chicago Album (see note under catalog no. 13) and in the Zurich Sketchbook (see no. 47 of this catalog). Despite Clément's rather circumstantial identification, it does not seem impossible that this portrait represents in fact Alexandrine-Modeste Caruel, Géricault's young aunt, with whom he began his liaison about 1815. On stylistic grounds, the portrait is datable ca. 1815-1816.

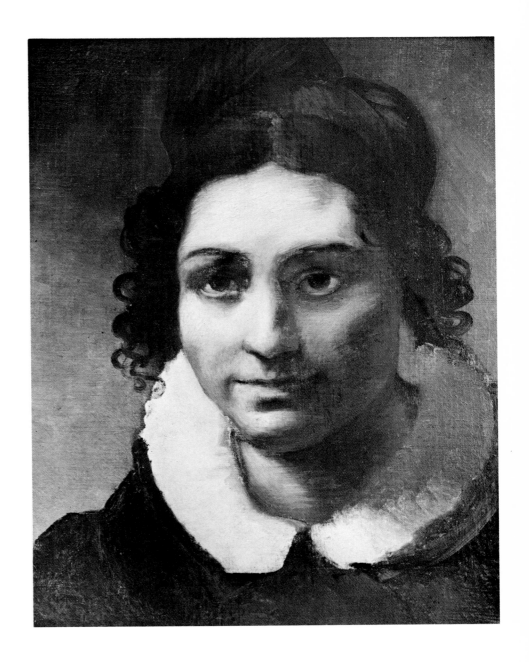

**23**

## Portrait of
## Alfred Dedreux Seated
## in a Landscape

Oil on canvas
18 x 15 in. (457 x 381 mm.)
Collections: Eugène Delacroix
(sale, 1864); Dejean; R. Goetz (sale,
1922); Duc de Trévise (sale, 1938);
The Metropolitan Museum of Art
(Alfred N. Punnett Fund, 1941), New York.

The sitter is Alfred Dedreux, son of Géricault's good friend, the architect Pierre-Anne Dedreux. Another portrait of the boy, with his sister Thérèse Elizabeth, was formerly in the collections Becq de Fouquières and Vicomte Beuret. The heavy and harshly angular contours of the figure; compact, sculptural modeling; sharp contrasts of light and dark; and somewhat strident color make this a very characteristic example of Géricault's style of about 1815-1816. Born in 1810, Alfred Dedreux would have been five or six at the time the portrait was painted.

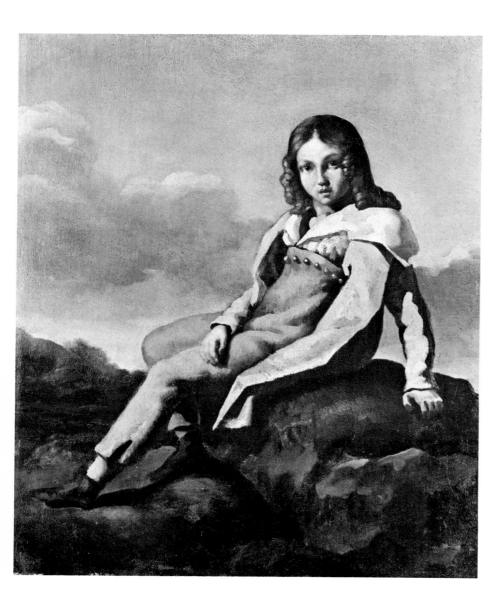

**24**

## Portrait of a Man
## Wearing
## a Police Cap

Oil on canvas
23⅝ x 18⅞ in. (600 x 479 mm.)
Collection: Denise Aimé-
Azam, Paris.

The subject has been variously identified, by Klaus Berger as Colonel Langlois, by Denise Aimé-Azam as the economist Brunet; but neither of these suggestions carries much conviction. On the basis of age and appearance, it would seem more plausible to identify the sitter as Colonel Bro de Comères, a retired officer who was a neighbor and tenant of the Géricaults in the Rue des Martyrs. A pencil drawing of Colonel Bro wearing a police cap figured at the Centenary exhibition (no. 253), and a smaller portrait in oil of a *"Militaire en bonnet de police"* was shown in the Géricault exhibition at the Galerie Bernheim-Jeune in 1937 (no. 31). The style of the portrait, with its striking chiaroscuro of broad color areas, suggests a date around 1815-1816.

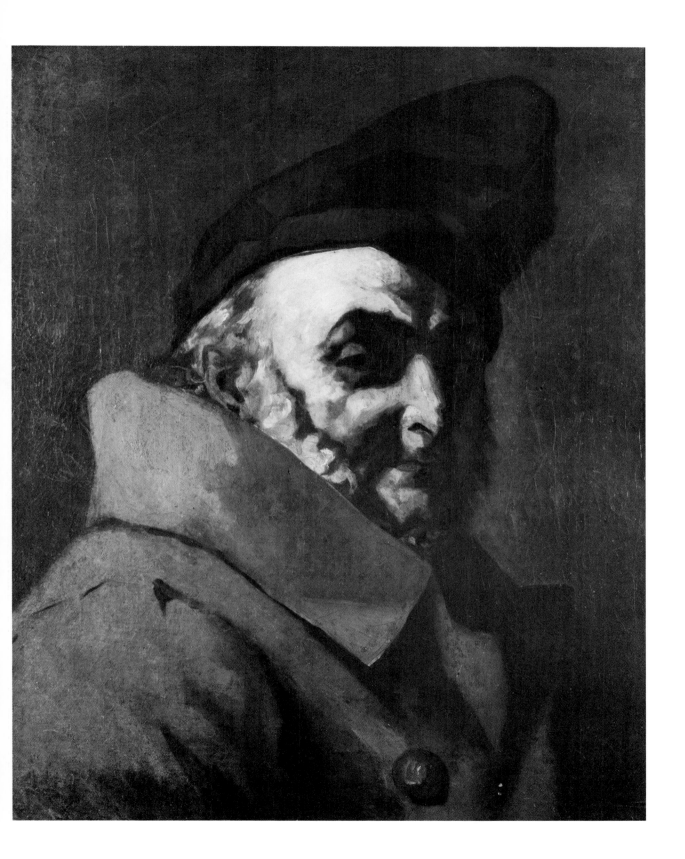

*Assassination
in a Boat
(the Murder of Pompey?)*

Pen and ink, pencil, ink and sepia wash
5¼ x 6½ in. (130 x 165 mm.)
Collections: Thomas S. Cooper, London;
Christopher Powney (sale, 1968);
Frances S. Jowell, Toronto.

About 1814, Géricault began to experiment with classical subject matter and with arbitrary, expressive stylistic devices that have some affinities with classicism. He practiced an "antique" manner side by side with his quite different, "modern" manner. In the latter he dealt with experienced or remembered reality, in the former he composed imaginary subjects. Beside the refinement and realism of his "modern" work, his drawings and painted sketches in the "antique" manner seem — particularly in the early stage of its development — excessively heavy, labored, and hard. A sketchbook at the Louvre, the so-called Zoubaloff Sketchbook, contains scores of small compositional exercises, many of them based on classical themes. Datable around 1813-1814, they illustrate Géricault's effort to form a constructive and expressive style. Through the constant rehearsing of the same stock shapes, the same crisp abbreviations for muscle, hair, or garment folds, Géricault sought to teach himself a method for the expression of every imaginable attitude, gesture, and fall of drapery. What distinguished this expressive shorthand from the tame routines of neo-classicism was its rough strength and emotional energy. The exhibited drawing, which dates from about 1815-1816, exemplifies the characteristics of Géricault's "antique" manner in its developed state: its brutally rugged contour, the mannered athleticism of the figures, and the vehemence of the pantomime. An oil sketch of the same subject, but of different composition, was exhibited at Winterthur in 1953 (no. 14).

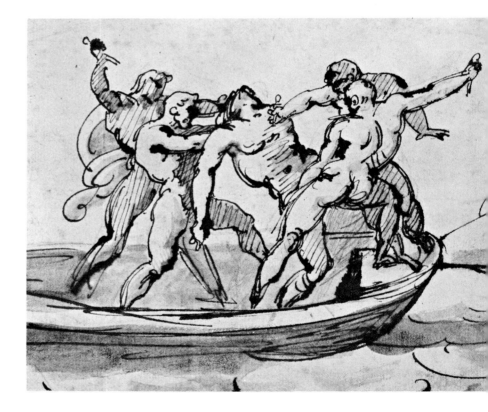

*Three Dramatic
Figure Compositions*

Pencil, pen and ink, ink wash on paper
(originally the end-paper of a sketch-
book, the page still carries the label of
the art supply shop of "Richard
Jeune, successeur du Sieur Jodier,
rue de la Paroisse Notre Dame,
No. 59, a Versailles".).
8 x 11 in. (203 x 280 mm.)
Collections: Pierre Dubaut, Paris;
Dr. Peter Nathan, Zurich.

In this composite of separate sketches, the subjects are difficult to identify. The man at the upper right defending himself and a child against a giant serpent is reminiscent of other drawings and paintings (see no. 27 of this catalog) of what might be called the Laocöon motif to be found among Géricault's works at this time, i.e., ca. 1815-1816 (cf. the drawings in the Marcille Coll., Clément, Dessins, 79, and the Musée de Rouen, cat. 1396). The fallen figure at the lower right might be for the *Gigantomachy* composition which occupied Géricault about 1816 (cf. Clément, Peintures, 94; and drawings in a private collection, Paris, and at Smith College, Northampton). The style of all three sketches is typical of Géricault's "antique" manner at its most exuberant, both in the grotesquely over-muscled figures and in the vigorous play of heavy outlines and broad ink washes. The pen sketches are drawn over unrelated pencil doodlings in a quite different, "modern" manner. At the bottom of the sheet, beside an unidentified collector's stamp, appear various scribblings in Géricault's hand: the date "commencé le 28 Septembre," and the names of relatives and friends "Juliette—ma t(ante) Clouard—Vernet—Bonnesoeur." Pierre Dubaut, the former owner of the drawing, believed that the drawing once belonged to a sketchbook started by Géricault on the eve of his Italian voyage, in September of 1816.

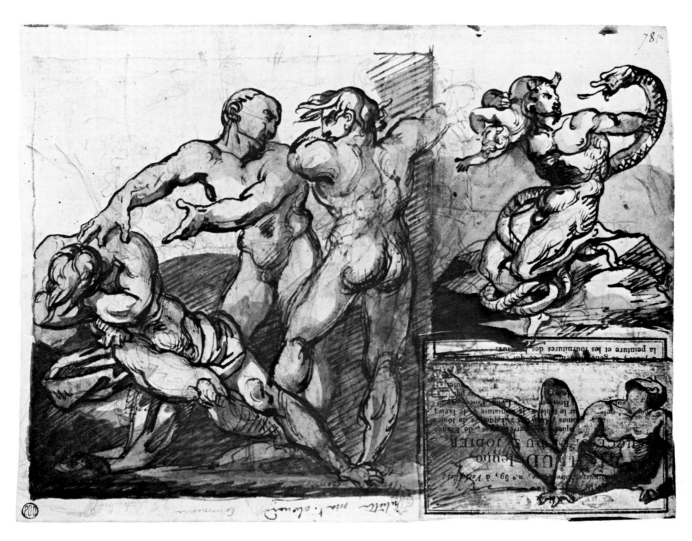

*Nude Prisoner
Battling with
a Serpent*

Oil on impregnated paper,
mounted on canvas
12 x 10 in. (305 x 254 mm.)
Collections: R. Longa; Pierre Dubaut,
Paris; James Lord, New York.

The themes of prison, torture, and execution run through a series of compositions executed in the distinctive sculptural, "antique" manner which Géricault developed in 1814-1816. Characteristic examples are the drawings of a *Man Being Strangled* (Bayonne, inv. 224), *Ugolino in Prison* (Bayonne, inv. 2056), *Prisoner in Chains* (formerly Duc de Trévise Coll.; Clément, Dessins, 167*bis*) and *Study of Nudes* (Buehler Coll., Winterthur), all of which correspond closely in style and conception to the painting of a *Nude Prisoner Battling with Serpents*. Whether these are free fantasies or are related to a definite theme — the Dantesque derivation of the *Ugolino* drawing is worth noting in this connection — has not been determined. The fact that Géricault was much preoccupied by imaginary or witnessed spectacles of this kind is clear from the sketches of an actual execution which he later drew in Rome (Jowell Coll., Toronto; Ecole des Beaux-Arts; and Clément, Peintures, 92) and the drawing of a *Public Hanging in London* which is included in this exhibition (see no. 95).

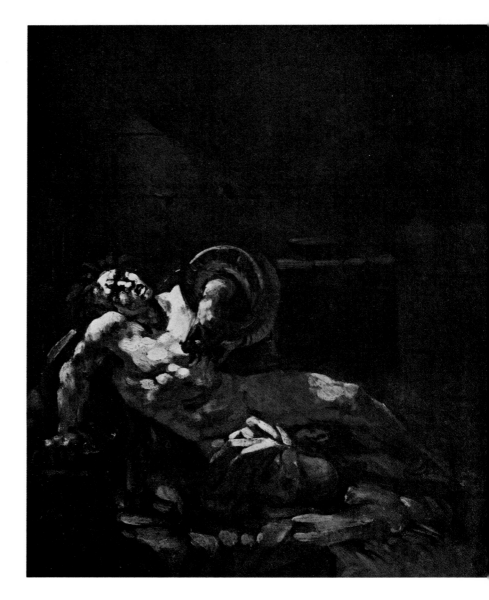

## Satyr Approaching a Sleeping Woman (Jupiter and Antiope)

Pen and ink with bister wash on paper
4⅞ x 7⅝ in. (124 x 194 mm.)
Collections: Lambert de Cilleuls;
Pierre Dubaut; private collection, Paris.

Despite Clément's assertion that "Géricault scarcely ever depicted women," his work in fact contains many frankly erotic compositions. The majority of these can be dated about 1815-1817. The robust sensuality evident in these subjects expressed a side of his character at which Clément also hinted when he recorded Géricault as saying: *"Je commence une femme et ça devient un lion,"* (and, nudging an unnamed friend) *"Nous deux, x ..., nous aimons les grosses f ..."* A remarkable series of drawings representing men and satyrs embracing women (in the museums of Bayonne and Rouen, and in various private collections), some of them of a very frankly sexual character, illustrate Géricault's expressive "antique" manner at its most vehement extreme. Their chief characteristic is the craggy pen contour that defines bodies internally articulated by hard alternations of light and shadow. The gigantic musclemen and muscle-women are twisted into postures that emphasize every flexing and swelling of their powerful thighs and hunched backs. It is a figure style which violates the neo-classical aesthetic and amounts to a personal, baroque amplification of classical types with frequent allusions to Michelangelo. The affinity to sculpture is very close. The exhibited drawing of *Jupiter and Antiope* is, in fact, directly related to one of the few sculptural essays by Géricault, the carving in stone of a *Satyr and a Bacchante* in the Musée de Rouen. On the verso of our drawing is a sketch for the composition *Death of Paris,* a project which can be dated with certainty in March of 1816.

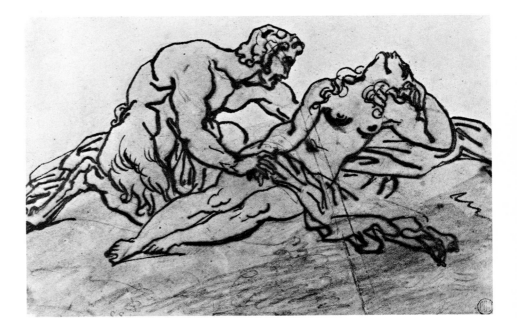

## The Deluge

Oil on canvas
38¼ x 51¼ in. (971 x 1302 mm.)
Collections: Julien de la Rochenoire
(1858); Alphonse Th. de Girardin
(sale, 1869);
Ernest Gabriel; A. Piot;
Musée du Louvre (RF 1950-40), Paris.

This free paraphrase of Poussin's *Déluge* (Louvre) can be dated about 1815-1816. Géricault had also painted a copy in oil (A. Scheffer sale, 1859, no. 42, 450 x 590 mm; cf. Tourneux in *Bulletin de la société de l'histoire de l'art français,* 1912, p. 56 ff.) and made several drawings after the Poussin picture. The foreground figures are in Géricault's heavy, "antique" manner, closer to Michelangelo than to Poussin. It illustrates Géricault's interest at that time in heroic, expressive landscape composition, an undercurrent that was to run through the remainder of his work. It is noteworthy that the stimulus for landscape painting came from art rather than from impressions of nature. There is no apparent relationship between the grandiose artificiality of the *Déluge* and other heroic landscape compositions of that time (cf. nos. 30-32 of this catalog), and the casual, quite prosaic landscape sketches found in the portion of the Chicago Album which dates from about 1814 and in other drawings of the time.

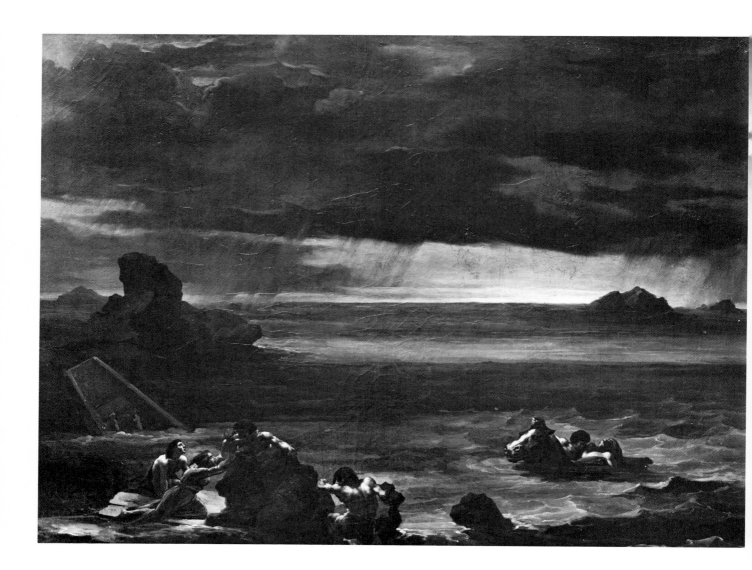

*Heroic Landscape
with Fishermen*

Pen and brown ink, grey wash
over graphite pencil on paper
9⅛ x 8⅛ in. (232 x 206 mm.)
Collections: Sauvé; Mathey;
Duc de Trévise (sale, 1938);
Maurice Gobin, Paris; Paul J. Sachs;
Fogg Art Museum, Harvard University
(Bequest of Meta and Paul J. Sachs).

Landscape composition played a large role
in Géricault's work during 1815-1816. In
the backgrounds of his military paintings
he had shown his awareness of the expres-
sive possibilities of landscape when applied
to modern subjects. In turning to classical
themes and heroic style, he came strongly
under the influence of the masters of the
grand tradition of landscape painting (see
his adaptation of Poussin's *Déluge,* no. 29
of this catalog). He began to experiment
with the expressive stylization of landscape
elements, just as he was experimenting
with the construction of expressive figures.
Nearly all his landscape compositions of
those years are synthetic and artificial. They
represent fantasy settings furnished with
stock motifs borrowed from the tradition
of seventeenth and eighteenth century "his-
torical" landscape painting. The drawing in
the Fogg Museum is a study for a large
painted panel which was until recently in
The Huntington Hartford Collection, New
York. It belongs to a group of connected,
monumental landscape designs intended as
wall decorations (see nos. 31 and 32 of this
catalog). Closely related sketches are to be
found in the Pierre Dubaut Collection, and
in the Musée Bonnat, Bayonne. The general
character of this spacious scene derives
from the tradition of Poussin; it reminded
Clément of the "manner of Guaspre" (Gas-
par Dughet). The vigorous, angular hand-
writing is the same as that which appears
in Géricault's "antique" figure composi-
tions of ca. 1815-1816.

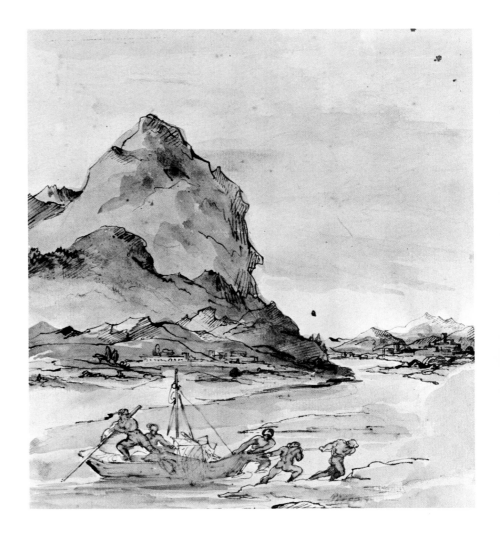

## Landscape with an Aqueduct

Oil on canvas
98½ x 86½ in. (2502 x 2197 mm.)
Collections: Marceau, Villers-
Cotterets; private collection,
Paris (sold, 1953);
H. Brame and C. de Hauke, Paris;
Walter P. Chrysler, Jr., New York.

This is one of a set of three very large landscape panels which Géricault painted about 1815-1816 to decorate the walls of a room in a friend's house in Villers-Cotterets, near Paris. Lost sight of for nearly a century, the entire set reappeared in the early 1950s. One of the panels, representing a rocky coast with fishermen beaching a boat, was until recently in the collection of Huntington Hartford, New York. The other two are included in the present exhibition. The entire group is conceived as a landscape-drama in successive acts, each expressive of a particular mood. The individual panels are composed of stock motifs taken from the repertory of heroic landscape painting and interspersed with such familiar Italian motifs as the Spoletan aqueduct, the *ponte rotto,* and the tomb of Cecilia Metella. These suggestive quotations from tradition and the strong, contrasting effects of illumination give to each panel a distinctive dramatic character. The broad river which winds through all three provides a continuity between them; the *Landscape with Fishermen* (formerly in the Huntington Hartford Collection) resumes, in its middle distance, elements of the other two: the broken bridge of the landscape in the Petit Palais and the aqueduct of the landscape in the Chrysler Collection. Géricault painted these grand scenes before setting foot on Italian soil, perhaps in a spirit of romantic anticipation.

In describing the one landscape of the group which he had seen, the *Landscape with the Fishermen,* Clément spoke of it as being "in the manner of Guaspre," i.e., of Gaspar Dughet who was, together with Poussin and Claude Lorrain, one of the masters of French, Italianate heroic landscape in the seventeenth century. The char-

acterization is certainly apt, although the landscapes are even more eclectic than Clément suggests. In the *Landscape with an Aqueduct* the atmospheric and luminous effect of low, slanting rays breaking into the picture from behind the vine-covered ruin recalls Claude Lorrain, while aqueduct, rock, and *fabriques* resemble certain compositions by Claude Joseph Vernet (particularly the *Temple of the Sibyl,* formerly Staatliche Museen zu Berlin, no. 484). The Michelangelesque bathers in the foreground, finally, resume figure motifs frequently used by Géricault about this time (cf. the *Déluge* composition and the drawing of the *Bull Tamer* in the Louvre).

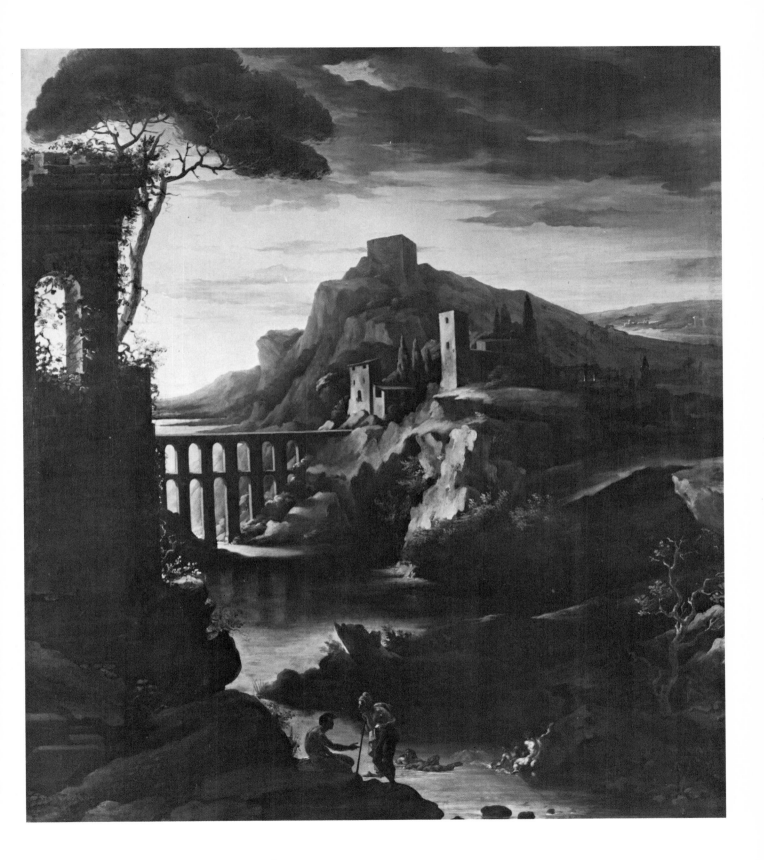

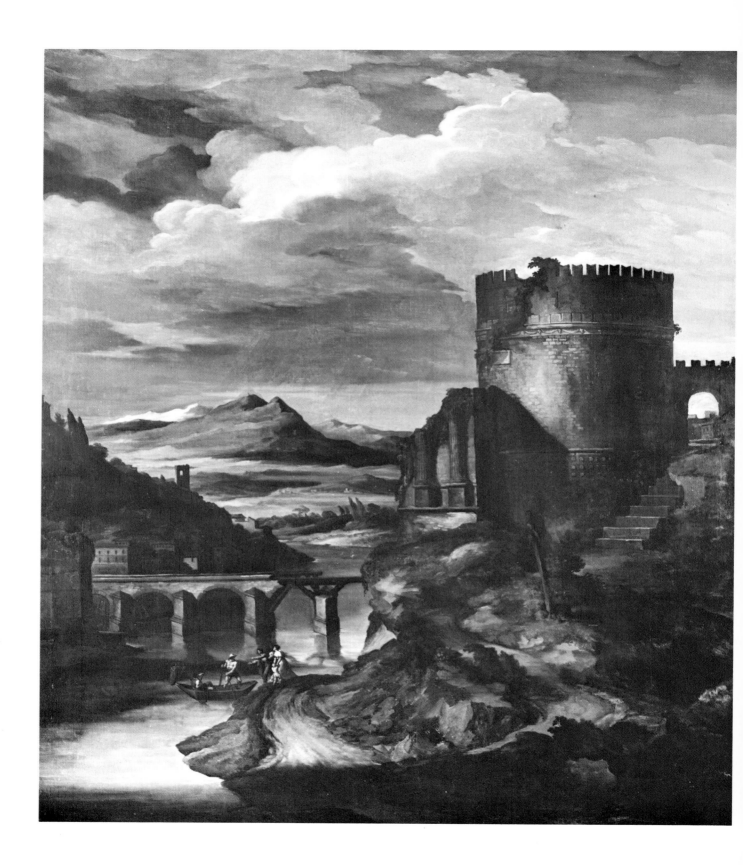

## Landscape with a Roman Tomb

Oil on canvas
98½ x 86½ in. (2502 x 2197 mm.)
Collections: Marceau, Villers-
Cotterets; private collection,
Paris (sold, 1953);
H. Brame and C. de Hauke, Paris;
Walter P. Chrysler, Jr., New York;
Musée du Petit Palais, Paris.

Concerning the group of landscape panels painted in 1815-1816, of which this forms a part, see the preceding entry. In contrast to the other two landscapes in the set which present heroic or Arcadian vistas without definite supporting subject matter, the *Landscape with a Roman Tomb* hints at some dramatic occurrence. The family group at the shore pleads urgently with the men in the small boat, as if escaping a pressing fate. Behind them a broken bridge spans the river; storm clouds are gathering in the sky above the ruined Roman tomb (possibly derived from an engraving by Piranesi of the Tomb of Cecilia Metella on the Appian Way). Near the path which leads to the river stand gallows from which hang a decaying leg and an arm — giving a curious foretaste of Géricault's later studies of dissected limbs (see nos. 88-91 of this catalog). It is not necessary to suppose that any particular narrative, such as a passage from some novel or poem, inspired this scene. More probably it is a free invention, yet it has not merely been inserted into the landscape. The sense of menace, flight, and urgency which the figures convey fits the picture's whole design well: the oppressive weightiness of its forms, its clashing diagonals, and baleful colors.

**33**

## The Triumph of Silenus

Pencil, sepia wash, and white gouache on yellow paper
8¼ x 11 in. (206 x 279 mm.)
Collections: Camille Marcille (sale, 1876); Lesourd; Musée des Beaux-Arts, Orléans.

During his stay in Italy (September 1816-September 1817) Géricault produced a series of mythological compositions which directly continued his work in the "antique" manner begun in France about 1814 (cf. nos. 26, 34, 35 of this catalog). Centaurs, fauns and nymphs, Silenus and his retinue — a pagan world peoples these drawings. The themes are of love, pursuit, and struggle. They are similar, in this respect, to the erotic compositions of ca. 1814-1815 (cf. no. 28 above) but are distinguished from them by their lighter, swifter, more fluent design and their much subtler use of chiaroscuro. An almost playful exuberance pervades Géricault's Italian mythologies. Their mood is more suggestive of the Arcadian strain in French art of the eighteenth century than of classical antiquity. The *Triumph of Silenus* is the most elaborate of his mythological compositions of 1816-1817. Several versions of it are known or recorded: a crayon drawing in the Ecole des Beaux-Arts (inv. 34961), a pen drawing in the Chévrier Marcille Collection (Clément, Dessins, 83; exhibited at the Centenary, 1924, no. 79), and a wash and gouache drawing in the same Collection (Clement, Dessins, 81; exhibited at the Centenary, 1924, no. 77). The general arrangement of the scene seems inspired by Perino del Vaga's *March of Silenus* (Louvre) and by Annibale Caracci's and Pietro da Cortona's treatment of similar themes.

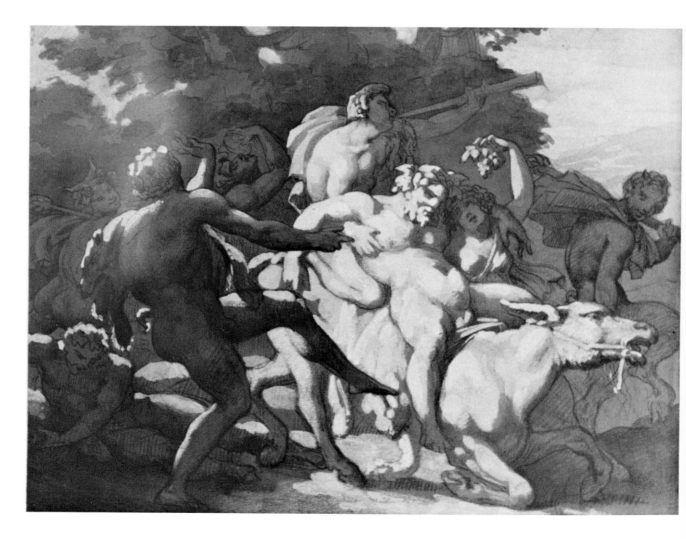

## Centaur Abducting a Nymph

Pen and ink on paper
9⅛ x 6¾ in. (230 x 172 mm.)
Collections: E. Martin, London;
Frances S. Jowell, Toronto.

This subject strongly preoccupied Géricault in 1816-1817, as is shown by a considerable group of sketches and finished drawings (Louvre RF 5176; Louvre RF 26737, Clément, Dessins, 92; Louvre RF 26738, Clément, Dessins, 91; Eudoxe Marcille, Clément, Dessins, 90-*bis;* Maherault, Clément, Dessins, 90-*ter;* LaTouche, Clément, Dessins, 90-*quat.;* Clément, Dessins, 90-*quinque;* Rouen, cat. 1397-8; and variants in several private collections). The motif of the centaur carrying off a struggling woman may have been inspired by the frieze of the Apollo Temple at Bassae Phigalia which Géricault knew through line engravings in G. M. Wagner's *Bassorelievi antichi della Grecia ... del tempio di Apollo Epicurio in Arcadia,* Rome, 1814. He drew some sixteen tracings (Ecole des Beaux-Arts, Paris) after the Wagner engravings. The exhibited drawing corresponds closely to the wash and gouache drawing at the Louvre RF 26738) and the drawing in wash and gouache on tracing paper in Rouen (cat. 1397).

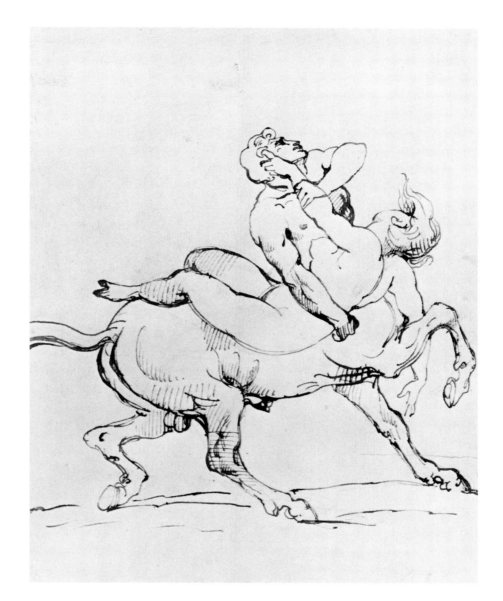

## Centaur Abducting
## a Nymph

Pen and ink, white gouache
on oil-impregnated paper
6⅞ x 10 in. (175 x 254 mm.)
Collections: A Colin;
His de La Salle; Musée du Louvre
(RF 26737), Paris.

In Italy Géricault developed the technique of painting in white gouache over a pen drawing on dark-tinted paper, boldly reducing to a sharp light-dark contrast what in his more conventional wash and gouache drawings (cf. no. 33) had been a graduated range of tones. The neo-classical linearity of the underlying design (cf. no. 34) is drowned in the darkness of the ground; a dappling of light-patches, "baroque" in their unquiet flicker, models the forms. The effect is rather like that of sculpture seen by torch light. Many of these drawings are on oil-impregnated, transparent paper which not only produced the proper dark ground but allowed Géricault to trace and, in tracing, to modify his compositions. The lyrical classicism of his mythological compositions and their chiaroscuro technique have caused some critics to see the influence of Prud'hon in them; but their resemblance to Prud'hon's work is in fact fairly superficial. Concerning other drawings of this subject, see no. 34 of this catalog.

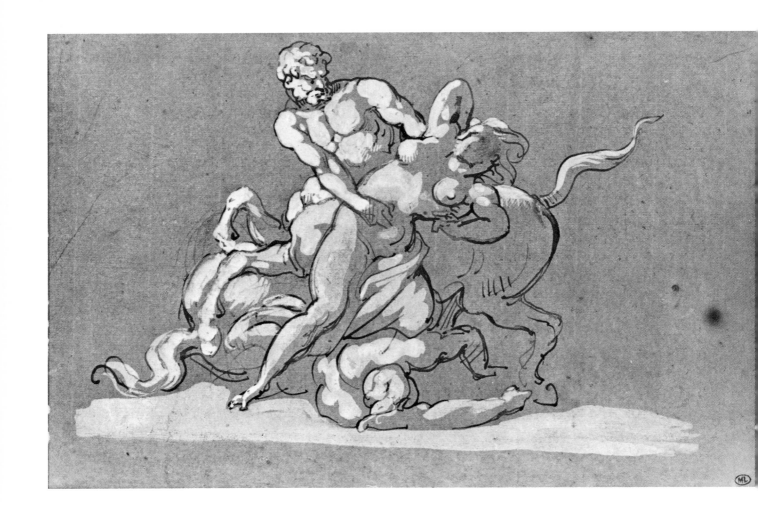

*Italian Peasant
with his Son*

Crayon, pen and ink, watercolor on paper
10 1/16 x 7 5/16 in. (257 x 185 mm.)
Collection: Ecole des Beaux-Arts
(inv. 964), Paris.

When Géricault drew his studies of Roman street-life in 1816-1817, the international vogue for picturesque or sentimental Italian genres had not yet begun. The noble brigands and pious *contadini* who were soon to become Salon stereotypes were still waiting to be discovered by French painters. Géricault had preceded to Italy the two chief popularizers of this specialty, Victor Schnetz and Leopold Robert. He was the first French artist of his generation to make serious use of motifs taken from the daily life of the common people of Italy. But in Rome itself there already flourished a vigorous exploitation of the local picturesque aimed chiefly at the tourist trade. At the time of Géricault's stay in Rome the most successful practitioner of this genre was Bartolomeo Pinelli (1781-1835) whose etched *motivi pittoreschi* and *costumi pittoreschi* had attained wide popularity. In his facile linear manner, which combined the habit of neo-classical stylization with a flair for realistic observation, Pinelli was treating subjects that Géricault shortly after was also to explore: cattle herdsmen driving their bulls, worshippers at the door of a church, a criminal conducted to the scaffold, the race of the Barberi horses during the Roman carnival. A drawing closely related to the exhibited one is in the Gobin Collection, Paris (Clément, *Dessins*, 77).

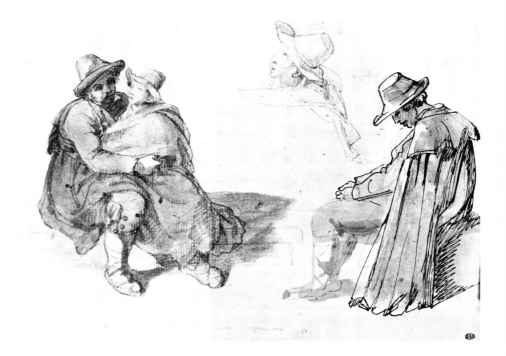

**37**

*Worshippers at the
Portal of a Church
("Prière à la Madone")*

Pen and ink on tracing paper;
mounted on heavier stock
10⁷⁄₁₆ x 15¾ in. (265 x 400 mm.)
Collections: His de La Salle
(stamp, Lugt 1332); Ecole
des Beaux-Arts (inv. 965), Paris.

An advanced compositional design, this drawing is possibly the remnant of a major project. A related drawing in Lyons (inv. X-1029/24) bears the old label *"The Plague in Rome"* which may give a clue to the actual subject. Closely related to this are the composition in oil, known as *La pauvre famille* (Stuttgart Museum, Clément, Peintures, 115) and various drawings of Italian family groups (The Metropolitan Museum of Art; Ecole des Beaux-Arts; Rouen Museum, cat. 1409; etc.). Though the subject is taken from the street life of Rome, its arrangement, stylization, and the borrowings from both Michelangelo and Raphael make it appear that Géricault was attempting to translate these impressions of common reality into a monumental composition of grand style. It is thus possible to regard the *"Prière à la Madone"* as the direct precursor of the project of the *Race of the Barberi Horses* (see nos. 38-46 of this catalog).

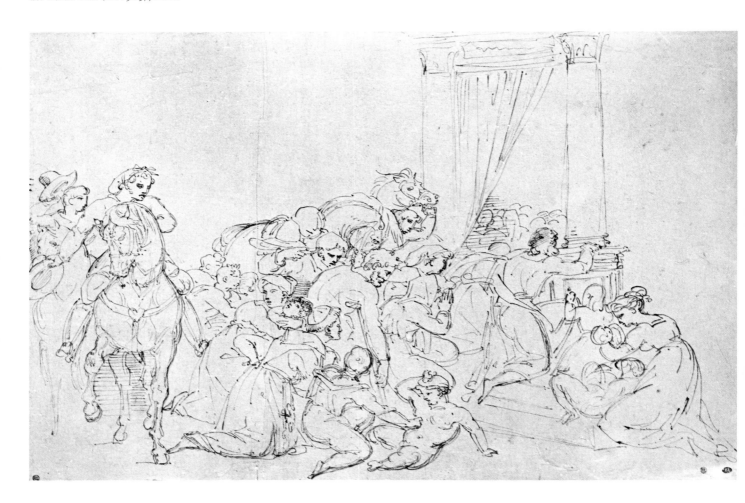

## Roman Groom
## Leading a Horse

Oil on paper, mounted on canvas
17¾ x 23¾ in. (451 x 603 mm.)
Collections: A. M. Binant, Paris;
Victor D. Spark, New York.

During February of 1817 Géricault witnessed the races of the riderless Barberi horses in the Corso, the concluding event of the carnival celebrations. The spectacle fascinated him, and he resolved to treat it in a painting of large dimensions. Work on this project occupied him during the remaining months of his Italian stay. He began by treating the event realistically, as a scene of picturesque Italian life. The study in the Victor D. Spark Collection is one of several which he painted, by way of general documentation, at the outset. A drawing closely related to it is in the Besançon Museum (D-2132). Other studies of Roman grooms leading horses to the start of the race are in the Gobin Collection (Clément, Peintures, 89), the former Chevrier Marcille Collection (Clément, Dessins, 70), and the former His de La Salle Collection (Clément, Dessins, 73).

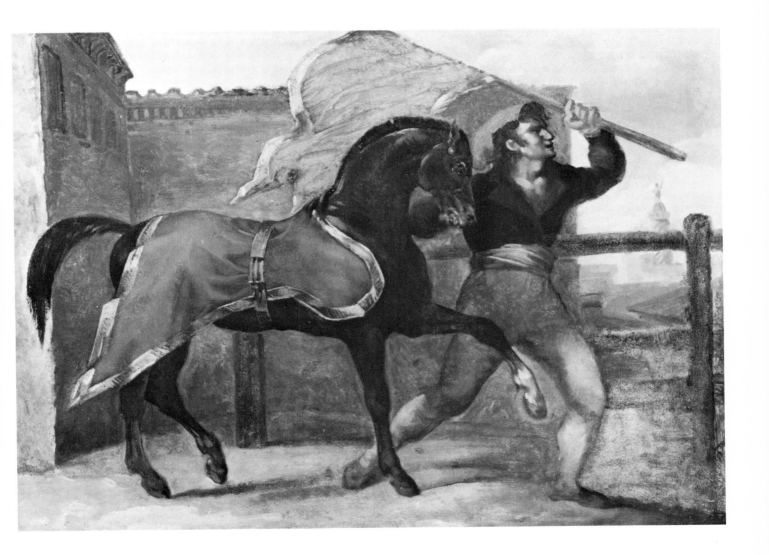

## Sketch for the Race of the Barberi Horses

Pen and ink on yellowish paper
6⅝ x 10⅝ in. (168 x 270 mm.)
Collections: Camille Marcille
(sale, 1876); His de La Salle (stamp,
Lugt 332; sale, 1880); de Pass;
Royal Institution of Cornwall, Truro.

In developing the theme of the *Race of the Barberi Horses* Géricault produced countless drawings and, according to Clément, more than twenty painted studies. His first concern was to single out from his impressions of the race those aspects which offered the greatest dramatic and pictorial possibilities. For some time he hesitated among several alternatives: the start of the race, the race itself, and the finish. But from the first his interest was directed mainly to the struggle between the men and the horses; the race itself does not seem to have occupied him to a like degree. In a large oil study (Walters Art Gallery, Baltimore) he represented the suspenseful instant before the release of the horses, in a wide inclusive view — evidently as a record of his own experience of the event. The pen drawing here exhibited represents another moment of the race, the wild tumult of the recapture of the horses at the finish, and shows the struggling grooms in classical nudity. The drawing is most directly related to the oil study in the Lille Museum (see no. 40 of this catalog), but it also has affinities with the study in Rouen (see no. 43).

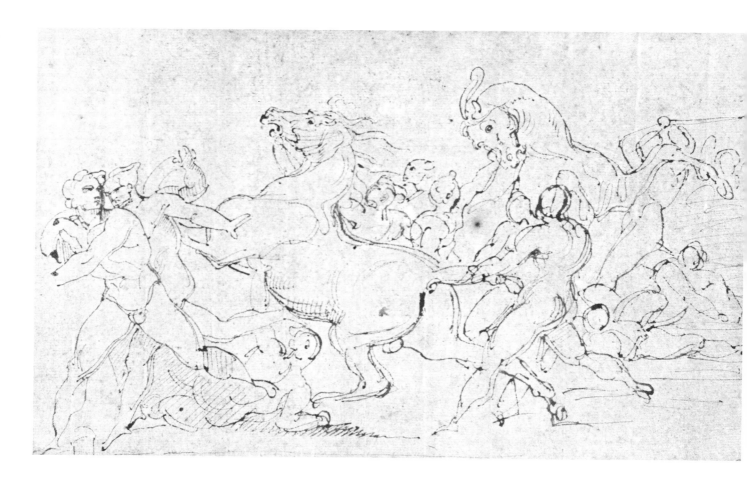

## Study for the Race
of the Barberi Horses

Oil on paper, mounted on canvas
17¾ x 23⅝ in. (451 x 600 mm.)
Collection: Musée des
Beaux-Arts, Lille.

Like the foregoing drawing, the oil study in Lille represents the capture of the riderless Barberi horses at the finish of the Race. While the *Start of the Race of the Barberi Horses* in Baltimore presents a fairly literal picture of the scene as Géricault presumably saw it, the study in Lille gives the impression of an imaginative interpretation. The view is taken close to the struggling figures which, fewer in number, loom much larger. The compact mass of men and horses has dissolved into separate groups. The horses bolt in every direction; their broken, confused movement is heightened by the scattered light which falls at a slant among the figures. The race is conceived as a contemporary event with the grooms in modern costume, but the physical intensity of the drama raises it above ordinary reality.

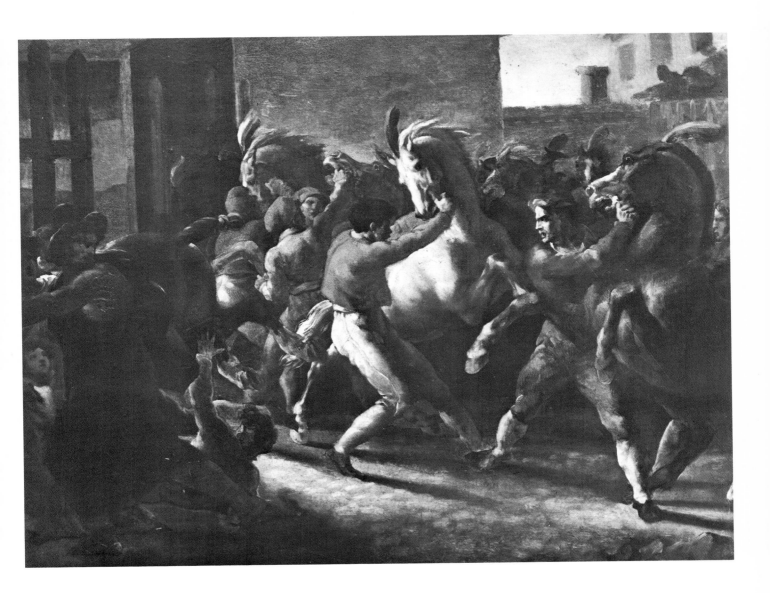

*Men Struggling with
Horses and Other Sketches*

Pencil, pen and ink on paper
7 x 10½ in. (178 x 262 mm.)
Collections: Thomas S. Cooper, London;
Christopher Powney (sale, 1968);
Frances S. Jowell, Toronto.

Several of the rapid compositional pen
sketches appear to be connected with the
project of the *Race of the Barberi Horses,*
suggesting that the sheet, probably cut
from a sketchbook, dates from 1817. At the
lower left is a pencil sketch of a man escap-
ing over rocky terrain. Figures of similar
type and pose occur in drawings in Rouen
(cat. 1375), at Smith College, and in the
Pierre Dubaut Collection, Paris. They may
represent fleeing giants, parts of a *Gigan-
tomachy.*

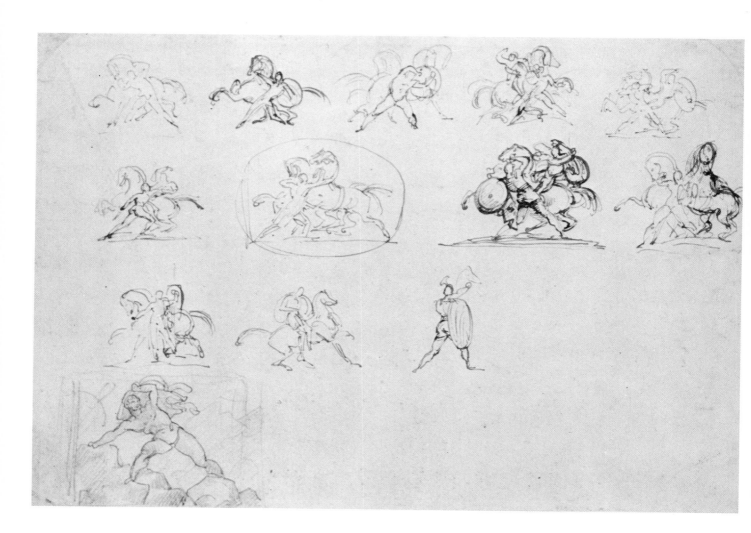

*Sketch of an Ephebe
Holding a Running Horse*

This very rapid and evidently spontaneous sketch is related to the painting in Rouen (cf. no. 43 of this catalog). On the verso is a drawing in pen and pencil of an antique warrior in a chariot.

Pen and ink on paper
9¼ x 13 in. (235 x 330 mm.)
Collections: E. Martin, London;
Frances S. Jowell, Toronto.

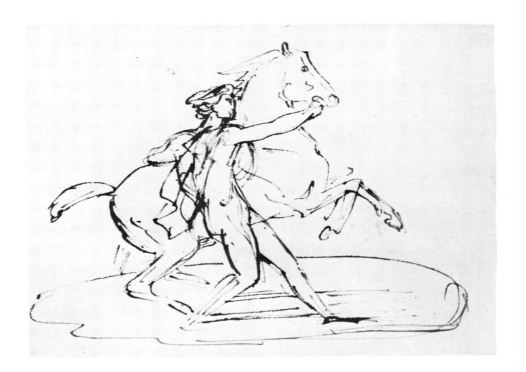

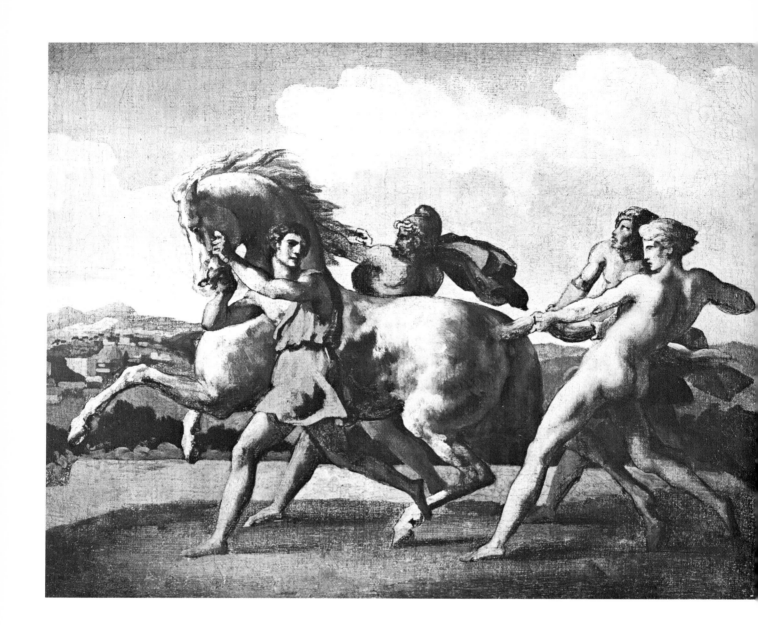

## Four Ephebes Holding a Running Horse

Oil on paper, mounted on canvas
19⅛ x 23⅞ in. (486 x 606 mm.)
Collections: Pillet (sale, 1866);
Couvreur (sale, 1866);
Musée des Beaux-Arts, Rouen.

As Géricault developed the composition of the *Race of the Barberi Horses,* he gradually divested it of all modern detail. He sacrificed the picturesque turbulence of the scene to a clear and balanced order, and gradually shifted the figures, much reduced in number, to the foreground. The only constant element in this development was Géricault's preoccupation with the struggle between the horses and their grooms. The group, consisting of a ramping horse held by athletic attendants, was the invariable center of all of the successive versions. Repeated in different variations, it was the basic unit of which he constructed his compositions. The painting in Rouen, which isolates this group and raises it to monumental grandeur, is a by-product of this compositional work. It places the figures in an Arcadian setting and gives them classical features. No longer arranged in depth, but in a plane, they expose the unobstructed lines of their bodies. The measured rhythms of the gestures and the balance of the arrangement, even the resonant colors, make this the most serenely "antique" of all of Géricault's paintings. It is probable that, in addition to unmistakable reminiscences of Poussin, impressions of classical art played a role in shaping the *Race of the Barberi Horses.* Géricault was familiar with the *Horse Tamers* of the Quirinale, and, through his friend the sculptor Giraud who had made casts of the Parthenon reliefs in London and who was in Rome at the time, he may have acquainted himself with the type of the Phidian horse. A full-scale drawing for the painting in Rouen is in the Meyer-Huber Collection in Zurich.

## Sketch for the Start of the Race of the Barberi Horses

Pen and ink on yellowish paper
5⁷⁄₁₆ x 9⁷⁄₈ in. (138 x 175 mm.)
Collections: Feltre; His de La Salle
(stamp, Lugt 1332; sale, 1880);
de Pass; Royal Institution
of Cornwall, Truro.

In this working drawing for the definitive version of the composition, the arrangement is frieze-like, developing from left to right in three main groups — each consisting of a horse being held by nude youths. Only the starting rope at the right recalls the original significance of the scene. (Other drawings for this composition are in the Musée Bonnat, Bayonne, inv. 2039; the Louvre, RF 26736, Clément, Dessins, 59; the Fogg Museum, Clément, Dessins, 60; the Buehler Coll.; and the former Chevrier Marcille Coll., Clément, Dessins, 58.) A curious parallel to Géricault's *Race of the Barberi Horses* exists in the form of compositional drawings by a Milanese artist, Giuseppe Bossi (1777-1815). One of these, in the Robert Walmsley Collection, Toronto, shows the start of the race in a composition which recalls Géricault's picture in Baltimore, but casts the scene in an antique setting. Two other drawings, in the Norma Goldberg Collection, St. Petersburg, Florida, present the start of the race in the form of long friezes of classical nudes struggling with horses. A pen and wash drawing in the Castello Sforzesco, Milan, singles out particular group from one of these compositions, rather in the manner of the *Four Ephebes Holding a Running Horse*. The resemblance, in general conception and in individual figure motifs, between Bossi and Géricault's compositions is close enough to suggest a connection between them. This can only have been in the form of an influence by Bossi's designs on Géricault, since Bossi died the year before Géricault's arrival in Italy.

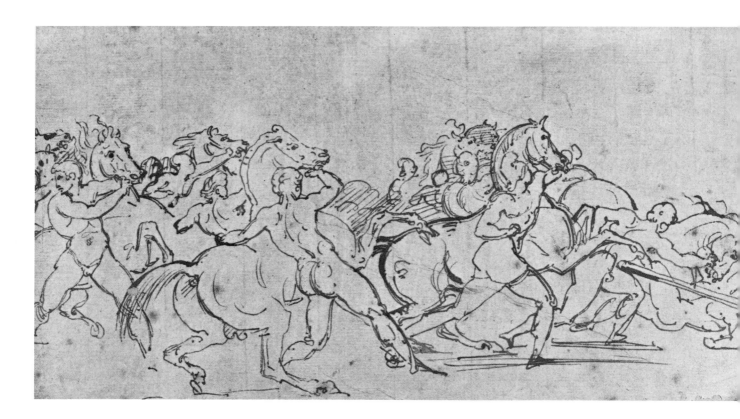

*Study of a Nude Man
Holding a Rearing Horse*

Pen and ink on paper
9⅞ x 7½ in. (250 x 190 mm.)
Collections: Michel-Levy (sale, 1919);
Duc de Trévise (sale, 1938);
William Rockhill Nelson
Gallery of Art and Atkins Museum
of Fine Arts, Kansas City.

A life study for the central figure of the final version of the *Race of the Barberi Horses,* this drawing recalls Coustou's monumental "Horsetamers of Marly" in the Champs Elysées. It is in fact a composite of the two sculptures, corresponding in the position of the legs to the one and in the position of head, shoulders, and arms to the other. The resemblance may be accidental, but Géricault had a very retentive memory. It is not inconceivable that these French works, of a classicizing baroque style that he may well have found congenial, were in his mind when he composed his picture in Rome in 1817.

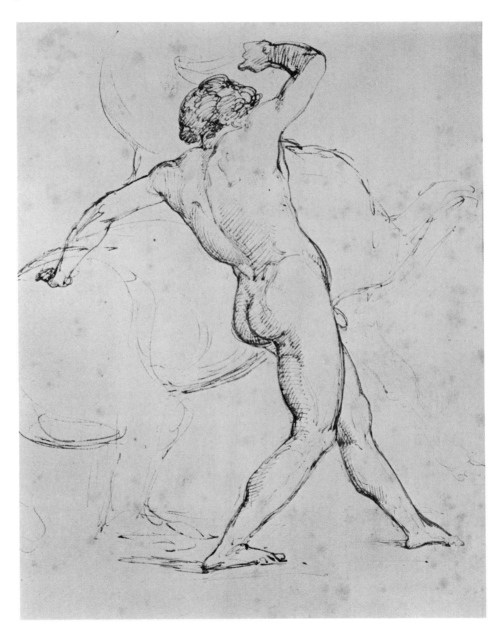

## Start of the Race of the Barberi Horses

Oil on impregnated paper,
mounted on canvas
24¼ x 32¼ in. (616 x 819 mm.)
Collections: Anna Ortalli, Parma;
Bianchedi, Parma; private collection.

This is one of several oil studies which represent the final version of the composition. The smallest and roughest of these is in the Buehler Collection, Winterthur (Clément, Peintures, 83-*bis*), the most finished at the Louvre (RF 2042). According to Clément (p. 100) Géricault painted more than twenty studies of the composition, all of them on paper. On his return to Paris it was found that these painted studies had become stuck together and could be separated only with great difficulty. The majority of them seem already to have been lost at the time of Clément's writing. The exhibited study was found some time ago in Italy where it may have been left at the time of Géricault's departure in 1817. It is considerably larger than the picture in the Louvre (which measures 450 x 600 mm.), and it reverses the direction of the composition causing the figures to face to the left; in all other respects it conforms very closely to the Louvre version. The reversal may have been achieved by tracing through the paper or by making an off-print of another painted study. The surface of the exhibited study shows traces of old damage and of repairs by means of in-painting which have affected its style, particularly in the main figure.

Géricault intended to execute the composition of the *Race of the Barberi Horses* on a large canvas and had already begun to transfer the design when he abruptly left Rome in September of 1817. The painted versions of the composition deliberately obscure the clear linearity of the underlying drawing. The light falls in patches on the animals and the men. A shadow seems to pass over the scene. The modeling of the figures does not assert itself in the contours, but in scattered areas of illuminated surface. By silhouetting the main groups against a blank wall, Géricault has detached them from the deeper, spatial setting and given them something of the compactness of a relief frieze. Had he carried out the *Race of the Barberi Horses* as a monumental painting, he would have accomplished a work of entirely exceptional character for its time. The picture represents neither an event of the present, nor one of the historical or mythical past. The struggle of men and animals in a timeless setting is its sole content. The novelty of Géricault's approach lies in his avoidance of any descriptive or narrative motivation; for him, the dramatic image was self-sufficient. In this respect the *Race* marks an epoch in the nineteenth century's shifting attitude toward subject matter; it appears to be the earliest monumentally-conceived work of the period in which a dramatic "motif" takes the place of the narrative subject.

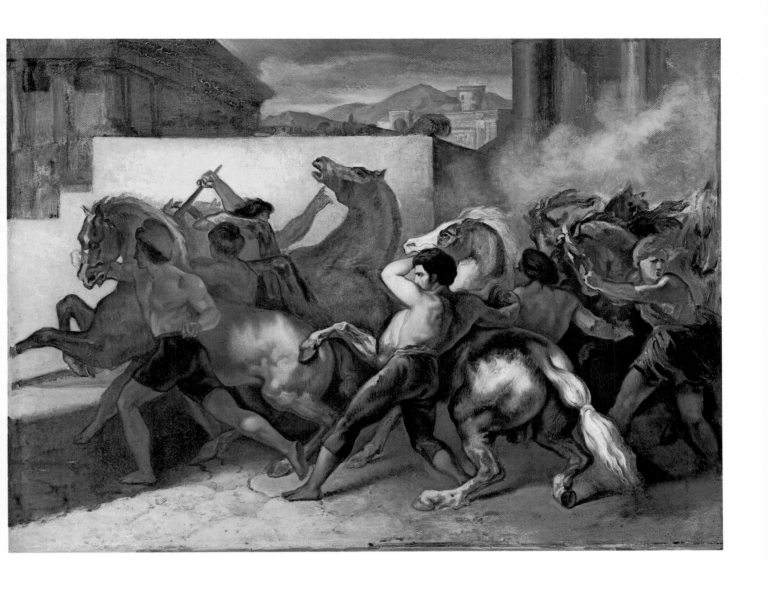

*Sketchbook Page:
The Interior of the
Temple of Poseidon
at Paestum*

Pen and ink on paper
8⁹⁄₁₆ x 10¾ in. (218 x 274 mm.)
Collections: DeMetz; J. Ulrich;
Kunsthaus, Zurich (acquired in 1877).

Géricault began this sketchbook about 1814, used it during his Italian voyage in 1816-17, and drew the last sketches in it in 1819, at the time of the completion of the *Medusa*. The exhibited drawing (page 49) records his visit to Paestum. Other views of Paestum—of the Temple of "Ceres" and the exterior of the so-called Temple of Poseidon — are to be found on pages 48 and 50.

Of all the extant sketchbooks, this offers the greatest variety of motifs and styles. It includes a notable series of portrait drawings, ranging from 1814 to 1819; some caricatures; studies from the life for the *Medusa;* copies after sculptures and paintings in the museums of Naples, Rome, and Florence; sketches after Greek vases; Italian genre scenes, and various Italian views, including a grand panorama of the Bay of Naples.

The sketchbook, now in the Kunsthaus in Zurich, was bought at the sale of Géricault's studio in 1824. Included in the sale were no fewer than thirty-three sketchbooks (item 42 of the sale; cf. L. Eitner, "The Sale of Géricault's Studio in 1824," *Gazette des Beaux-Arts,* February 1959, VI period, vol. LIII, p. 117). Today, only four sketchbooks are known: the so-called Zoubaloff Sketchbook in the Louvre, containing drawings dating from about 1813-1814; the two sketchbook fragments which form the Chicago Album (see nos. 13, 14, 66, 67 of this catalog), and the sketchbook in Zurich. Other sketchbooks have occasionally appeared in sales (two sketchbooks in the Sir Thomas Lawrence sale in London, 1830; two sketchbooks in the de Musigny sale, Paris, in 1845; two sketchbooks — including the Zoubaloff Sketchbook — in the Coutan-Hauguet sale, Paris, in 1889; and one sketchbook in the Chennevières sale, Paris, 1900). The majority have probably been disassembled and have supplied a large proportion of the separate drawings now scattered throughout the collections.

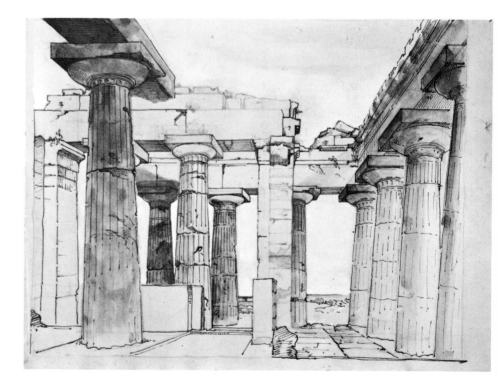

*Entrance to a Park*

Pen and ink, watercolor on paper,
mounted on cardboard
5⅜ x 8⁵⁄₁₆ in. (137 x 211 mm.)
Collections: J. Gigoux (stamp,
Lugt 1164); Musée des Beaux-Arts,
Besançon (inv. 3637;
acquired by bequest in 1894).

The dating of Géricault's casual landscape
sketches is extremely difficult since they
show little stylistic development over the
years. It is possible that this watercolor
drawing records a travel impression of the
Italian voyage, 1816-1817.

## Nude Horseman

Pen and ink on paper
8 1/16 x 5 1/8 in. (205 x 130 mm.)
Collections: J. Gigoux (stamp,
Lugt 1164); Musée des Beaux-Arts,
Bescançon (inv. 2137;
acquired by bequest in 1894).

A figure similar to this *Horseman* occurs in a pen drawing of *Nude Horsemen Attacking an Artillery Position* in the Musée Bonnat, Bayonne (inv. 705), one of several sketches for a major project which occupied Géricault in the months after his return from Italy (winter 1817—spring 1818). As in the *Race of the Barberi Horses,* Géricault developed a modern subject (cf. the drawing of *Cavalry Attacking an Artillery Position* in the Ecole des Beaux-Arts, Paris, inv. 34949) into a "timeless" image conceived in a grandly monumental style (cf. in addition to the drawing mentioned above, there is a second drawing of the subject at the Musée Bonnat, Bayonne, inv. 704). On the verso of the exhibited drawing are indistinct sketches of horsemen and perspectival studies related to *The Raft of the Medusa.*

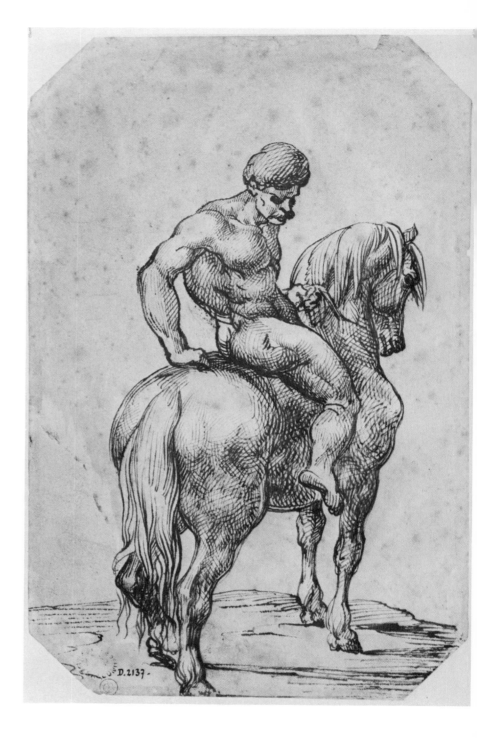

*Three Studies of a
Female Model*

Pen and ink on paper
12¹⁄₁₆ x 8⅜ in. (307 x 213 mm.)
Collections: Destailleur;
Armand-Valton; Ecole
des Beaux-Arts (inv. 971), Paris.

A drawing at the Musée Bonnat, Bayonne
(old inv. 2061), presents the same model,
together with a male nude. The modeling
of the body by means of closely laid hatch-
ings, in a manner somewhat reminiscent of
pen drawings by Michelangelo, is a com-
mon feature of Géricault's figure studies of
1817-1819.

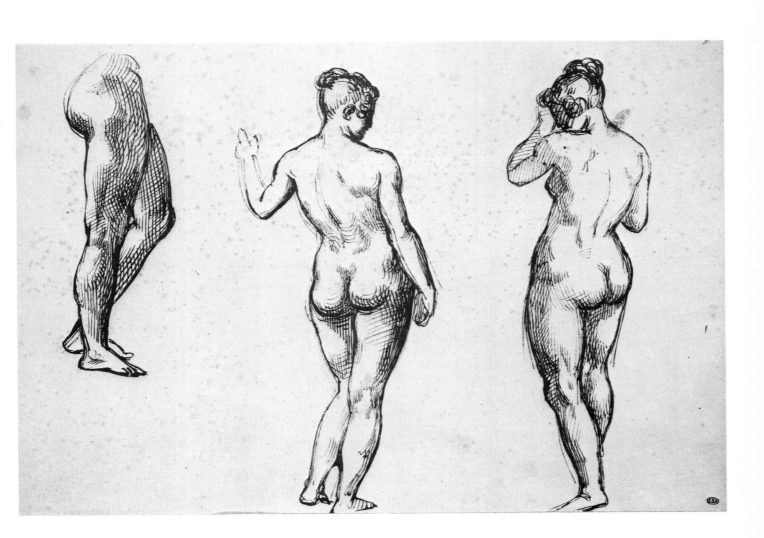

## *Mameluke Horsemen in Battle*

Pen and ink on paper
7¾ x 11 in. (197 x 279 mm.)
Collections: E. Martin, London;
Frances S. Jowell, Toronto.

Of extremely rapid and spontaneous execution strongly reminiscent of Gros, this drawing of Oriental cavalry in battle is related to a number of compositions which can be dated about 1818-1819 (see no. 52 of this catalog). It recently (1970) came to light in London as part of a group of pen drawings by Géricault, all of them belonging to the period of 1817-1819 and representing, perhaps, the fragments of a disassembled sketchbook. (For other drawings from this group, see nos. 34, 42, 70, 82, and 84 of this catalog.) On the verso are the pen drawing of a horse, the portrait of a mustachioed man, and (lower right) an indistinct inscription: *"M . Steuben ... des prés, no. 6."* The painter Steuben, a friend of Géricault, is mentioned by Clément (p. 137) as having been among the handful of friends and admirers whom Géricault admitted to his studio at the time of the execution of *The Raft of the Medusa.*

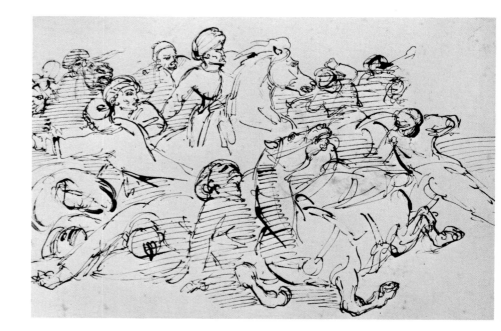

*Mameluke Unhorsed by Attacking Grenadiers ("Episode de la Campagne d'Egypte")*

Crayon, ink wash, white gouache
on bister paper
8⅛ x 11⅛ in. (206 x 282 mm.)
Collections: His de La Salle;
Musée du Louvre (RF 796), Paris
(acquired by gift in 1878).

After his return to France in the autumn of 1817 Géricault gradually reverted to modern and, particularly, to military subjects. But the habit of monumental stylization, gained in the preceding years, stayed with him. Some of the battle scenes which he composed at this time are conceived with the same formal grandeur and are executed in the same sculptural chiaroscuro manner as his Italian mythologies. Clément (p. 334, note 1) mentions a pencil drawing, now lost, for this highly finished wash-and-gouache drawing in the Louvre; another sketch for this composition is in the Buehler Collection, Winterthur. Despite its suggestion of monumental scale, the drawing of the *Unhorsed Mameluke* is in fact most closely related to Géricault's lithographic essays of the time, in particular to his lithograph *Mameluke défendant un trompette blessé* (1818, Delteil 9) which resembles it in its compositional structure.

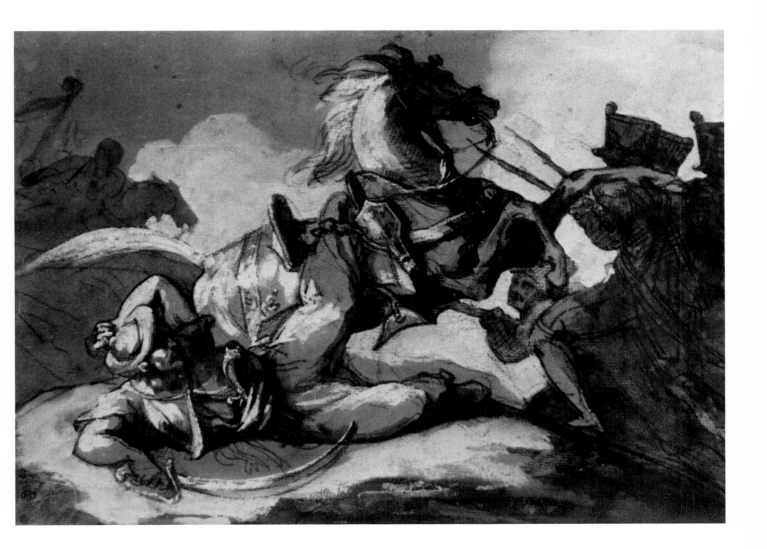

## 53

*Portrait of a Young Man*

Oil on canvas
18¾ x 15 in. (476 x 381 mm.)
Collections: Richard Goetz
(sale, 1922); Duc de Trévise;
Julius H. Weitzner, New York;
Walter P. Chrysler, Jr., New York

The identity of the sitter, a young man of about eighteen to twenty years of age, is not known. The portrait dates from ca. 1816-1818.

## 54

*Portrait of a Boy*

Oil on canvas
18 x 14¾ in. (457 x 374 mm.)
Collections: de Kat (sale, 1866);
anonymous sale, Hôtel Drouot, Paris,
December 22, 1920, no. 83; Duc de Trévise
(sale, 1938); Robert Lebel, Paris.

It has been suggested that the subject may be Alfred Dedreux (see no. 23 of this catalog). The style and execution of this portrait indicate a date of about 1818-1820.

## 55

*Portrait Study of a Youth*

Oil on canvas
18½ x 15 in.(470 x 381 mm.)
Collections: Leclerc; Pierre Dubaut;
private collection; The Kimbell
Art Foundation, Fort Worth, Texas

The identity of the sitter, an adolescent of about twelve to fourteen years old, is not known. The portrait probably dates from 1818-1820.

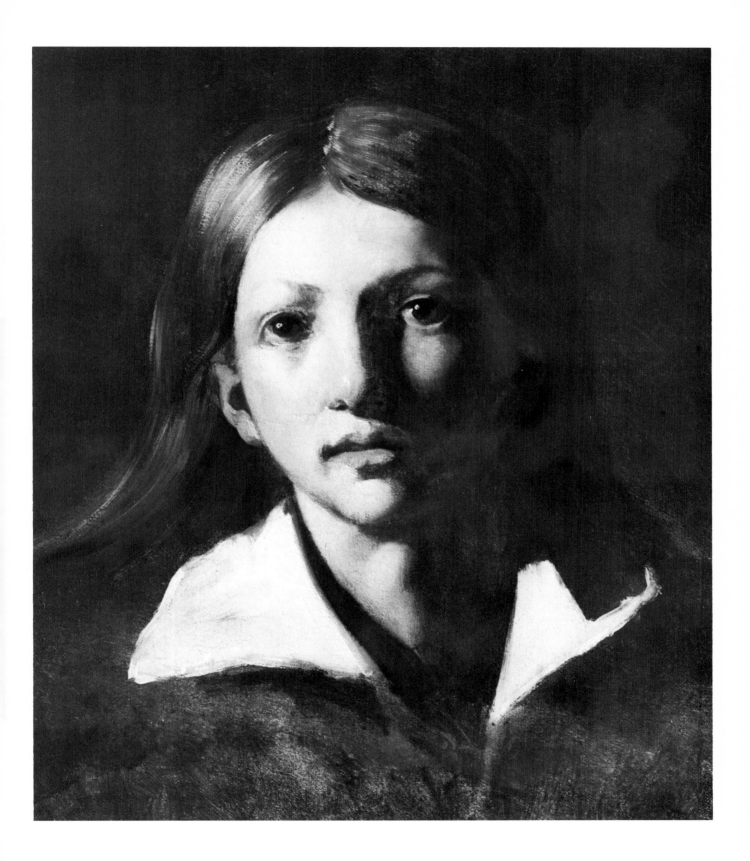

95

## Portrait of a Young
## Man in an
## Artist's Studio

Oil on canvas
57¾ x 39¹⁵⁄₁₆ (1467 x 1014 mm.)
Collections: Antoine Vollon
(sale, 1901); Musée du Louvre
(RF 1225), Paris.

Formerly accepted as a self-portrait, this painting has lately provoked questions affecting not only its subject but also its authorship. Its large size, the elaborate presentation of sitter and setting, and the rather smooth execution make it appear exceptional among Géricault's portraits, most of which are more casual and spontaneous. But there is nothing in its conception or style that rules out Géricault's authorship. He did paint full-length portraits of high finish and elaborate detail, witness the *Portrait of Mme. Bro Seated in a Chair* (Clément, Peintures, 125; ill. Berger, *Géricault,* Vienna, 1952, pl. 80) which is even more circumstantial in its description of the setting than the *Young Man in an Artist's Studio.* Nor was the striking intensity of feeling and of self-revelation, which caused this picture to be wrongly called a self-portrait (and rightly considered as a "classical image of the Romantic artist"), beyond the range of his work in 1818-1820, as several of the portraits in this exhibition prove.

The features of the portrait are not Géricault's own (cf. his self-portraits, nos. 70 and 121 of this catalog), but they are not entirely unfamiliar. Grotesquely intensified, they occur among the caricatures in his sketchbooks of 1818-1819 with sufficient

frequency to suggest that they belonged to someone in Géricault's intimate circle (cf. fol. 29 recto of the Chicago Album, p. 2 of the Zurich Sketchbook, and nos. 13 and 47 of this catalog). These features are distinctive enough to be easily recognized even when not exaggerated — the hair parted over the right eye and brushed sideways to form stiff, arching wings over the forehead; the very long, straight, pointed nose, and the pouting mouth with its unusually full, protruding upper lip. They can be spotted among the faces of *The Raft of the Medusa* in two figures: the dead youth in the left foreground (cf. the head study no. 93 of this catalog) and one of the men standing at the mast of the raft. Both of these figures, according to Clément, were posed by Louis Alexis Jamar. This identification can be verified by comparison with Géricault's bust-length portrait of Jamar (Clément, Peintures, 120), a picture which perished in 1944 but of which photographs survive. Jamar was a young painter who assisted Géricault during the work on the *Medusa,* in 1818-1819, and lived in his studio at that time. The evident resemblance of known likenesses of Jamar to the *Portrait of a Young Man in an Artist's Studio* make it possible to identify its subject with a high degree of probability and to confirm its attribution to Géricault. The picture seems to have been known to Géricault's friend Ary Scheffer who adapted it for one of the figures (that of the sorrowing Dedreux-Dorcy) in his painting of the *Death of Géricault* (1824, Louvre).

The signature "T. Géricault" appears on one of the rungs of the chair.

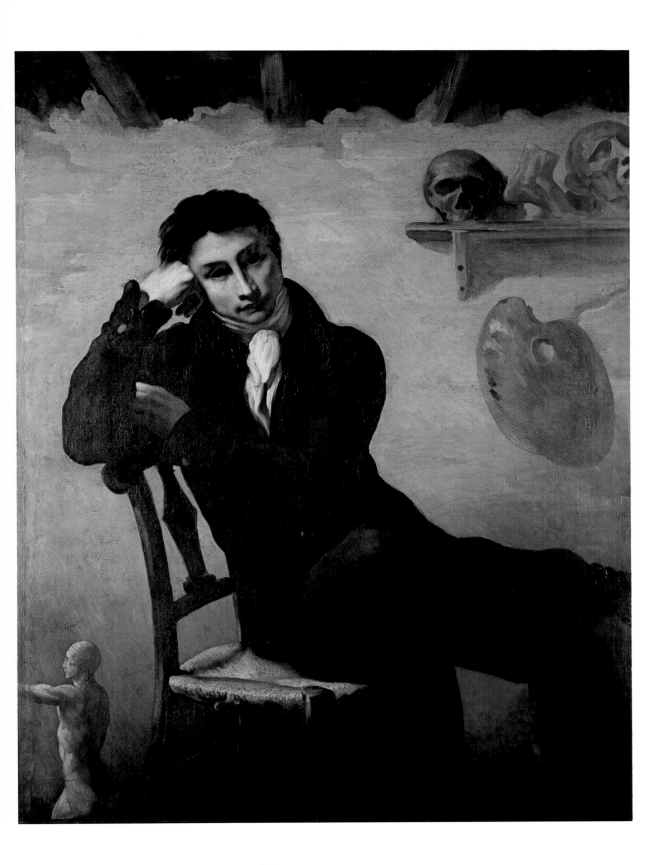

*The Plotting of
the Murder of Fualdès
("La Réunion
de la Saint-Martin")*

Black chalk, wash, and
watercolor on paper
9¼ x 13⅜ in. (216 x 340 mm.)
Collections: Thomas S. Cooper, London;
Christopher Powney (sale, 1968);
Claude Aubry, Paris.

After his return from Italy in the autumn of 1817, Géricault began to search for a suitable subject for a painting of large dimensions with which he hoped to win success at the forthcoming Salon of 1819. He experimented for a time with grandiose, timeless images in the manner of his *Race of the Barberi Horses;* but his interest drew him increasingly toward modern subject matter, and he conceived the novel idea of treating a newspaper story of the most immediate and sensational actuality in the format of grand history painting. The recent murder of Fualdès, a magistrate of the town of Rodez, was very much in the public mind during the winter and spring of 1817-1818, partly because of the atrocious brutality of the crime itself, partly because of an unfounded suspicion that it had been politically motivated. Géricault decided to try his hand at composing a painting in an elevated style of this murder. As he had done in developing the subject of the *Race of the Barberi Horses* (see nos. 38-46 of this catalog), he began by dissecting the event into its successive phases. The exhibited drawing represents the murderers plotting their crime. Other drawings show Fualdès being dragged into the murder house, Fualdès being murdered (both drawings formerly in the collection of the Duc de Trévise), Fualdès' body being carried to the river (see no. 58) and thrown into the river (formerly in the collection of the Duc de Trévise), and the escape of the assassins (Rouen Museum). Géricault used popular prints to guide him, but he translated the journalistic prose of his models into the language of monumental art and in most of his compositions represented the assassins in heroic nudity. The project (which Géricault soon abandoned) is of some importance as a rehearsal for *The Raft of the Medusa* in which he attempted a similar transformation of a contemporary horror into a history painting of grand style.

**58**

*The Assassins*
*Carrying Fualdès Body*
*to the River*

Pencil, black chalk, ink washes
on yellow paper
8½ x 11⅜ in.(216 x 289 mm.)
Collections: Lehoux; Musée des
Beaux-Arts, Lille (inv. 1395).

The murder of Fualdès occurred on March 19, 1817, while Géricault was in Rome. It is likely that Géricault drew his compositions in the spring of 1818, probably while the second, final trial of the murderers was in progress (March 25-May 4, 1818). The Bibliothèque Nationale, Paris, preserves a series of lithographs of the murder of Fualdès — by Sebastien Coeuré (1778-ca. 1831) — which may have influenced Géricault's designs. One of the prints, *Le corps de M. Fualdès transporté dans l'Aveyron,* corresponds in subject matter to the drawing in Lille; but in contrast to Géricault's "antique" conception the subject is rendered in a banally modern form; (cf. no. 57 of this catalog.)

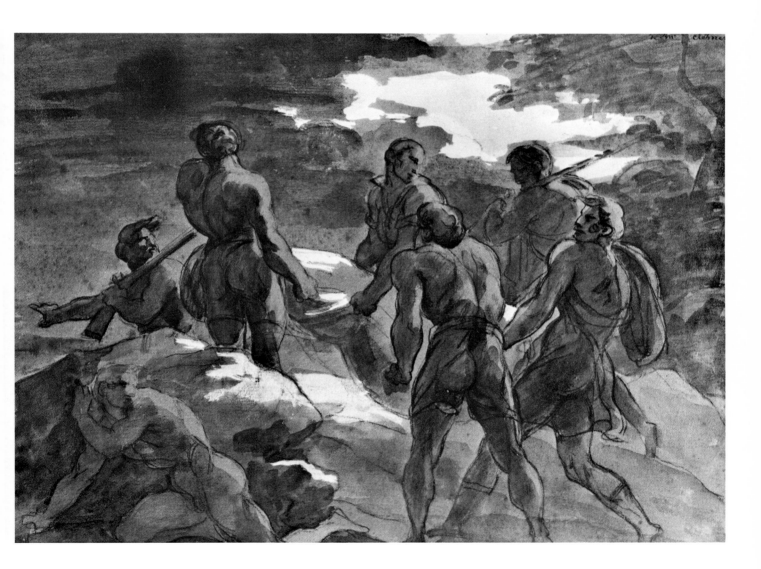

*Sketches of Horsemen*

Pencil, pen and ink on paper
9½ x 7 in. (241 x 178 mm.)
Collections: Thomas S. Cooper, London;
Christopher Powney (sale, 1968);
Frances S. Jowell, Toronto.

The five small drawings of Hussars, Cuirassiers, and Lancers in the upper portion of the sheet closely resemble drawings in the sketchbook fragment in Chicago (cf. nos. 13 and 14 of this catalog) which date from about 1814. The two sketches of a wounded horseman, in the lower part of the sheet, refer to the lithograph *Retour de Russie* (Delteil 13) of 1818. On the verso the sheet bears a study for the composition known as *Death of Poniatowski* which can be dated in 1814-1815 on the basis of its subject matter and style. The date of the sheet as a whole thus poses a problem. Conceivably, Géricault drew all the sketches before his Italian voyage, i.e., about 1814-1815; but for stylistic reasons it seems more likely that the small sketches of the recto are of later date and are directly connected with Géricault's lithographic work of 1818. At that time he again took up some of the Napoleonic themes which had occupied him before his Italian stay and in dealing with them often reverted to earlier stylistic mannerisms. It is therefore difficult to date some of the military genres with absolute confidence in the years just before or just after the Italian stay even when they seem to refer to the lithographs of 1817-1819.

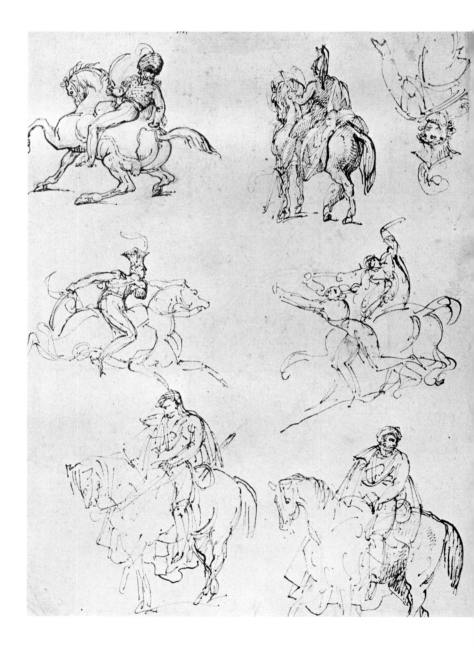

## Sheet of Sketches

Pen and ink on paper
8¾ x 13¼ in. (222 x 337 mm.)
Collections: Sauvé; His de La Salle
(stamp, Lugt 1332); Paul Huart (stamp,
Lugt 2084); Sir Robert Witt;
Courtauld Institute of Art, London
(Witt Bequest, 1952, no. 714).

The sheet presents a group of separate sketches, rather finely executed and set down either in the manner of vignettes or of small, framed compositions, an arrangement often found in Géricault's sketchbooks. The drawing of an Italian family, in the upper middle of the sheet, is a reminiscence of a work dating from ca. 1817 and known as *La pauvre famille*. The majority of the other sketches are related to Géricault's military compositions of 1818-1819.

The sketch in the center of the sheet seems to represent wounded soldiers on a field of battle after a charge by Cossacks. The men carrying ladders and pulling a heavily loaded cart, at the bottom of the sheet, may be engaged in siege or fortification work. A drawing resembling the sketches of a mounted officer, at the right and the lower left of this sheet, is in the Museum of Lyon (inv. X-1029/23).

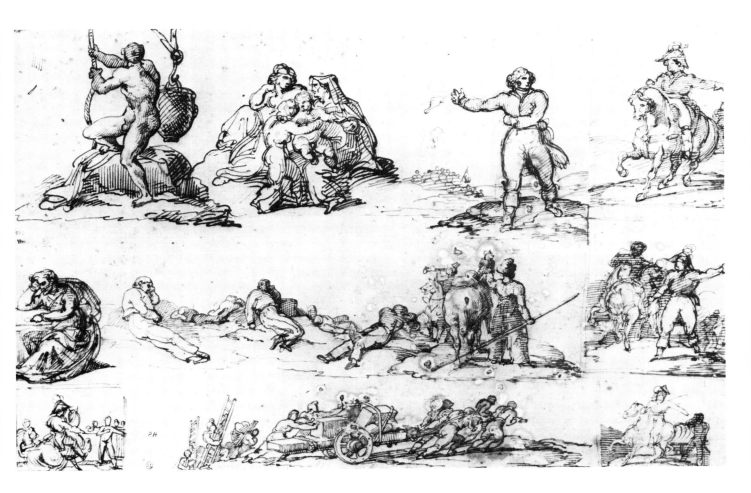

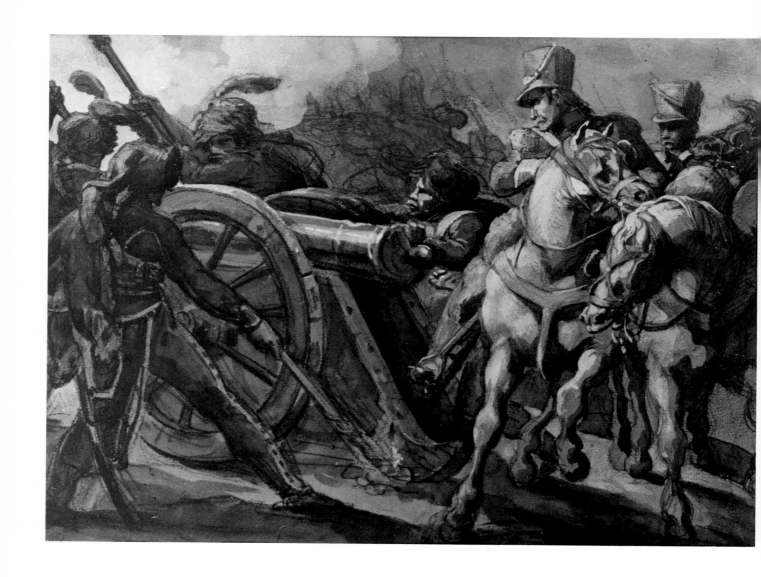

*Field Artillery
During a Battle*

Black chalk, pen and ink, watercolor,
and white gouache on bister paper
8⅜ x 11⅛ in. (213 x 282 mm.)
Collections: Destouches (gift, 1891);
Musée du Louvre (RF 1748), Paris.

The subject may be related to the battle project of 1818 (cf. no. 49 of this catalog), but the drawing is also connected with Géricault's lithograph *Artillerie à cheval changeant de position* (1819, Delteil 16). It illustrates Géricault's renewed preoccupation after 1817 with dramatic modern themes, and the effect this had on his style. Lithography played a key role in his shift to contemporary subject matter and modern style. Nearly all his military or equestrian compositions after his return from Italy are more or less directly connected with lithographic projects. Géricault had begun to experiment with lithography shortly after his arrival in France in 1817. He was probably guided by his friend Horace Vernet, one of the earliest and most successful practitioners in the new medium. The great popular success of lithography during the years of the Restoration was due not only to the cheapness of lithographic prints, which made it possible for a large public to buy original works by well-known artists, but also to its special fitness for journalistic and political use. At a time when the demand for newspapers and for pictorial reportage was steadily growing, lithography offered a cheap and rapid process for the mass-production of sensational, patriotic, or satirical ephemera. Some artists found lithography not merely profitable and convenient but also came to value its aesthetic qualities, especially its wide tonal range. Tainted by its popularity and its flavor of political polemic, and very little suited to work in a neo-classical style, lithography had an unsettling effect on both the academic and the political establishments of the period. To Géricault, tired of timeless,

ideal themes, it offered a welcome chance to try contemporary subjects, unconfined by stylistic restrictions. Lithography was to him an alternative to work in the grand manner. In the great series of military scenes which he drew on stone in 1818-1819, he returned wholeheartedly to his own, earlier realism, fortified now by his experience with work of large scale. His lithographs of the time give evidence of what had become his habit of monumental stylization in the amplitude of the figures and the noble simplicity of their groupings.

## General Kléber
## at Saint-Jean d'Acre

Black chalk, grey, blue, and yellow
washes, white gouache on bister paper
11⅜ x 8⅝ in. (289 x 219 mm.)
Collections: Soubeyran;
Georges Sortais (sale, 1911);
Musée des Beaux-Arts, Rouen.

Depicting an episode of Bonaparte's cam-
paign in Syria, this work belongs in terms
of subject to Géricault's military litho-
graphs of 1818-1819. However, Géricault
did not use it for a print (see no. 61 of this
catalog). A sheet — then in the Aylies Col-
lection — containing four small sketches for
the figure of Kléber, was shown at the Cen-
tenary exhibition (no. 50) in 1924. The
sketch of a battle scene in Lyon (inv. X-
1029/23) contains related figures.

    The drawing is signed at the lower left
"Géricault."

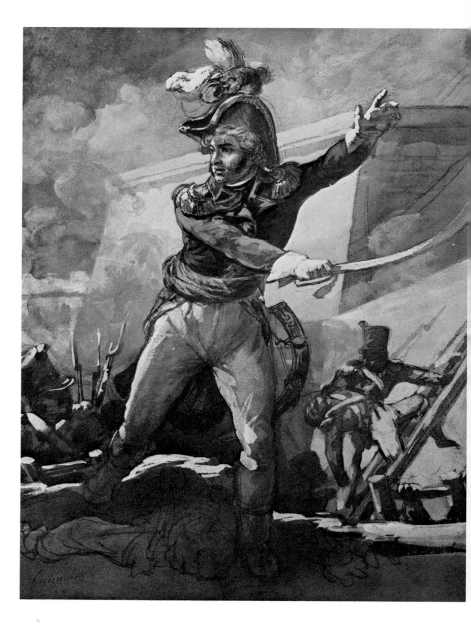

*Mounted Carabinier
Leading an Attack*

Black chalk, bister wash,
watercolor and white gouache on paper
10 x 8½ in. (254 x 216 mm.)
Collections: His de La Salle
(gift, 1878); Musée
du Louvre (RF 800), Paris.

Like the previous drawing this work is re-
lated to the lithographic projects of 1818-
1819 (see no. 61 of this catalog). At the
Museum of Besançon there is a drawing of
a mounted Cuirassier (inv. D-2124) in a
somewhat similar style (cf. also the draw-
ing of a *Charging Cuirassier,* Clément,
Dessins, 21, formerly in the Pic-Paris Coll.).

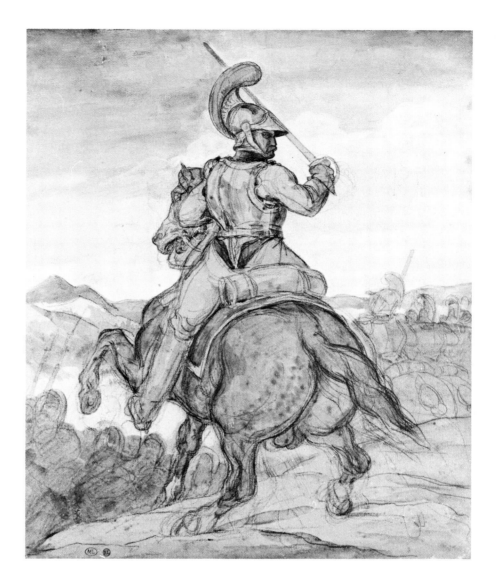

*Groom Holding a
Rearing Horse
("Le Dressage")*

Black chalk, pen and ink, and
watercolor on paper
8¹⁄₁₆ x 11¼ in. (205 x 286 mm.)
Collections: A. Colin (sale, 1845);
Musée du Louvre (RF 26741), Paris.

A sketch of a horse in a similar position
occurs in the Chicago Album (folio 19
recto) among drawings related to the litho-
graphs of 1818-1819. Géricault also used
the motif in a drawing of *Bro de Comères
à St. Domingo,* exhibited in Winterthur in
1953 (no. 142); it recurs, finally, in the
lithograph *Cheval franchissant une barrière*
of 1823 (Delteil 69). The date of the ex-
hibited drawing is most likely 1818-1819.

The sheet is signed at bottom right,
"Géricault."

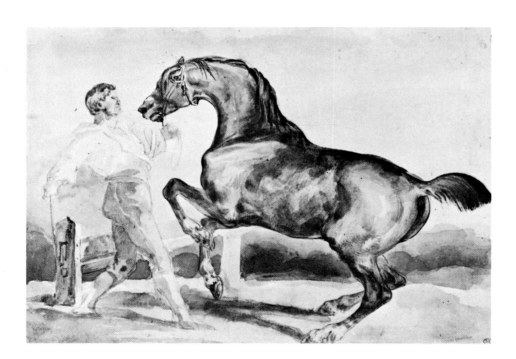

## Horses Battling
## in a Corral

Pencil, brown, blue, and black
washes on paper
8½ x 11⅝ in. (216 x 296 mm.)
Collections: Marquess of Hertford;
Sir Richard Wallace; Sir John Murray Scott;
E. Leggat; Dr. Guy Bellingham
Smith; The Cleveland Museum of Art
(Charles W. Harkness Fund).

A small sketch of this subject is in the Musée Bonnat, Bayonne (inv. 2037) and a painted version is in the E. Buehrle Collection, Zurich (exhibited in Winterthur in 1953, no. 47). Although related to the lithograph *Deux chevaux gris-pommelés se battant dans une écurie* of 1818 (Delteil 12), the wash drawing in Cleveland is of a conspicuously painterly execution. Beside it the lithograph seems rather sharply drawn and almost sculptural in effect. The subtlety of tone, lightness of contour, and the loose-knit composition of the drawing indicate the direction of Géricault's development after 1819. It is possible that he made the drawing some time after the lithograph, perhaps in 1820, deliberately recasting the subject in a new style.

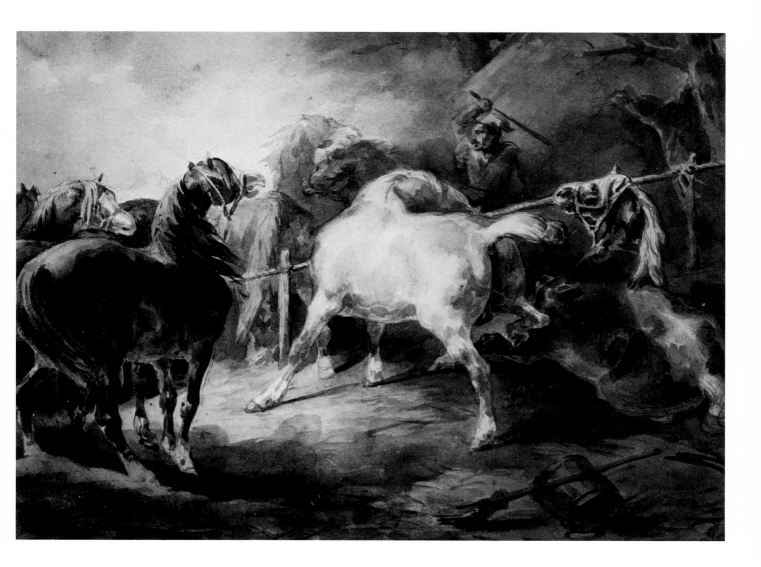

*Sketchbook Page:
Munitions Cart Drawn
by Two Horses*

Pencil and blue-grey washes on paper
8¾ x 11⅜ in. (222 x 289 mm.)
Collections: Ary Scheffer (sale, 1859);
A. Hulot (1892); Baron Vitta;
The Art Institute of Chicago
(Tiffany and Margaret Blake Bequest).

This page is folio 4 recto of the Chicago Album which combines fragments from two sketchbooks. One of the fragments dates from about 1813-1814 (see nos. 13 and 14 of this catalog), the other (which includes this page) from the time of Géricault's early series of lithographs, 1818-1819. The sketch of a munitions cart occurs among preparatory drawings for the lithograph *Caisson d'artillerie* of 1818 (Delteil 14), but it is more closely related in theme to the somewhat later lithograph *Artillerie à cheval changeant de position* (1819, Delteil 16). The subject recurs in various forms in Géricault's work of that time. Its grandest expression is the *Artillery Train Passing a Ravine* in Munich, of which there exists a variant (copy?) in the Museum of Johannesburg, South Africa.

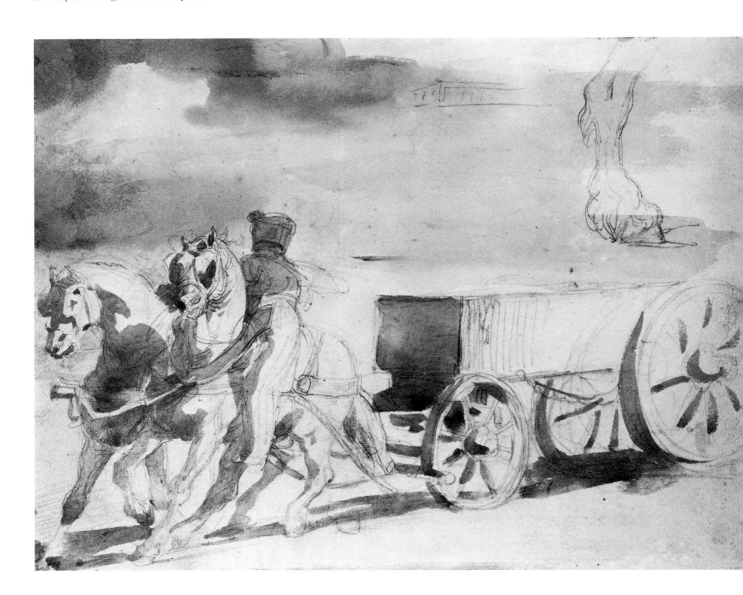

**67**

*Sketchbook Page:*
*Seven Sketches of Pairs of*
*Boxers and Wrestlers*

Pencil, pen and ink on paper
8⅞ x 11⅜ in. (225 x 289 mm.)
Collections: Ary Scheffer (sale, 1859);
A. Hulot (sale, 1892); Baron Vitta;
The Art Institute of Chicago
(Tiffany and Margaret Blake Bequest).

This, like the foregoing, is a page from the Chicago Album — folio 14 recto — part of the remains of a sketchbook which Géricault used in 1818-1819. The sketches on this page are action studies of a boxing and, possibly, a wrestling match. Géricault had occasion to witness boxing bouts in the studio of his neighbor and friend, the painter Horace Vernet. A painting by Vernet of that period shows the interior of his studio filled with a crowd of admirers and friends,

two of them — Montfort and Lehoux, also disciples of Géricault — stripped to the waist, wearing gloves, and ready for a match (cf. the account of this picture in Clément, p. 62 ff.). Following his characteristic procedure, Géricault has recorded the action in a succession of phases. The sketch at the lower left corresponds roughly to the composition which he adopted for his lithograph *Les boxeurs* of 1818 (Delteil 10).

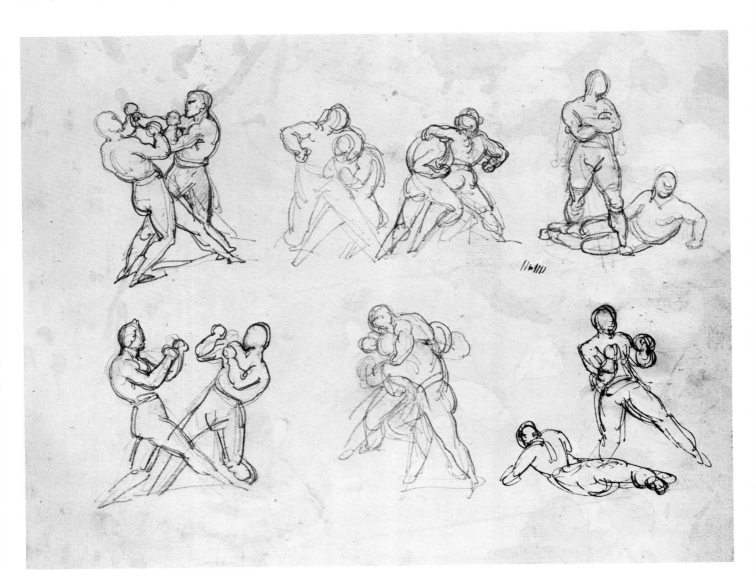

*General Letellier
After His Suicide*

Pencil on paper
5¾ x 8⅝ in. (146 x 219 mm.)
Collections: Bro de Comères;
Denise Aimé-Azam, Paris.

General Letellier committed suicide after the death of his wife. Géricault was with his friend Bro de Comères when the latter discovered the General's body (on July 9, 1819) lying in his bed with his head wrapped in a shawl which had belonged to his wife, with the pistol, still hot, nestled in the bed covers (Bro de Comères, *Mémoires,* Paris, 1914, p. 175 ff.). Géricault made his drawing on the spot and later based a painting on it (G. Renand Coll., Paris; Clément, Peintures, 128). It is entirely characteristic of him that the shock of this sudden tragedy should have moved him to draw a portrait of such quiet objectivity and subtle execution. Strong emotion sharpened rather than distorted Géricault's vision. His "romanticism" had the clarity of immediate and intense experience; it excluded sentimental embroidery (see also nos. 90, 91, and 123-125 of this catalog).

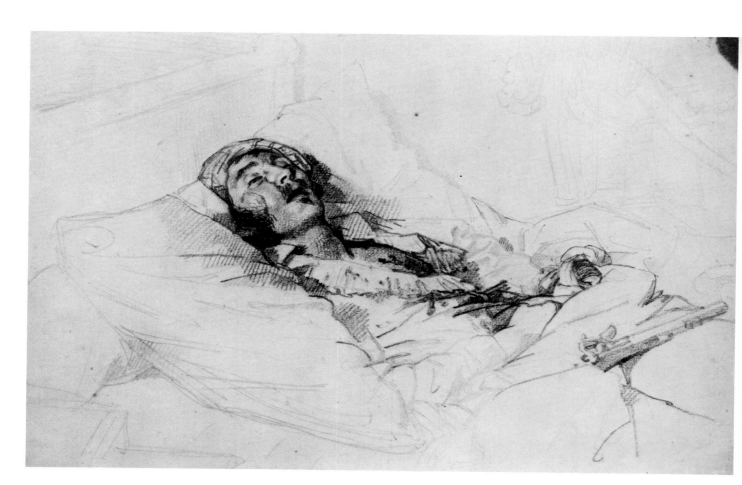

*Sketch of*
*a Reclining Woman*

Pen and ink on paper
5⅛ x 6⁵⁄₁₆ in. (130 x 135 mm.)
Collection: Claude Aubry, Paris.

This small drawing, dating most probably
from about 1817-1819, exemplifies the
extraordinary power of expression in Géri-
cault's graphic "handwriting" which here
transforms a casual observation into an
image of tragic intensity.

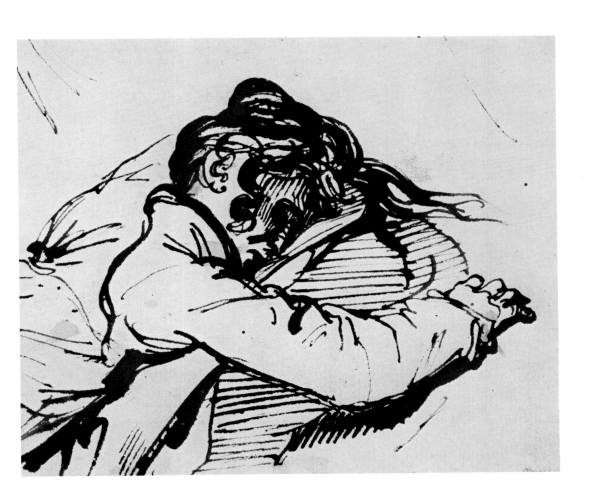

*Self-portrait*

Pen and ink on paper
8 x 5¾ in. (203 x 147 mm.)
Collections: E. Martin, London;
Frances S. Jowell, Toronto.

This drawing until fairly recently (ca. 1970) formed part of a larger sheet which contained still another, smaller self-portrait and a sketch for the head of the "Father," one of the figures in *The Raft of the Medusa* (see no. 83 of this catalog). It shows Géricault wearing a kerchief topped by a small Greek cap, evidently a favorite headgear since several known portraits (Clément, p. 422) show him wearing it. The self-portrait is datable in 1818-1819; it shows Géricault as he appeared at the time of his work on *The Raft of the Medusa.*

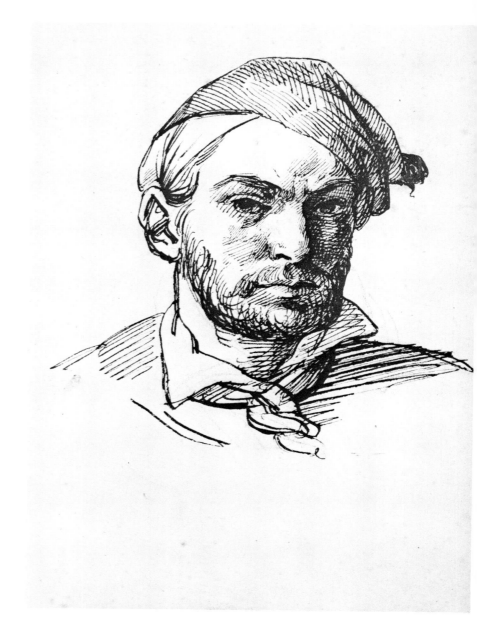

*Portrait of
a Young Woman*

Oil on canvas
19¹¹⁄₁₆ x 16¹⁵⁄₁₆ in. (500 x 430 mm.)
Collection: Musée Calvet
(cat. 193), Avignon.

Of unusually free and evidently rapid exe-
cution, this portrait of an unknown young
woman is difficult to date on the basis of
its style alone. It has affinities with
Géricault's early work, particularly in the
spirited looseness and speed of its brush
strokes, but the accomplished ease and am-
plitude of its presentation suggest a later
date, possibly 1817-1818.

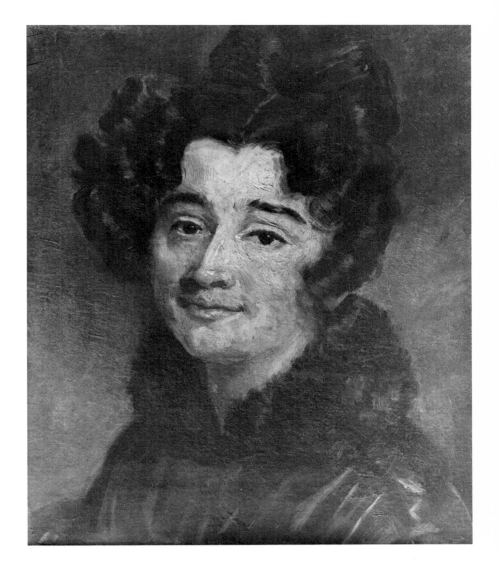

## Portrait of a Boy

Oil on canvas
19⅛ x 15³⁄₁₆ in. (486 x 390 mm.)
Collections: P. Boucher;
Musée de Tessé, Le Mans.

The boy bears a certain resemblance to known portraits of the son of Bro de Comères, Géricault's tenant and neighbor in the Rue des Martyrs (cf. *Bro de Comères Astride a Bulldog,* Clément, Peintures, 126; formerly in the Duc de Trévise Coll.). The probable date of the portrait in Le Mans is 1817-1819.

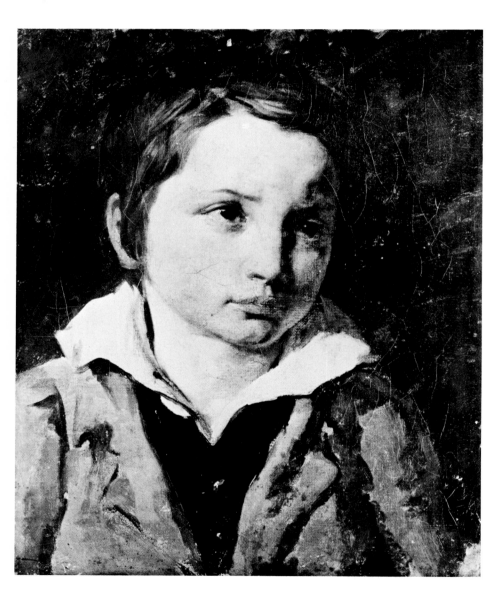

## Portrait of a Man

Oil on canvas
16¼ x 12¾ in. (412 x 323 mm.)
Collections: anonymous sale,
Hôtel Drouot, Paris, March 9, 1867;
Moreau-Nelaton (sale, 1900);
Richard Goetz (sale, 1922); Duc de Trévise; Robert Lebel, Paris.

Its stylistic affinities with portrait studies related to *The Raft of the Medusa* suggest that this powerful portrait was painted about 1818-1819. Clément described it as a "head of a soldier." The subject has not been identified.

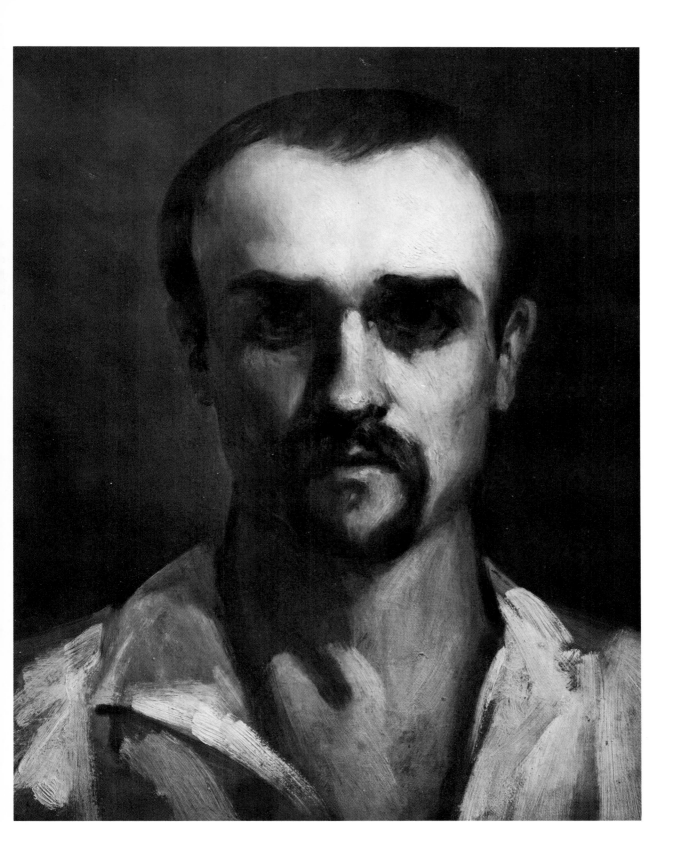

## The Rescue of the Survivors of the Raft of the Medusa

Pen and ink on paper
8¼ x 11⅜ in. (209 x 289 mm.)
Collections: Courtin; Pierre Dubaut;
private collection, Paris.

Géricault decided sometime in the spring of 1818 to treat the shipwreck of the Medusa in a painting of monumental scale. The Medusa, a French government frigate, had foundered off the Senegal coast in July of 1816. Since her lifeboats were insufficient, 150 passengers and crew members were put on a makeshift raft to be towed to the nearby shore. But the captain and the officers in their haste to reach land abandoned the raft and let it drift. For thirteen days it floated helplessly while the men on it fought for food and space. Mutinies and battles steadily reduced the number of the shipwrecked. After a few days without food cannibalism was practiced by all the survivors. When a rescue ship finally sighted the raft on the thirteenth day, only fifteen men of its crew were found to be still alive. In planning his picture Géricault faced the initial problem of selecting a particular episode of the disaster as his subject. He wavered in choosing from the mutiny on the raft, the outbreak of cannibalism, the sighting of the rescue vessel, and the actual rescue. This drawing, one of the earliest for the project, represents the ultimate rescue. In visualizing the scene Géricault remembered Michelangelo's cartoon of the *Pisan Battle*. The nude sailor who is about to climb into the rowboat is taken from this source. Géricault had used this same figure motif earlier in composing his *Landscape with an Aqueduct* (see no. 31 of this catalog).

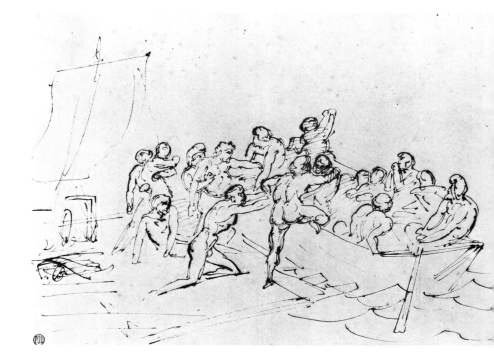

## The Mutiny
## on the Raft

Pen and ink, crayon, pencil on paper
16 x 23⅜ in. (406 x 593 mm.)
Collections: A. J. Lamme;
C. J. Fodor; Fodor Museum, Amsterdam
(stamp, Lugt 1036); Stedelijk Museum,
Amsterdam (Fodor Collection).

The mutiny on the raft strongly preoccupied Géricault in the early stages of his planning for his picture of *The Raft of the Medusa*. An eyewitness account by two of the survivors, Corréard and Savigny, had furnished him a detailed and vivid description of the mutiny. In the spring or early summer of 1818 he made several careful drawings of the *Mutiny* (others in the Rouen and Fogg Museums) and evidently toyed with the idea of adopting this composition for execution in a large format. In addition to the actual description of the battles on the raft, he was guided in the development of this composition by various artistic models. The spill of tumbling bodies from the raft's stern recalls, in general effect, the Bark of the Damned in Michelangelo's *Last Judgment*. But the immediate source on which Géricault drew was Rubens' *Fall of the Rebel Angels* (Munich), known to him through an engraving of which he drew several copies.

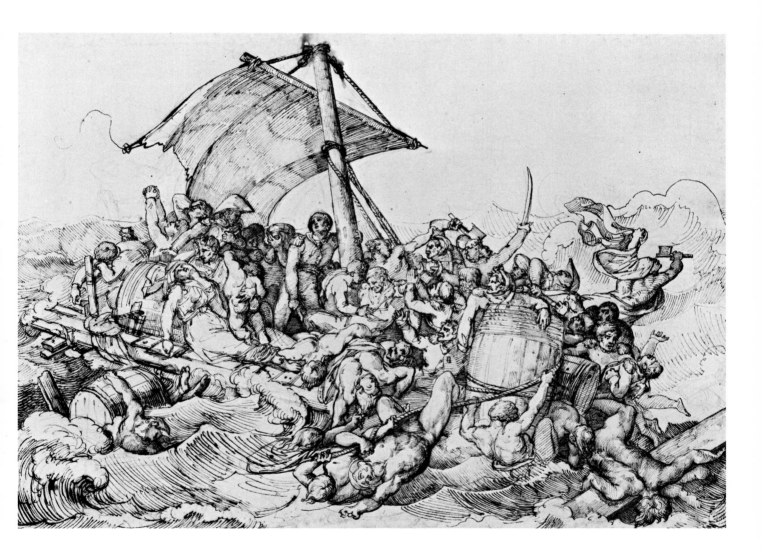

*Fall of the Rebel
Angels (After Rubens)*

Pencil on paper
8¹⁄₁₆ x 9¹⁄₁₆ in. (205 x 232 mm.)
Collections: E. Devéria;
Stanford Museum, Stanford,
California (inv. 67.50).

A partial copy after the engraving by Jonas Suyderhoef of Rubens' so-called *Little Last Judgment* (Munich), this drawing is one of several made by Géricault after the engraving. His intention was to adapt the tumbling bodies of Rubens' rebel angels to his own composition of the *Mutiny*. Several of the falling figures of mutinous sailors, at the lower right of that composition (see no. 75 of this catalog), echo figure motifs in Rubens' *Last Judgment* which Géricault knew only at second hand through the (reversed) engraved copy by Suyderhoef.

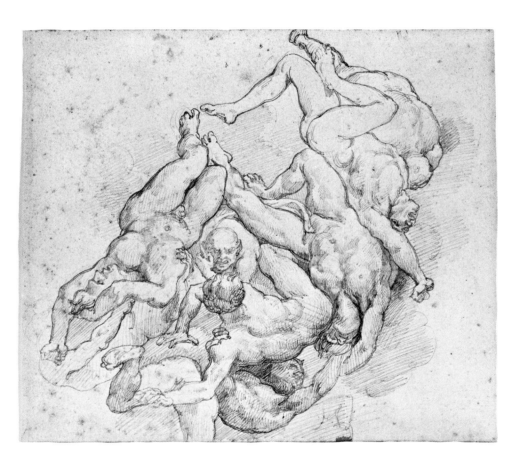

### The Survivors on the Raft Hailing an Approaching Rowboat

Pen and ink, sepia wash on paper
8⅛ x 10¼ in. (206 x 260 mm.)
Collections: Coutan-Hauguet (stamp,
Lugt 464); Musée des Beaux-Arts,
Rouen (cat. 1385; acquired in 1890).

Among the episodes in the story of the shipwreck of the Medusa which Géricault investigated in his search for a subject was the joyful reception of their rescuers by the survivors of the raft. This drawing only gives the right half of the total composition (known only through an old reproduction of a drawing now lost, cf. *L'Arte*, IV, 1876, p. 294) which included, at the left, a rowboat bearing the rescuers. Géricault also painted an oil study of this episode (destroyed in 1944; cf. Clément, *Peintures*, 101). Among his early, experimental versions of *The Raft of the Medusa*, the hailing of the approaching rescuers comes closest to the episode Géricault finally adopted. The Rouen drawing exemplifies the vigorous pen-and-wash technique which Géricault used to determine the distribution of the main areas of shadow and light. He was aided in this determination, as Clément records, by a scale model of the raft on which he placed figures modeled in wax.

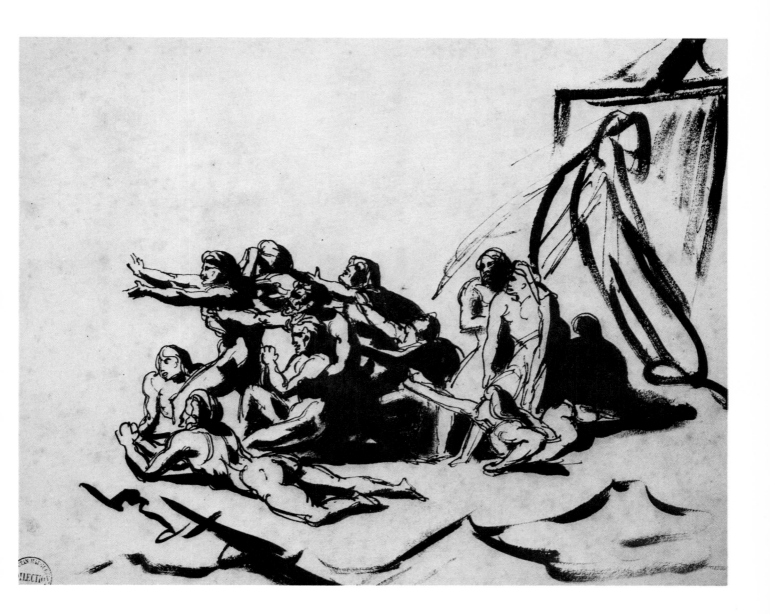

*The Sighting of the
Rescue Ship*

Pen and ink on paper
13¾ x 16⅛ in. (349 x 410 mm.)
Collections: Jules Boilly
(sale, 1869); Musée des Beaux-
Arts, Lille (inv. 1391).

The episode which Géricault finally chose as the subject for his painting was suggested to him by the following passage from the account of the raft's voyage by two survivors, Corréard and Savigny *(Naufrage de la frégate la Méduse,* Paris, 1817, p. 91 ff.): "On the 17th (of July 1816) in the morning, the sun appeared entirely free from clouds...when a captain of infantry, looking towards the horizon, descried a ship, and announced it to us by an exclamation of joy: we perceived that it was a brig; but it was at a very great distance; we could distinguish only the tops of the masts. The sight of this vessel excited in us a transport of joy...yet fear mingled with our hopes: we straightened some hoops of casks, to the end of which we tied handkerchiefs of different colors. A man, assisted by us all together, mounted to the top of the mast and waved these little flags. For about half an hour we were suspended between hope and fear...(then) the brig disappeared. From the delirium of joy, we fell into profound despondency and grief; we envied the fate of those whom we had seen perish at our side." The pen drawing in Lille presents the composition in a state of fairly advanced development. In the grouping and strong leftward orientation of its figures, it recalls the scene of the hailing of an approaching rowboat which Géricault had treated earlier. The sheet bears an erased and illegible inscription at its upper left in a handwriting which does not appear to be that of Géricault.

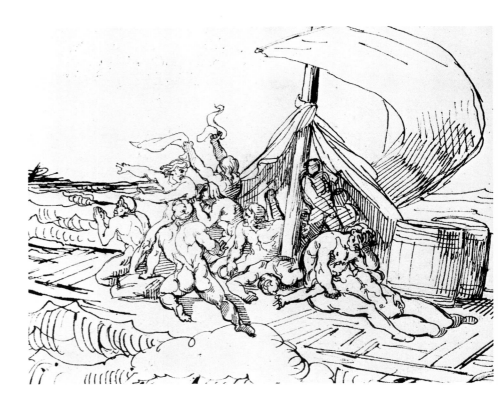

## The Sighting of the Rescue Ship

Pen and ink, sepia wash on paper
8⅛ x 11¼ in. (206 x 286 mm.)
Collections: Coutan-Hauguet
(stamp Lugt 464); Musée
des Beaux-Arts, Rouen (cat. 1385).

The drawing contributes three important innovations; it reverses the direction of the composition; it organizes the figures into distinct groups; and it determines the illumination of the scene. In all these respects it foreshadows the final composition of *The Raft of the Medusa*. But the scene still lacks several figures which will appear prominently in the picture. The space which will be occupied by the signaling black sailor and his helpers is still void.

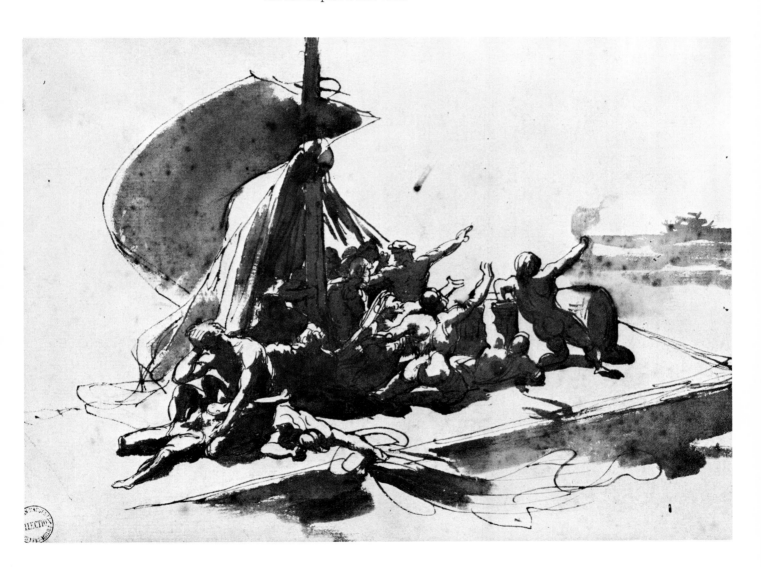

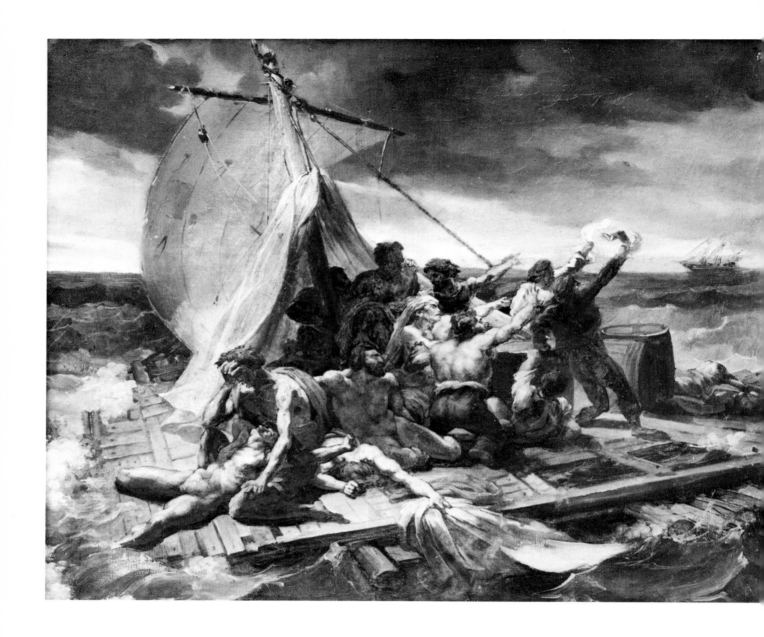

## 80

### *The Raft of the Medusa*

Oil on canvas
14¾ x 18⅛ in. (375 x 463 mm.)
Collections: Baron Schickler, Paris;
Musée du Louvre (RF 2229), Paris.

In this earlier of two preserved painted studies for the final version of the picture, the composition is still far from complete. The figures are grouped along a line which begins at the lower left in clusters of dead, dying, or despondent men and rises toward the right with the men who struggle to their feet and point or signal to the rescue vessel in the far distance. But these gesticulating figures give only a weak termination to the upward thrust of the composition. They add little to the drama of the scene and are not prominent enough to form its visual climax. The long horizon still weighs heavily on the raft although Géricault in the course of painting this study lowered its line somewhat, causing the extended arms of the figures at the raft's forward edge to be silhouetted against the sky. It was only some time after he had completed this oil study that Géricault invented the group of men who support a black sailor standing high atop a barrel, his powerful torso and the cloth which flutters from his raised hand projected against the clouds. In the final picture this group is dominant. Without it the dramatic and formal structure of *The Raft of the Medusa* would be incomplete; yet it was not in his mind when he painted this oil study, and it came into being only in the subsequent, final stage of the compositional process.

## 81

### *The Raft of the Medusa*

Pen and ink, sepia wash on paper
7⅞ x 10⅝ in. (200 x 270 mm.)
Collections: Walferdin (sale, 1880); Claude Aubry, Paris.

This drawing is the earliest known of those which include the important figure of the black sailor who, mounted on a barrel, signals to the distant rescue vessel with a piece of cloth. The pyramid of rising figures now has received its apex, and the composition its expressive climax. On the verso of the sheet is a study in ink, sepia wash, and white gouache for the figure of a man reaching forward with his left arm.

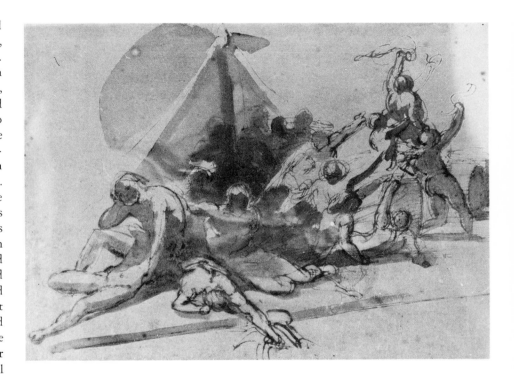

*Studies of a
Reclining Male Nude;
a Seated Figure*

Pen and ink on paper
9½ x 13½ in. (241 x 343 mm.)
Collections: E. Martin, London;
Frances S. Jowell, Toronto.

Datable on stylistic grounds in about 1818-1819, these life studies are loosely related to the preparatory work for *The Raft of the Medusa* although the poses do not exactly correspond to those of any of the figures in that composition. Eugène Delacroix, who evidently had this drawing in his possession sometime in the 1820s, drew a copy of one of the reclining figures (now in the collection of Mrs. B. Diamonstein, New York). On the verso of the sheet are studies of two flayed cadavers, probably drawn in the dissecting room of the Beaujon Hospital which Géricault frequently visited during his work on the *Medusa* (cf. Clément, p. 130 and nos. 88-92 of this catalog).

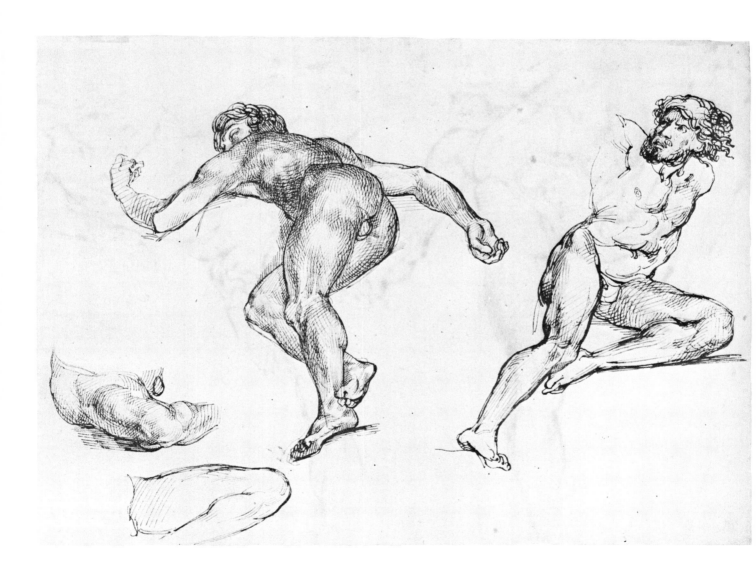

*Study of the "Father"
for the Raft
of the Medusa*

Pencil, pen and ink on paper
9⅞ x 11⅞ in. (251 x 302 mm.)
Collections: Camille Marcille
(sale, 1876); Musée des
Beaux-Arts, Lille (inv. 1393).

This is a study for the figure, in the left foreground of *The Raft of the Medusa,* of a bearded man grieving over the body of a youth. The group is usually referred to as the "father mourning his dead son" although such identification has no basis in the historical narrative of the raft's voyage. Like all the figures in the composition, this had a long and complex development. The pen drawing in Lille shows the "Father's" head in profile, as do all the early versions of the figure. The separate pencil drawing of the head, at the upper left of the sheet, corresponds to the later versions in which the "Father's" head is turned nearly to a full-face view. At the lower right is a list of names, probably of models. On the verso is a pen study for the figure of the "Son," related to the fairly early versions of the composition. The drawings are datable in 1818.

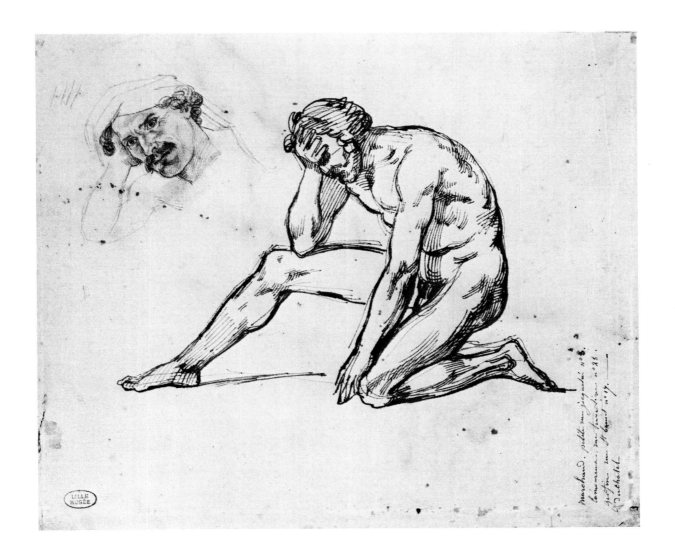

*Study of a Kneeling
Man Reaching Forward
with Both Arms*

Pen and ink on paper
7¾ x 10½ in. (197 x 267 mm.)
Collections: E. Martin, London;
Frances S. Jowell, Toronto.

This drawing is a fairly early study for the figure of the kneeling man who forms part of the group of straining and rising figures in the foreground of *The Raft of the Medusa* (cf. the compositional studies in Lille, Rouen, and at the Louvre, nos. 78-80 of this catalog). On the verso of this sheet are sketches in pen of a male head, of an officer standing before some horsemen, and of riders on rearing horses. The drawing is datable in 1818.

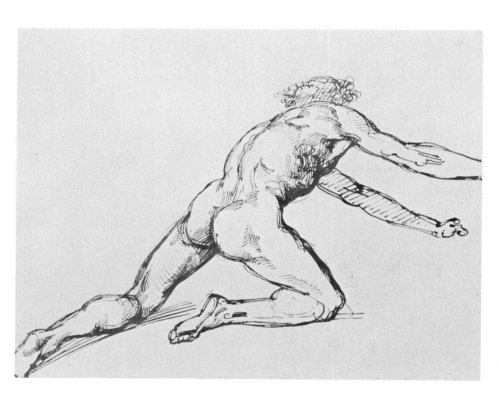

*Study for the Body
of a Dead Youth*

Oil on canvas
25½ x 32 in. (647 x 812 mm.)
Collection: Musée de Peinture,
Alençon (inv. 87;
purchased in 1860).

The figure is a reversal of one of the late versions of the dead "Son" (cf. no. 83 of this catalog) in *The Raft*. Although a suggestion of rocky shore, sea, and sky gives it the appearance of a complete picture in its own right, this is certainly a study. It very likely served for the cadaver at the extreme left of *The Raft of the Medusa*. One of the very last additions to the composition, it was made when the rest of the picture was finished (cf. Clément, p. 126 and 144, mentions Géricault's last-minute improvisation of the cadaver at the lower right of the composition; but it is clear from the evidence of all the preliminary compositional studies that the cadaver at the left was added at the same time). In his hurry Géricault evidently used the expedient of reversing one of the figures he had already fully developed in order to obtain this new motif. The very broadly executed study in Alençon probably served as an aid in this process.

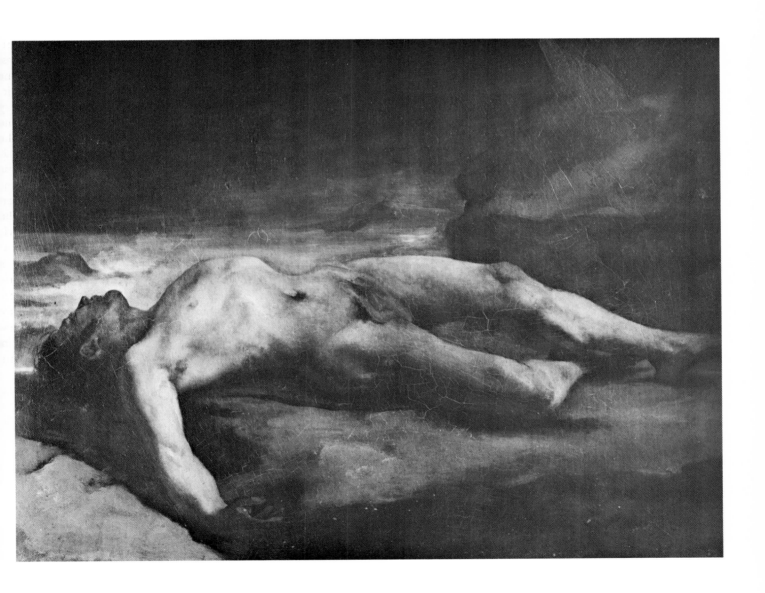

*Study of a Nude Man
Lying on His Back*

Black chalk on paper
11⅜ x 8⅙ in. (289 x 205 mm.)
Collections: J. Gigoux (stamp,
Lugt 1164); Musée des Beaux-Arts,
Besançon (inv. D-2153).

A study for the shrouded cadaver which
trails from the raft at the lower right of the
composition, this is one of the two figures
which Géricault inserted into his already
finished painting just before its exhibition
(see the previous entry; cf. Clément, p. 126
and 144). Another sketch for this figure is
in the collection of G. Delestre, Paris. On
the verso is a faint drawing of the group of
"Father and Son" (cf. no. 83 of this catalog).

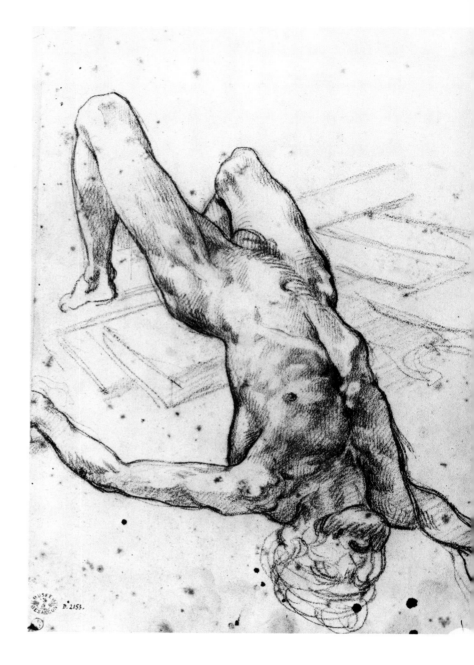

**87**

*Study of a Nude Man
Lying on His Back*

Black chalk on paper
7⅞ x 10 1/16 in. (197 x 256 mm.)
Collections: J. Gigoux (stamp,
Lugt 1164); Musée des Beaux-Arts,
Besançon (inv. D-2125;
acquired by bequest in 1894).

Another study for the cadaver at the lower right of the *Raft,* it is somewhat closer than the foregoing to the form which Géricault finally adopted. On the verso are studies for the head of the young man who lies on his face in the center of the composition, immediately to the right of the group of "Father and Son."

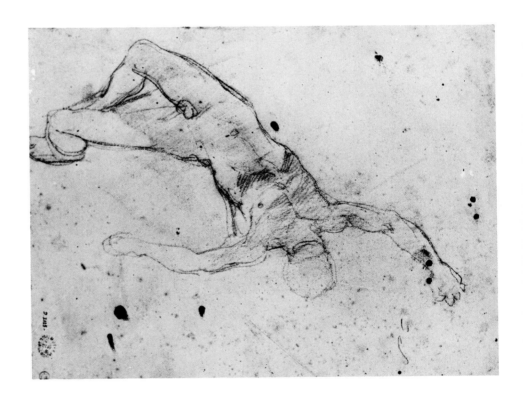

*Four Studies of
the Severed Head
of a Man*

Pencil on paper
8¼ x 10⅞ in. (209 x 276 mm.)
Collections: J. Gigoux (stamp,
Lugt 1164); Musée des Beaux-Arts,
Besançon (inv. D-2157;
acquired in 1894).

While at work on the *Medusa* Géricault drew and painted a number of studies of severed heads and dissected limbs furnished him by medical friends on the staff of the near-by Beaujon Hospital. "For several months, his studio was a kind of morgue. He kept cadavers there until they were half-decomposed, and insisted on working in this charnel house atmosphere, the infection of which only his most devoted friends and the most intrepid models were bold enough to risk..." (Clément, p. 131). These macabre studies did not directly serve for his picture; all the figures of the *Medusa* were painted after living models. Géricault, it seems, needed to be close to the horrible reality of his subject. By liv-ing intimately with death he was able share something of the experience of t men on the raft whose suffering he was tr ing to express. The head in this study (a in nos. 89 and 90) was that of a thief; Gé cault had obtained it from Bicêtre, an ins tution which was at once a home for t aged, a prison, and an insane asylum. A cording to Clément (p. 131) he kept th head on the roof of his studio in the R des Martyrs for fifteen days. He drew a painted many studies of it during this tim It is possible that he made use of the studies in improvising the head of the c daver at the extreme left of *The Raft of t Medusa.*

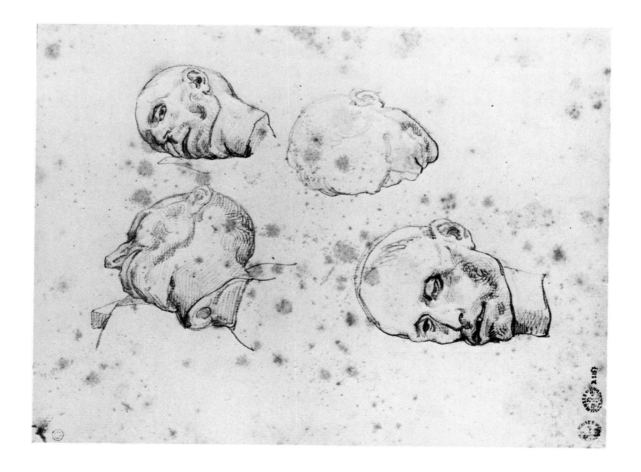

**89**

*Four Studies of
the Severed Head
of a Man*

These studies are of the same head as in the
previous drawing.

Black chalk on paper
8¼ x 11 in. (209 x 279 mm.)
Collections: Maherault (sale, 1880);
General Mellinet (sale, 1906); Pierre Dubaut;
private collection, Paris.

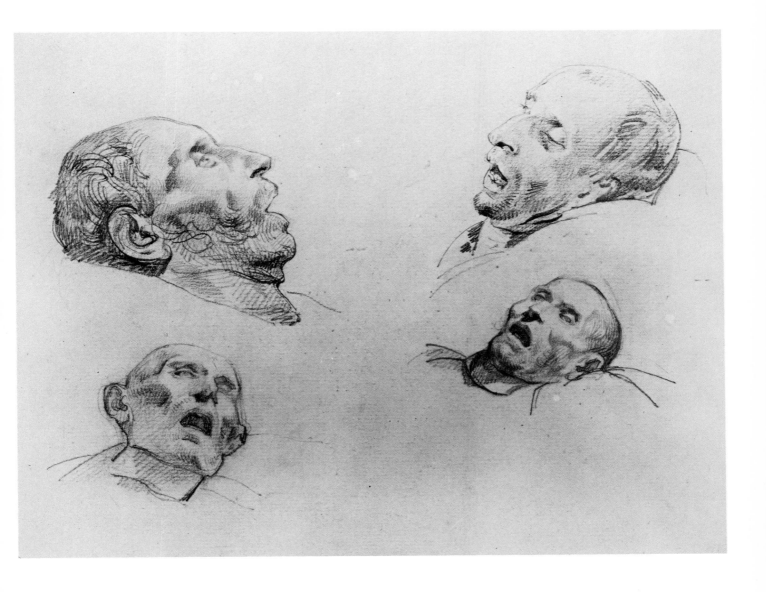

*Study of
the Severed Head
of a Man*

Oil on impregnated paper,
mounted on a wooden panel
16⅛ x 14¹⁵⁄₁₆ in. (410 x 380 mm.)
Collections: Auguste Boulard;
Duc de Trévise; Pierre Dubaut;
private collection, Paris.

The head which also figured in the two preceding drawings is of the thief who died at Bicêtre. It is in the same position as the head at the upper left in the drawing in Besançon (see no. 88 of this catalog). The same head also appears in the larger oil study of the *Severed Heads of a Man and a Woman* in the National Museum in Stockholm (inv. 2113). In these studies Géricault's realism reaches its most daring extreme. They show no trace of conventional stylization, no attempt to soften the grimness of their subject matter; but they are also quite free of romantic graveyard horror. There can be little doubt, on the other hand, that an element of aesthetic pleasure in the cadaverous entered into Géricault's preoccupation with these subjects. It was at this time that he painted the portrait of his friend Théodore Lebrun whom he had found suffering from a case of jaundice (Clément, p. 132). "How beautiful you are!" he exclaimed, according to Lebrun who adds, "I did seem beautiful to this painter who was searching everywhere for the color of the dying."

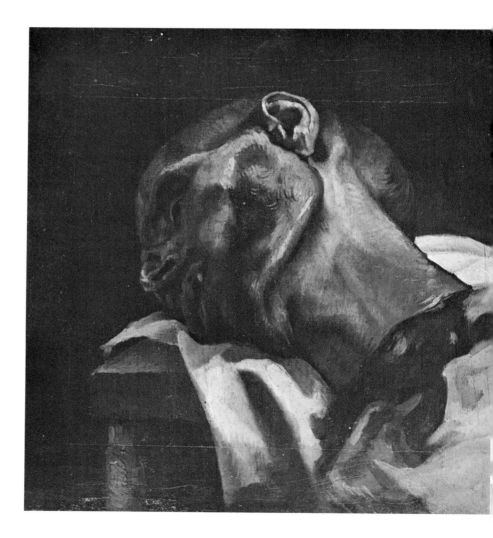

*Study of
Two Severed Legs
and an Arm*

Oil on canvas
21 x 25¼ in. (533 x 641 mm.)
Collections: J. Claye; Duc
de Trévise; Robert Lebel, Paris.

Géricault painted several still-life studies of an arrangement consisting of two legs, severed above the knee, placed crosswise one upon the other, and covered by an arm cut off at the collar bone. Clément included two such studies in his catalog (Peintures, 107 and 108). One of these (108), then in the collection of Lehoux, is almost certainly identical with a study now in the Louvre (RF 579-a). Two other extant studies claim to be the second picture catalogued by Clément (107), namely, the one he saw in the collection of J. Claye. The point is difficult to decide. One of the extant studies, now in the Museum of Montepellier, corresponds fully to Clément's description and can be traced with certainty to the Claye Collection. The other, the one included in this exhibition, also fits the description given by Clément and is believed to have come from the Claye Collection. It is, in any case, worthy of Géricault, and its style and manner of execution support its attribution to him. He probably painted more studies of this kind than are now known. The catalog of the posthumous sale of his studio lists a lot of ten studies of *"diverses parties du corps humain;"* these very likely were the pictures of dissected cadavers — the unusually low price realized by them would seem to support this assumption. Like the severed heads (no. 90 of this catalog), the dissected limbs are shown sharply illuminated against a surrounding dark. Their effect is strongly sculptural. Delacroix who knew one of these studies thought it "truly sublime."

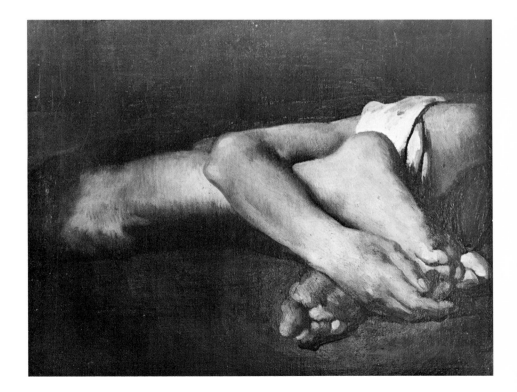

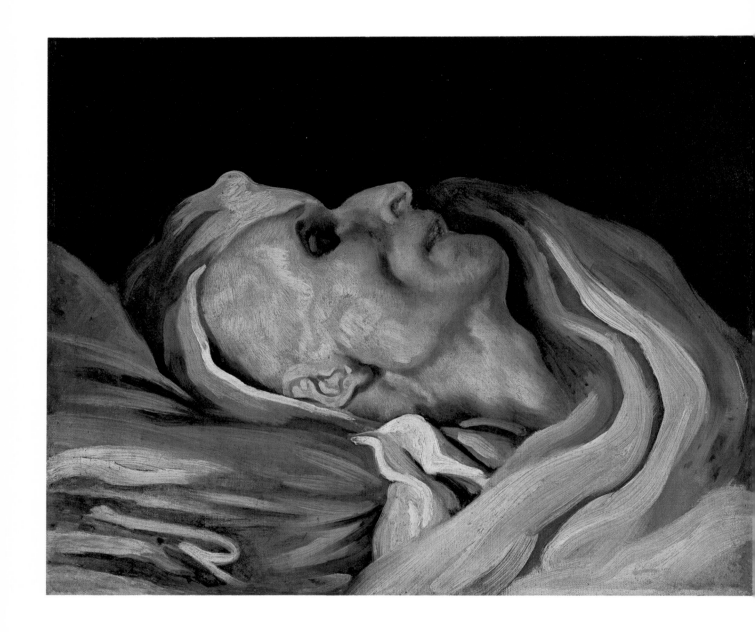

*After Death
(Study of the Head
of a Corpse)*

---

Oil on canvas
17¾ x 22 in. (451 x 559 mm.)
Collections: Champmartin (sale, 1884);
Foinard (sale, 1914); R. Goetz,
Paris (sale, 1922); A. A. Munger;
The Art Institute of Chicago.

This study once belonged to the painter Charles Emile Champmartin (1797-1883) who occasionally accompanied Géricault to the dissecting rooms of the hospitals and there painted side by side with him (Clément, p. 305). Clément reports that during the months of his work on *The Raft of the Medusa* (spring 1818–summer 1819) Géricault made study visits to the hospitals where "he found models who did not have to grimace to show every nuance of physical or mental suffering, the ravages of sickness, and the terror of death" (p. 130-131). Like the studies of severed heads and dissected limbs which it resembles in style and technique, this study did not serve any immediate, practical purpose in the execution of *The Raft of the Medusa*. Drawings of similar subjects are in the Musée Bonnat, Bayonne (inv. 762) and in the Gobin Collection, Paris.

**93**

*Study of the Head
of a Young Man*

Oil on canvas
12¼ x 13 in. (311 x 330 mm.)
Collections: Mathey; Musée
des Beaux-Arts, Rouen (cat. 1365;
acquired in 1904).

This is a study for the head of the dead youth (the "Son," cf. no. 83 of this catalog) resting on the lap of an older, bearded man, in the left foreground of *The Raft of the Medusa.* The model was Géricault's pupil and assistant Louis Alexis Jamar (see no. 56) who lived with Géricault at the time of his work on the *Medusa* and who posed for several of its figures (cf. Clément, p. 143 and 300). Like several of the studies of severed heads and dissected limbs, this head was painted by the light of a lamp.

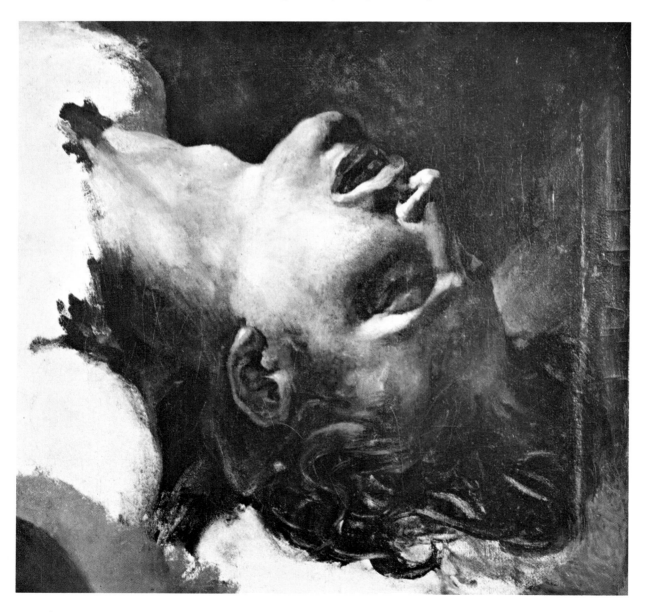

## Study for the Head of a Dead Man

Oil on impregnated paper,
mounted on canvas
18 x 15 in. (457 x 381 mm.)
Collections: H. Fantin-Latour;
Duc de Trévise; W. Miller;
Prince Alexander zu Hohenlohe
von Jagdsberg, Malaga.

More broadly executed than the foregoing
and probably not based on any particular
living model, this oil sketch appears also to
have served for the head of the "Son" in
the foreground of *The Raft of the Medusa*.

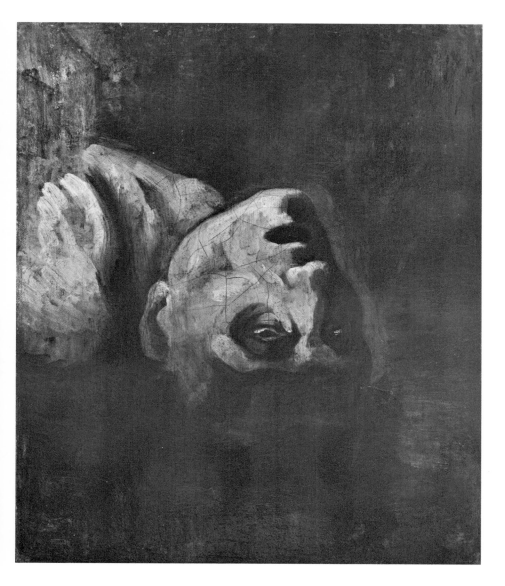

*A Hanging in London*

Pencil and ink washes on grey paper
15¾ x 12⅝ in. (400 x 321 mm.)
Collections: Lehoux (gift, 1882);
Musée des Beaux-Arts,
Rouen (cat. 1367).

Having arranged for a public exhibition of *The Raft of the Medusa* in London, Géricault sailed for England on April 10, 1820. He remained in Britain until the end of 1821. During these two years in England he busied himself with work of small scale, drew much, and painted little. Still not fully recovered from the fatigue and disappointment of the *Medusa,* he had given up for the time being all thought of grandiose subjects. Instead he devoted himself to the observation of English life and to lithographic work. "I work a lot in my room," he wrote to his friend Dedreux-Dorcy from London in February 1821, "and then roam the streets for relaxation. They are so full of constant movement and variety that you would never leave them, I am sure." Like many other observers from the continent, he was particularly impressed by the more sordid aspects of London, by the squalor of the poor, and the gloom of the slums. A note of sharp social observation is evident in his studies of English life, in contrast to his Italian genres in which this note is scarcely apparent. The main work of his English stay was a series of lithographs, *Various Subjects Drawn from Life and on Stone* (February-May 1821, Delteil 29-41), in which his interest in the social condition of men — and even the treatment of animals — is a pervasive theme. Sympathy with human suffering had occasionally played a role in his earlier work. But the suffering had been of the spectacular kind that is inflicted by war (as in the military lithographs of 1818-19) or by the elements (as in the *Medusa*), while the distress with which he dealt in his English lithographs

(the *Piper,* the *Paralytic Woman,* and *Pity the Sorrows of a Poor Old Man*) was a consequence of the normal social condition of poverty.

The *Public Hanging* is not related to any known lithograph or painting. The subject of an execution had occupied Géricault once before, in Rome, where he drew studies of a beheading in 1816-1817 (cf. the drawings in the Ecole des Beaux-Arts and the Frances S. Jowell Collection, Toronto, and the painted study recorded by Clément, *Peintures,* 92). The *Hanging* is very likely based on an eyewitness impression of an actual execution — perhaps that of the Cato Street conspirators — the most sensational to occur during Géricault's stay in London (May 1, 1820).

The sheet is inscribed, in the handwriting of Lehoux, who was a pupil of Géricault: *"Le Supplice"* (bottom left) and *"Géricault (Lhx) le No. 140. du catalogue de M. Clément."*

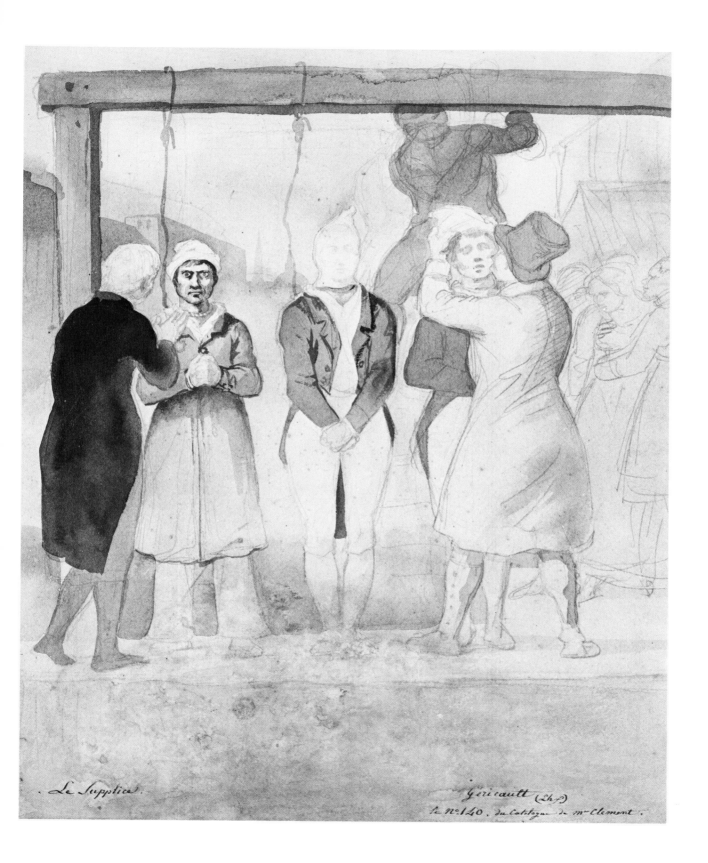

*Le Supplice.*

Géricault (Th.)
le n° 140 du Catalogue de M. Clement.

*London Sketches:*
*Lavender Seller,*
*Male Head,*
*Head of a Horse,*
*Two Hands*

Black chalk on paper
8 x 11¼ in. (203 x 286 mm.)
Collections: General de Brack;
Pierre Dubaut (stamp,
Lugt Suppl. 2103-B); Dr. Fritz Nathan
and Dr. Peter Nathan, Zurich.

A leaf taken from a sketchbook once owned by Géricault's friend General Brack, this drawing records casual observations made in London. A sketchbook sheet of similar character is in the Rhode Island School of Design, Providence (probably identical with Clément, Dessins, 157). On the verso is a study for the lithograph *The Piper* of 1821 (Delteil 39; related studies in Ecole des Beaux-Arts, 34945; former Trévise Coll.; Centenary, no. 151; Dijon Museum, 2093 verso).

## *English Horse Race*

Pencil on paper
7¹³⁄₁₆ x 10¹³⁄₁₆ in. (198 x 275 mm.)
Collections: Armand Valton (1908);
Ecole des Beaux-Arts
(inv. 995), Paris.

The most important single work of Géri-cault's English sojourn is the *Epsom Downs Derby* (Louvre) which he is said to have painted for his landlord, a Mr. Elmore, who was a horse trader. Around this large and highly finished canvas cluster several smaller painted studies (three of them in the Louvre, Clément, Peintures, 135-137, and one at the Musée Bonnat, Bayonne, inv. 80) as well as a number of drawings. Compared to the *Race of the Barberi Horses* (see nos. 39-46 of this catalog) these works of his English stay illustrate his renuncia-tion of monumental stylization and resolute espousal of a casual, realistic style, entirely oriented to visual impressions. They also show that Géricault was influenced by the traditions of the English sporting print and

horse race picture. They are taken from modern reality, either as direct observa-tions or as interpretations in a popular, vernacular mode.

Compared with the muscularity and vigor of his manner in the years of 1814-1819, the English drawings reveal a curious lessening of tension, a new lightness of touch, and at times a slightly tired elegance. The stroke is no less sure, but something of Géricault's former energy seems to be lack-ing. His pencil travels with speed, tracing thin, loose lines around the forms, linger-ing occasionally to accent a detail by a slight increase in pressure or to indicate shadow by feathery hatchings. Even in the pure pencil drawings there is a consider-able sense of light and color.

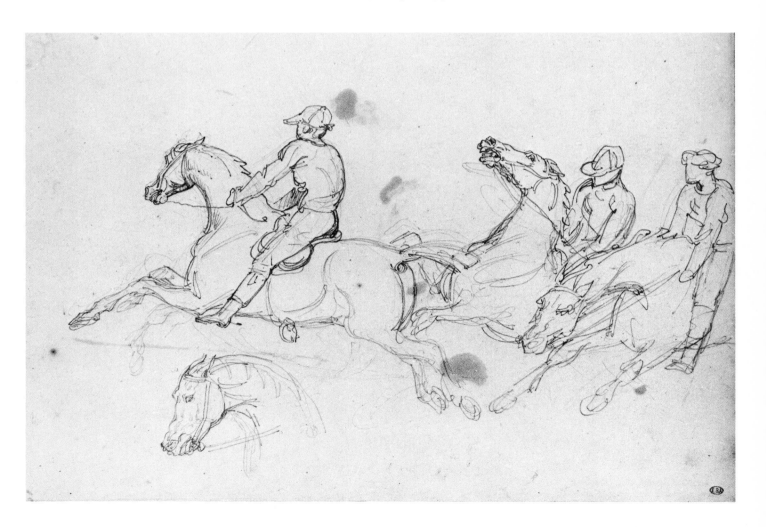

*Groom Leading
a Thoroughbred
("Pur Sang")*

Black chalk, watercolor,
and touches of white gouache on paper
9⅝ x 12⅛ in. (245 x 308 mm.)
Collections: His de La Salle
(gift 1878); Musée du Louvre
(RF 803), Paris.

The importance of watercolor in Géricault's English work (1820-1821) reflects the influence on him of the thriving British school of watercolor painting. Before his English voyage he had used broad touches of ink or sepia wash and, more rarely, of watercolor to establish areas of shadow or to heighten the solidity of figures. From 1820 onward he used washes and colors to suggest surface or atmosphere, applying his pigments with studied precision and refinement in carefully blended transparencies reinforced by accents of gouache in the lights and deepest shadows. The contrast with his earlier characteristic breadth of execution is very marked. The separate touches are set side by side, with the thinnest of brushes, in an almost Impressionist technique which sometimes give a slightly mottled effect to the surfaces and is capable of producing dazzling illusions — as in the glistening coat of the horse in the exhibited drawing.

The procedure which Géricault had formerly used in developing his compositions, namely, that of gradually shaping his design in a sequence of separate drawings, he now replaced with a more direct method in which the work of composition was no longer divorced from that of execution. The separate steps from first sketch to final completion were now blended in one continuous process which unfolded on the same sheet. The design grew in successive changes and additions; the washes and colors which in the end are applied over the drawing conceal the roughness of the original improvisation. A related study of a thoroughbred horse is in the Ecole des Beaux-Arts, 34935.

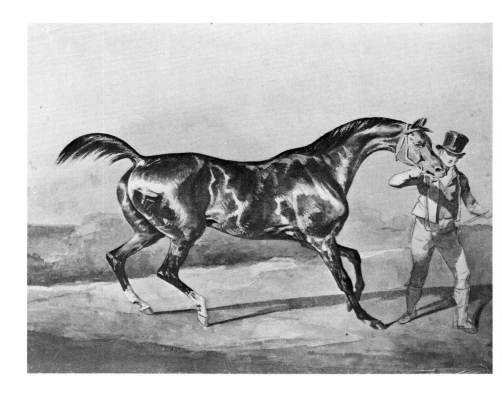

## Woman in a Riding Costume on a Dappled Grey Horse

Pencil and watercolor on paper
11 1/16 x 9 7/8 in. (282 x 251 mm.)
Collections: Gallimard; Koenigs; Museum
Boymans-van Beuningen, Rotterdam.

Géricault's English work is equally divided between "low" genres — beggars, work horses, grooms, and postilions — and elegant subjects. The latter are of marked conventionality in contrast to his popular genres; their silk-clad jockeys, "amazons," and gentlemen riders are stock types of the English tradition of sporting picture and horse portrait. The thoroughbred horse, fragile of limb and nervously alive, is invariably the center and hero of these compositions. It is worth recalling that Géricault had been initiated to the full range of sporting genre by his first teacher, Carle Vernet. By the time Géricault returned to this genre during his stay in England in 1820-1821, it had been thoroughly exploited by several generations of English and French practitioners. Thus, there is scarcely one among his compositions in this vein for which a close parallel cannot readily be found among the works of Carle Vernet or of the many English specialists.

Géricault's watercolors of his English stay and of the following years startle by the luminosity and intensity of their hues. In them more clearly than in any of his previous works, color assumes primary significance; it no longer supplements design but is as important as the design itself. Stimulated by the example of English painters, Géricault handled the pigments in his watercolors with a conscious relish, savoring the clean brightness of which this medium is capable. It seems as if after years of self-imposed restraint he were yielding to a strong innate bent. Some of his watercolors have a curiously over-intense, strident dazzle. In this respect Géricault occasionally departed from the English example. His colors, for all their vivid freshness and perhaps because of their very variety and strength, often suggest decorative choice rather than visual observation.

The subject of the exhibited drawing corresponds to that of an oil painting in the collection of Jean Stern (Clément, Peintures, 139). Related drawings are in the Musée Bonnat, Bayonne (inv. 2094-2097).

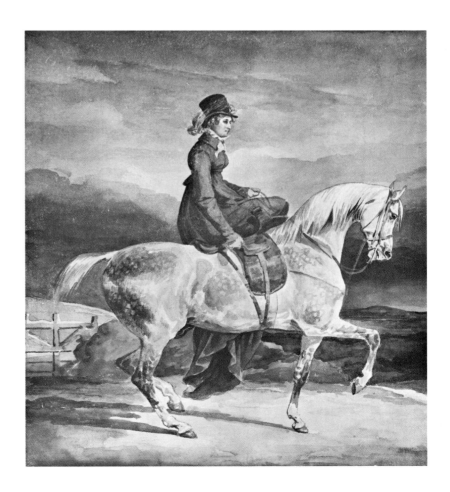

*Four Sketches of
an Oriental Horseman
Attacked by a Tiger*

Black chalk on grey paper
8⅝ x 11¹³⁄₁₆ in. (215 x 300 mm.)
Collections: Ch. Cousin; Musée
des Beaux-Arts, Lille (inv. 1397).

The subject of the exhibited drawing —
the verso of a study for the lithograph
*Mameluck défendant un trompette blessé*
of 1818 (Delteil 9) — is one which most
often occupied Géricault during and after
his English stay. Nonetheless, it probably
dates from 1818-1819, before his English
stay.

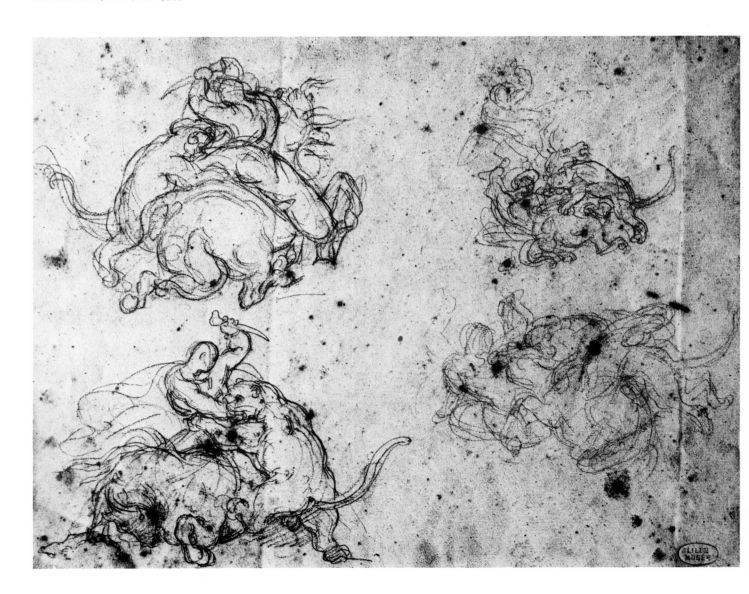

*Lion and Lioness*

Pencil, sepia wash and
watercolor on paper
5⅞ x 8⅞ in. (149 x 225 mm.)
Collections: Coutan; Hauguet;
Mme. Milliet (née Schubert;
gift, 1883); Musée
du Louvre (RF 1456), Paris.

Clément (p. 274) reports that during Géricault's stay in London (1820-1821) the artist made sketches at the animal houses of the zoo. Not all of his very numerous drawings and painted studies of lions, tigers, monkeys, swans, foxes, and cats can date from his English period, but the fact that many of them do is indicated by the frequent coincidences on one sheet of drawings for the English lithographs with drawings of animals. It is probable that the example of English painters, particularly of Stubbs and Ward, was a stimulus to him; he made tracings at the time after Stubbs' *Anatomy of the Horse* (Besançon Museum), and copied Stubbs' *Blenheim Tiger* (Aubry Coll.) and *White Horse Attacked by a Lion* (Louvre; cf. Clément, Peintures, 189). But his interest in dramatic animal compositions cannot be attributed to these external influences alone. He shared his fascinated admiration for beasts of prey with other French artists of his generation, notably with Delacroix and Barye. The struggle between animals, or between men and animals, is a theme which runs through all his work. It clearly was something more to him than a picturesque spectacle; the untamed animal seems to have embodied for him the very force and fatality of nature.

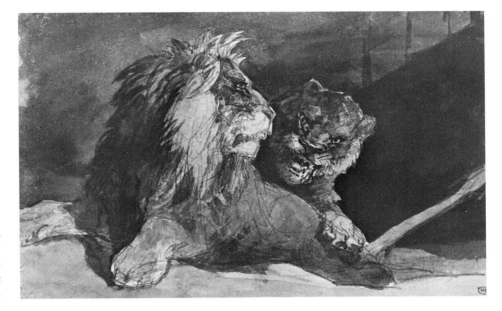

## Lion Attacking a White Horse

Black chalk with ink and
sepia washes on paper
8⅛ x 10¼ (206 x 260 mm.)
Collections: Mène; Henri Cain, Paris;
S. Meller, Budapest; H. Eisler,
Vienna (sale, 1929); F. Koenigs
(stamp, Lugt 1023a); Museum Boymans-
van Beuningen, Rotterdam.

This study for the lithograph *Horse Attacked by a Lion* (Delteil 42) probably dates from 1821 (cf. the related drawings in the Louvre, RF 26739, Clément, *Dessins,*

100; and Besançon, D-2139). The immediate inspiration for the composition may have been Stubbs' *White Horse Attacked by a Lion* of which Géricault painted a copy (Louvre, RF 1946-2; Clément, *Peintures* 189), but his first ideas for a subject of this kind are of a date considerably earlier than his English stay. A penciled entry in a sketchbook fragment of 1814 in the Art Institute of Chicago (see nos. 13 and 14 of this catalog) notes, as an idea for a painting, the episode of "Xerxes' Horses Being Attacked by Lions." It is likely that the motif was first suggested to Géricault by the lion hunts of Rubens.

On the verso are two sketches of the head of a horse, related to the drawing of a *Horse Attacked by a Lion* in the Louvre (RF 26739).

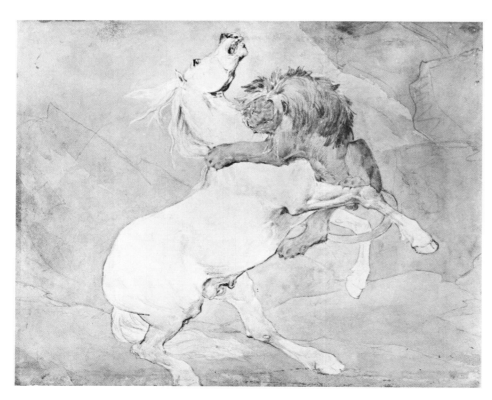

## Sketches of Horses

Pencil on paper
9¹¹⁄₁₆ x 14 (246 x 356 mm.)
Collections: H. S. Schaeffer
Galleries, New York (sold 1958);
Yale University Art Gallery
(acc. no. 1958.9.4a-b), New Haven.

The sketches are projects for lithographs, drawn most probably in England about 1821. Several of the subjects were later (1822-23) drawn on stone and published by Gihaut *frères* (Delteil 46-57 and 80-92). The dead horse at the upper left and the horse butcher's cart in the center of the sheet are early ideas for compositions which Géricault subsequently executed as paintings and lithographs (the dead horse, cf. the lithograph *Le cheval mort,* 1823, Delteil 77, an oil study in Bayonne, inv. 1040, and drawings in Besançon, inv. D-2129, 2155, 2159; the horse butcher's cart, cf. the lithograph *Chevaux conduits à l'écorcheur,* 1823, Delteil 65, and the watercolor drawing in the collection of Denise Aimé-Azam). These macabre horse genres go back to an English tradition which seems to have originated with the painter Thomas Gooch (1777-1802). Gooch and his imitators traced the *Life of the Race Horse* from birth, as he progressed to the day of glory on the turf, then declined through the ignominies of hard work and old age to the final horror of the horse butcher's cart; their sentimental biographies of the horse were clearly adaptations of the cyclical schemes used by Hogarth to trace the "Progress" of the Rake or the Whore. Géricault must have been familiar with this English specialty. His scenes of the carrion pit and horse-skinner's cart at any rate resemble Gooch's versions. The two inscribed drawings at the left are designs for title pages of a projected series of lithographs which

Géricault considered calling *"Ecole du dessin anatomique du cheval"* according to the one design, or *"Cours d'anatomie du cheval a l'usage des peintres et des amateurs"* according to the other. The very rough sketch, at the lower right, represents an Arab mourning his dead horse. A very similar, but more finished drawing of this subject, at the Ecole des Beaux-Arts (inv. 34946), is inscribed *"Anatomical studi* (sic) *of the Arabian Horse,"* indicating that this too is a frontispiece project most likely conceived in England (further drawings in the Ecole des Beaux-Arts, inv. 34947, and the Buehler Coll., Winterthur). It is not impossible that the idea of publishing a "course" in the anatomy of the horse was suggested to Géricault by George Stubbs' posthumous publication, the *Comparative Anatomical Exposition of the Structure of the Human Body with that of a Tiger and a Common Fowl* (1817), of which he may well have seen copies in England. Tracings by Géricault after plates in Stubbs' *Anatomy of the Horse* (1766) are in the Besançon Museum (inv. D-2141-2145), annotated studies of the equine anatomy in the Musée Bonnat, Bayonne (inv. 2109-2114), and the Ecole des Beaux-Arts (inv. 383).

On the verso is a sketch of a covered cart followed by two men, one of whom holds a placard. This is a preparatory design for the title sheet (*Un fourgeon attelé,* Delteil 29) of Géricault's great series of English lithographs *Various Subjects Drawn from Life and on Stone* of 1821.

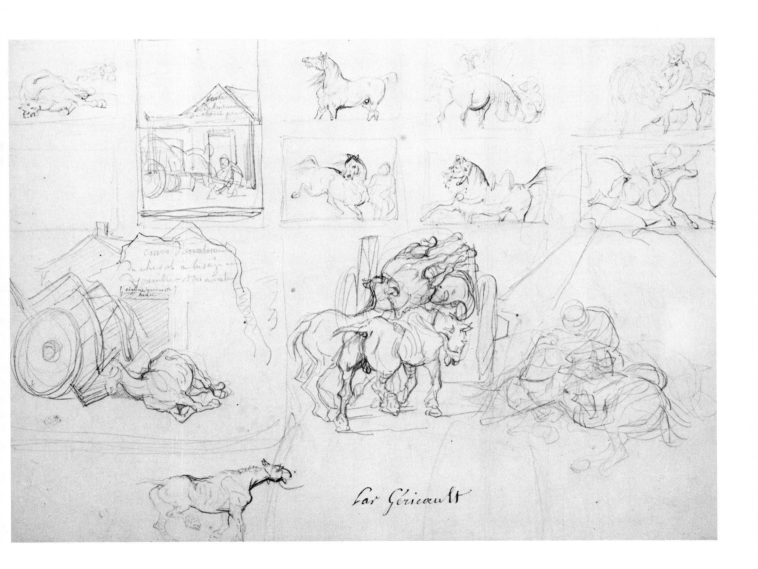

*A Beer Cart in an
Inn Yard ("Le Haquet")*

Oil on canvas
23½ x 28¾ in. (597 x 730 mm.)
Collections: Dr. Biète; Delessert (sale,
1911); Bernheim-Jeune; Mrs. O. Freund;
Mrs. R. Millman; P. Rosenberg & Co.,
New York; Museum of Art, Rhode Island
School of Design, Providence, (inv. 43-539).

The forms of the heavy draught horse particularly interested Géricault in his later years. This painting anticipates his studies of work horses in every-day settings, painted in England and after the English voyage, and culminating in the *Lime Kiln* (ca. 1822, Louvre). According to Clément, the *Beer Cart* was painted for Dr. Biète a short time before Géricault began work on the *Medusa,* or, early in 1818. The heavily *tenebrist* execution of parts of the picture, particularly of the cart itself and of the

deeply shaded farm yard behind it, confirms this dating. Dr. Biète was later to treat Géricault during his last illness in 1823, 1824.

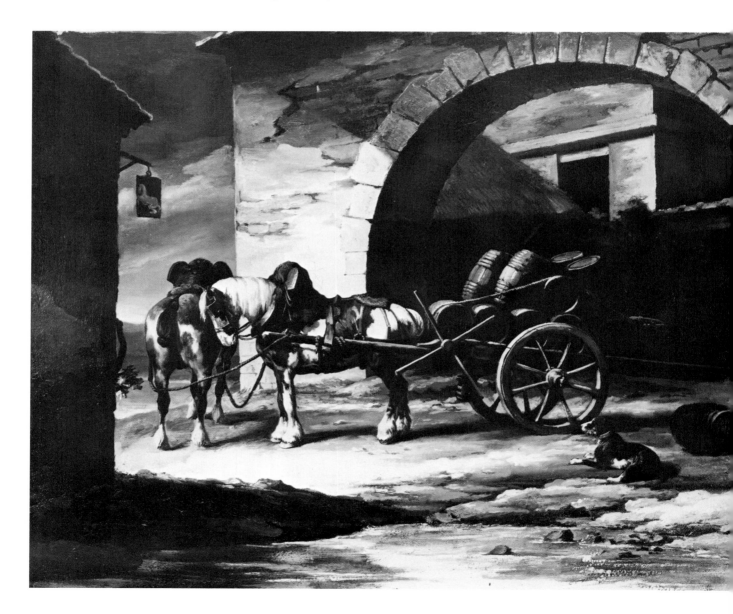

## *The Village Forge*

Oil on canvas
20 x 24⅛ in. (508 x 612 mm.)
Collections: Baron M. Schickler;
Count Hubert de Pourtalès;
F. Kleinberger & Co., New York;
Wadsworth Atheneum, Hartford
(purchased in 1948; Sumner Fund).

The composition is related to that of one of
Géricault's English lithographs, the *French
Farrier* of 1821 (Delteil 41), but this
painted version probably dates somewhat
later, very likely from 1822. Its careful exe-
cution and complex, restrained colorism are
characteristic of the painting of Géricault's
last years. The picture is signed "Géricault"
at the lower left.

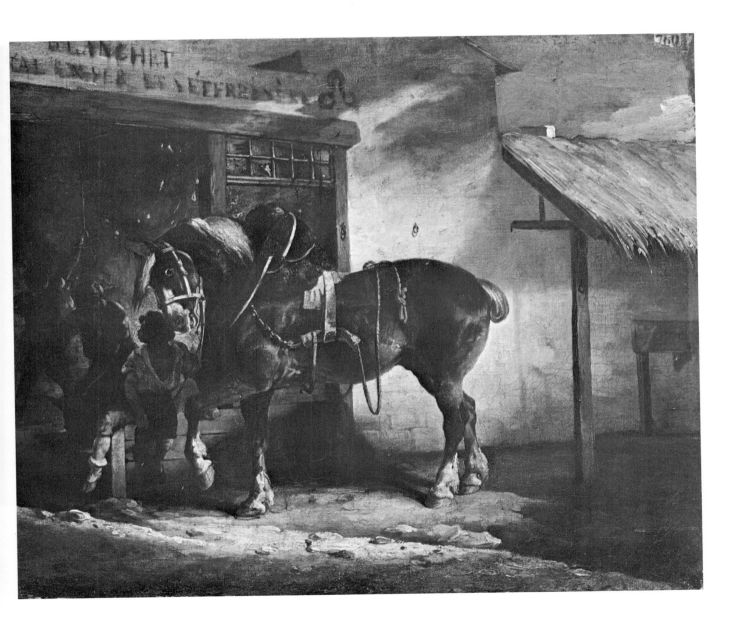

## Two Posthorses at the Entrance of a Stable

Oil on paper, mounted on canvas
14¹⁵⁄₁₆ x 18⅛ in. (379 x 462 mm.)
Collections: Coutan; Hauguet;
Mme. Milliet (née Schubert;
gift 1883); Musée
du Louvre (RF 367), Paris.

Painted in France after the English voyage, the picture served as the model for the lithograph *Deux chevaux de poste à la porte d'une écurie* of 1822 (Delteil 88). The realistic conception of the horses — tired working animals, sweat-stained, marked by saddle and harness — is in keeping with the strain of social observation which runs through Géricault's late work.

The picture is signed "Géricault" at the lower left.

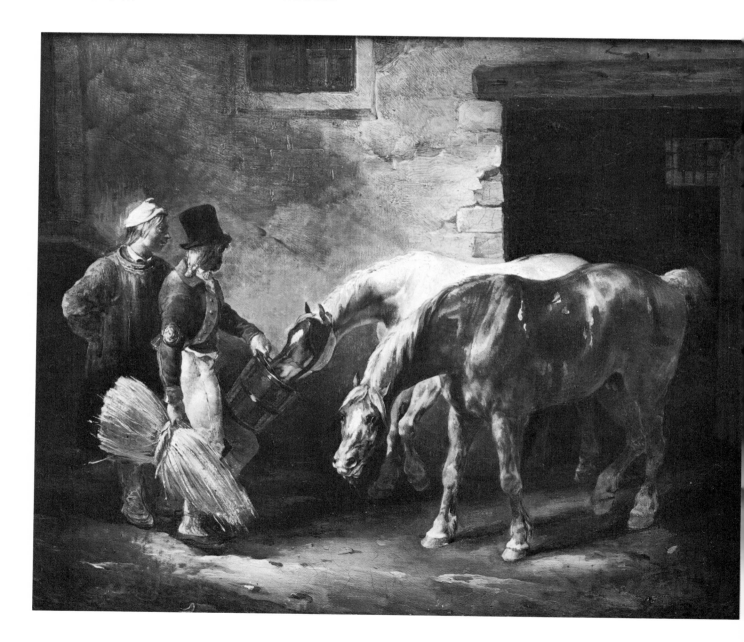

*Dappled Draught
Horse Being Shod*

Pencil, grey and brown
washes on paper
6½ x 9³⁄₁₆ in. (165 x 249 mm.)
Collections: Léon Suzor, Paris;
Museum of Fine Arts,
Boston (Mary L. Smith Fund).

Closely related to the lithograph *Le cheval que l'on ferre* of 1823 (Delteil 72) this drawing is nevertheless to be considered not as a preliminary study but as an independent work, carefully finished, and meant to be sold. Having suffered financial reverses, Géricault in the last years of his life found himself obliged to sell drawings to supplement his normally ample income. This necessity had some influence on his late work. It caused Géricault, in his water-color drawings and paintings of cabinet size, to aim for completeness and high finish.

The sheet is signed "Géricault" at the lower right.

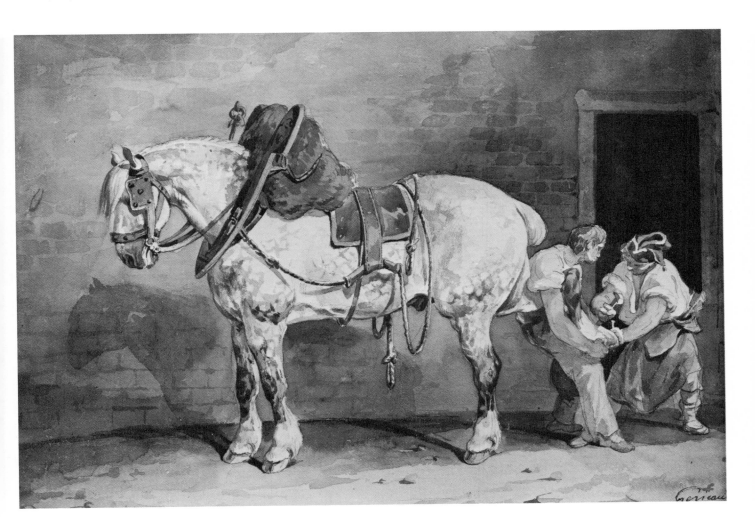

*Study of a Farrier*

Pencil and ink washes on paper
8¼ x 5¼ in. (209 x 134 mm.)
Collection: Mrs. and Mrs. Eugene
V. Thaw, New York.

This is a study for the lithograph *The French Farrier* of 1821 (Delteil 41) or for the revision of this print issued in 1822.

*Stallion*
*Covering a Mare*
*("La Monte")*

Black chalk, ink wash, and watercolor
9⅞ x 12⅝ in. (251 x 321 mm.)
Collection: Denise Aimé-Azam, Paris.

Clément (Dessins, 142) describes a related watercolor drawing — which was then in the collection of Edward Sartoris, London — of a stallion being led by an Arab to cover a mare. Another such drawing is in the Musée Bonnat, Bayonne (inv. 729). It may not be unreasonable to consider these compositions as works of erotic art, comparable in significance to the erotic mythologies which Géricault drew in 1815-1816.

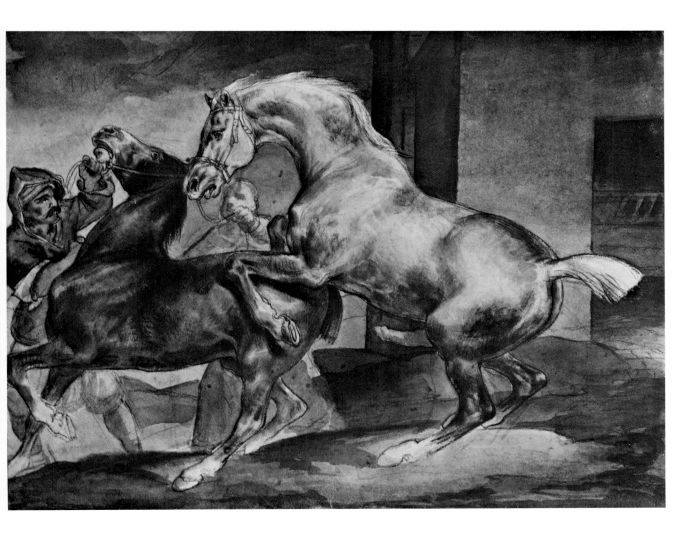

## Study of an Oriental

Watercolor over pencil on paper
11¾ x 8½ in. (298 x 216 mm.)
Collections: Baron Schwiter (sale,
1883); A. Chéramy (sale, 1913);
Stroehlin; Pierre Dubaut, Paris; Mr. and
Mrs. Eugene V. Thaw, New York.

A considerable part of Géricault's late work deals with Oriental subject matter. The taste for Mameluke costumes and Arab horses had first manifested itself in his youth, no doubt under the influence of the painters of the Empire, of Gros, and of his own teacher, Carl Vernet. His Orientals of those early years did not differ much from the stereotypes common to all painters of the time. After 1820 he began to treat Ori-ental subjects more frequently than befo[re] and in a manner markedly more authent[ic]. As in the time of Napoleon, it was war a[nd] politics that turned the eyes of Europe [to] the east. The unrest in the Balkans, soon [to] erupt in a war of liberation by the Hellen[es] against their Turkish overlords, arous[ed] strong emotions everywhere. Because t[he] Greek struggle had come to be identif[ied] with the larger cause of resistance to poli[ti]cal or national oppression, the stirrings [of] Greek independence were being watch[ed] with special sympathy by men of liber[al] outlook like Géricault and the frien[ds] among whom he lived. The Greeks were [in] fashion as champions of liberty and so we[re] their antagonists, the picturesque Alba[ni]ans and Turks. To artists and writers, starv[ing] for subject matter in a notably prosaic tim[e,] the Greek wars furnished motifs that we[re] heroic and yet modern, romantic yet true.

For the note of ethnographic realism th[at] appears in his studies of Oriental costur[e] from 1820 onward, Géricault was large[ly] indebted to his friend Jules-Robert Augus[te] (1789-1850), an artist who had travel[ed] widely in the Levant. Auguste had preced[ed] Géricault to England and, on returning [to] France, had settled in his immediate vicin[it]ity in the Rue des Martyrs. He had broug[ht] with him a large treasure of Oriental co[s]tumes and arms which he was willing [to] share with Géricault, as he was later [to] share it with Delacroix. Géricault mea[n]while indulged his fondness for Oriental[s] to the point of engaging a Turkish servan[t,] Mustapha, who frequently posed for hi[m] wearing M. Auguste's exotic costumes an[d] weapons.

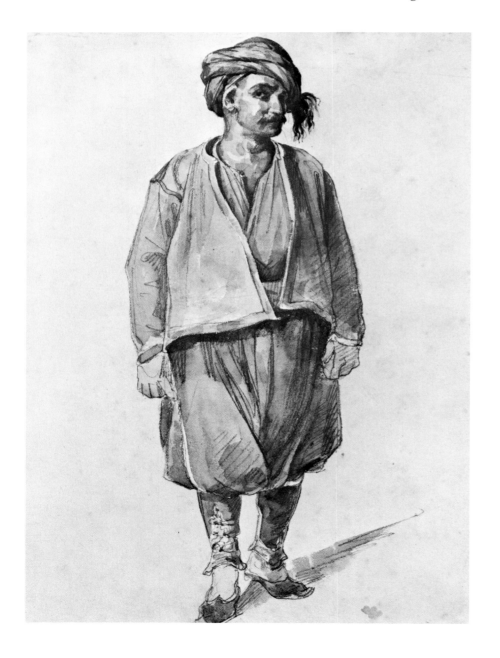

*Negro Soldier*
*Holding a Lance*

Pencil with brown ink and grey wash
13¾₁₆ x 9¾₁₆ in. (335 x 233 mm.)
Collections: de L'aage; Marmontel
(1883); A. Beurdeley (stamp, Lugt 421;
sale, 1920); Scott and Fowles;
Paul Sachs (gift, 1965); Fogg Art Museum,
Harvard University (Bequest
of Meta and Paul J. Sachs; 1965-285).

The artist's model posing in Oriental cos-
tume was possibly the famous black model
Joseph. The drawing may be related to one
of Géricault's late projects, such as the *Afri-
can Slave Trade* (see no. 120 of this cata-
log); more likely it is one of the many
costume studies which Géricault drew in
1822-1823 when his interest in Orientalia
was at its height (other studies at the
Louvre; Musée Bonnat, Bayonne; Gobin
Coll.; Buehler Coll.; many of these studies
were once in the possession of Baron
Schwiter, a friend of Géricault and Dela-
croix, cf. no. 110).

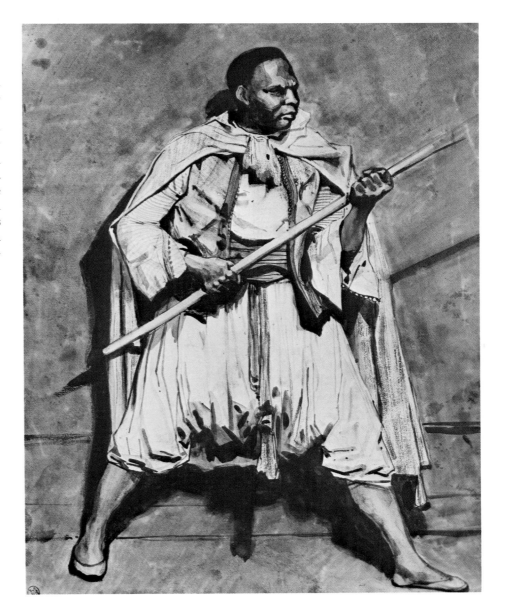

*Portrait of a Negro*

Oil on canvas
18⅛ x 14⅝ in. (463 x 372 mm.)
Collection: Musée Denon,
Châlons-sur-Saone (inv. 27;
acquired in 1829).

Negroes play a fairly prominent role in the work of Géricault. When he composed *The Raft of the Medusa,* he not only included three black sailors among his figures — despite the fact that there had been only one black man among the survivors of the raft — but he actually made one the very climax of his design. Whether he did this for artistic or other reasons cannot be determined with certainty. But it is perhaps noteworthy that A. Corréard, one of his chief sources of information about the shipwreck and himself one of the survivors, was prominent in the abolitionist movement and may have engaged Géricault's interest in this cause. The effort to suppress the illegal slave traffic was of great public concern at the time. It inspired Géricault to project a large painting on the subject of the *African Slave Trade* (see no. 120 of this catalog) which sickness prevented him from carrying beyond the early stages of planning. His various portrait studies of Negroes (Buehler Coll., Winterthur, Clément, Peintures, 104-*bis;* Musée Bonnat, Bayonne; Albright-Knox Gallery, Buffalo; Rouen Museum, etc.) appear to be only loosely connected with his compositional projects. They belong rather to that large body of studies which he evidently produced for their own sake. The majority date from about 1822-1823 and are close stylistically to his Oriental studies of those years.

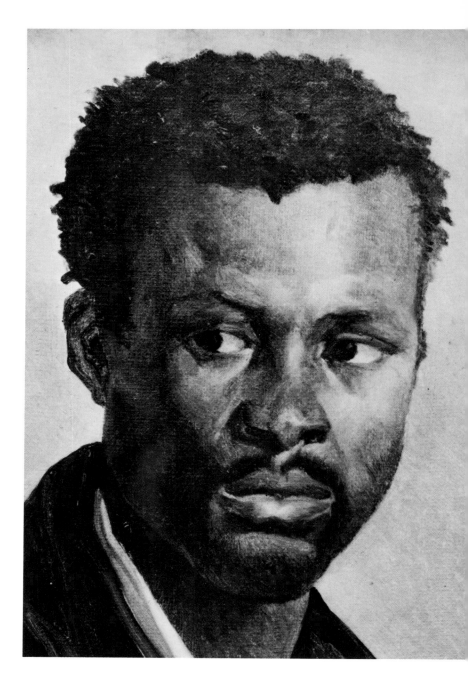

*Portrait Study
of a Negro*

Oil on paper, mounted on canvas
21½ x 18⅜ in. (546 x 467 mm.)
Collections: Laurent; O. Ackermann,
Berlin and Zurich; H. Thannenbaum
Galleries, New York;
Albright-Knox Art Gallery, Buffalo.

The black model who posed for this por-
trait wearing an Oriental costume does not
appear to be identical with the well-known
black model Joseph, whose quite different
features occur in Géricault's portrait in the
Buehler Collection, Winterthur (Clément,
Peintures, 104-*bis*). Portrait studies of Ne-
groes are not uncommon in French paint-
ings of the eighteenth and nineteenth
centuries. What distingushed Géricault's
portraits is their unusual degree of individ-
ualization. His evident aesthetic interest in
the physiognomy of Africans or Asians did
not lead him into romantic exaggerations
or reductions to mere types. The noble
factuality of Géricault's realism is most
evident in the works of his last years and
particularly in those subjects which were
apt to mislead his more "imaginative" con-
temporaries into trivial or false sentiment.
The portrait dates from ca. 1822-1823.

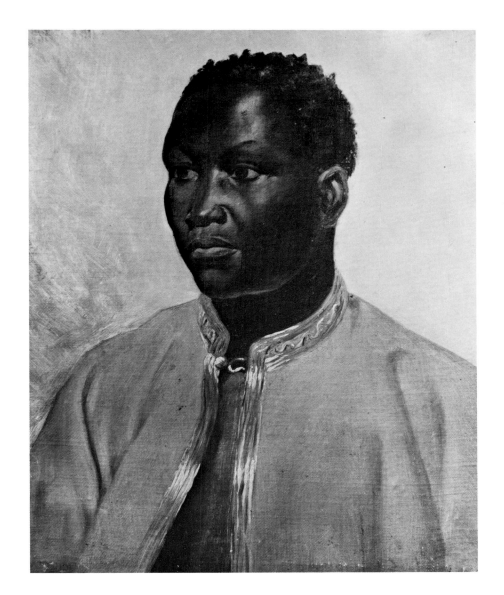

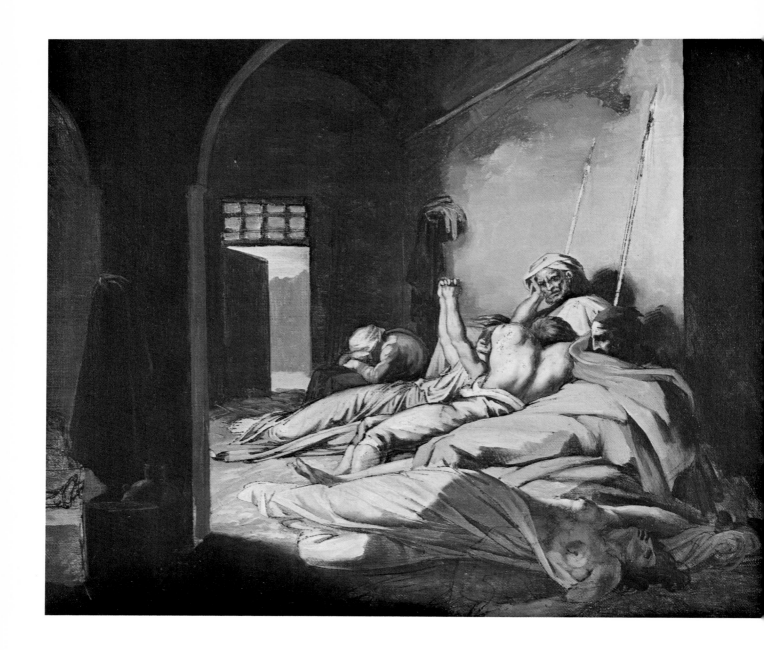

## Scene of the Plague at Missolunghi

Oil on canvas
15 x 18¼ in. (381 x 463 mm.)
Collections: Leconte; Bischoffsheim;
A. Chéramy (sale, 1908); Lierens,
Brussels (sale, 1931); Pierre Dubaut;
G. Renand, Paris; The Virginia
Museum of Fine Arts, Richmond.

The title now given to this unfinished oil study is conjectural. Neither the physiognomies nor the costumes or accessories of its figures offer any very striking clues to the picture's meaning. Clément described it, doubtfully, as a "Scene of the Greek Wars of Independence (?)," while the catalog of the Chéramy Collection, for unstated reasons, gives it the more specific label of "The Wounded of Missolunghi." Its style has nothing to do with the complex naturalism of Géricault's late period. The design has the compact strength of his earlier, monumental work. The contours are hard and angular, the color is laid on in broad patches, the bodies are of the powerfully-muscled, sculptural type met with in the "antique" compositions of his middle years. The main figure, finally, bears a striking resemblance to the so-called "Father" of *The Raft of the Medusa*. These affinities with Géricault's work of 1818-1819 may result from the fact that this is a rather deliberately composed picture, possibly a project for a painting of large scale; it may be that in planning for monumental effect Géricault reverted to an earlier, more formal manner. But the possibility cannot be excluded that the picture may in fact date from about 1818, rather than from 1822-1823 as is generally supposed.

## Sea Coast with Fishermen

Oil on canvas
18½ x 22 1/16 in. (470 x 560 mm.)
Collections: Paul Flandrin;
M. Moureaux; A. Stevens; O. Ackermann;
private collection, Zurich.

This is the most finished of several dramatic coastal sea-scapes (see nos. 116-118 of this catalog) which date from about 1822-1823. In them Géricault resumes his earlier strain of imaginary, poetic landscape composition (see nos. 29-32) although in a manner no longer indebted to the traditions of Claude or Poussin. Old photographs show that the picture in Zurich once included a dark cliff, silhouetted against the rocks at the right of the canvas. This proved to be a *pentimento* by Géricault himself; it was removed sometime in the 1920s or 1930s. The picture as it is now seen gives Géricault's original version. A closely related watercolor drawing is in the Gobin Collection, Paris.

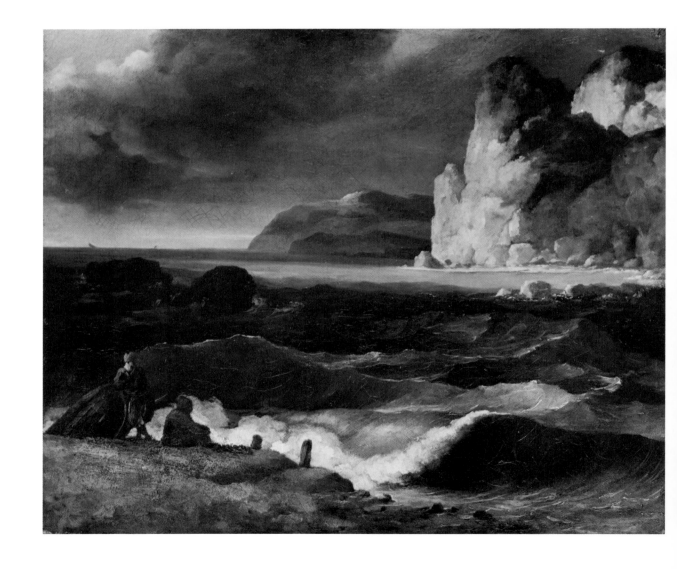

*The Body of a
Woman Discovered on
a Beach by a Monk
("La Tempête")*

Pencil and watercolor on paper
9⅛ x 8¼ in. (232 x 209 mm.)
Collections: P. J. Dedreux-Dorcy
(1832); Vicomte de Fossez; The Art
Institute of Chicago (65.13;
Gift of the Joseph and Helen
Regenstein Foundation).

This recently discovered watercolor drawing is related to the paintings in Brussels and at the Louvre, paintings long known under the names of *La tempête* or *L'épave* (see no. 117 of this catalog). The works in this group can be dated, by their style and their close association with other works, in the years of 1822-1823. They exhibit characteristic traits of Géricault's late style: a loose, painterly execution; an emphasis on effects of light and atmosphere rather than solid body; and the substitution of nuances of tone for firm contour. Their romantic subject matter and mood are somewhat unusual for Géricault; they represent a minor, but distinct strain of popular romanticism which runs through his late productions and links them with contemporary fashions in literature and art. The fullest expression of this trend is to be found in his lithographs of 1822-1823, particularly in those which illustrate Byron (Delteil 45, 71, 94-97). The different versions of *La tempête* may be by-products of Géricault's venture into literary illustration, but no definite "text" for them has been found.

The sheet is inscribed on the verso: *"Géricault, donné par M. Dedreux d'Orcy, 1832."*

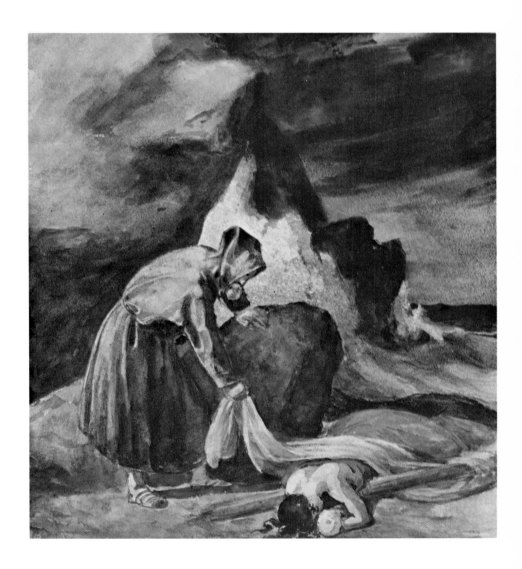

*The Body of a
Woman and Child on
a Rocky Beach
("La Tempête")*

Oil on canvas
19⅝ x 24¼ in. (498 x 616 mm.)
Collections: Constantin;
E. Clarembaux, Brussels (1901);
Musées Royaux des Beaux-Arts
de Belgique, Brussels.

A smaller version of the same subject is in the Louvre (RF 784). According to Clément this boldly brushed sketch was painted "as a sort of imitation of a painting which Horace Vernet executed in Géricault's studio, in the Rue des Martyrs, for a Russian collector." No such painting by Vernet is known, but there exist several lithographs by him which correspond in subject and treatment to Géricault's *Tempête* (also known as *L'épave*). One of these is an illustration of Byron's "Shipwreck Canto" *(Don Juan)*; it shows the unconscious Don Juan on a rocky beach very similar to that of Géricault's *Tempête*. The picture can be dated, by its style and by these associations, about 1822-1823.

It is tempting to see in this composition the elegaic sequel to the dramatic *Medusa*. Both have their place in romantic shipwreck imagery, but the sentiment of *La tempête* has a literary flavor which the *Medusa* lacks. The *Medusa's* lineage reaches back to Michelangelo and Rubens, that of *La tempête* only to Bernardin de Saint-Pierre and Chateaubriand. Possibly some now forgotten poem or romance furnished the image, although the special poignancy achieved in Géricault's picture probably had its roots in personal associations.

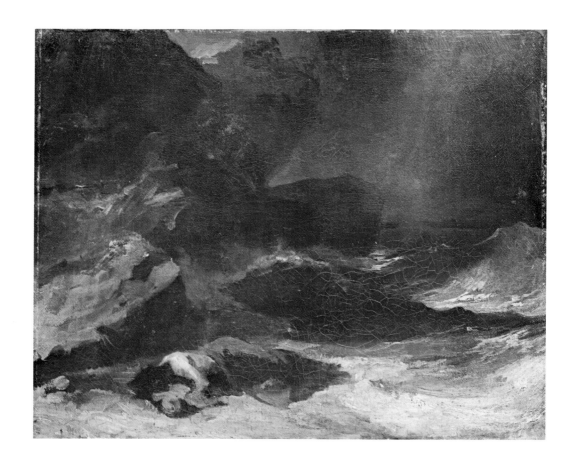

## Shipwrecked Man
## on a Beach

Oil on paper, mounted on canvas
13⅜ x 20¾ in. (339 x 527 mm.)
Collections: Drs. F. and P. Nathan,
Zurich; Yale University Art Gallery,
New Haven (acc. no. 1966.89;
Stephen Carlton Clark Fund).

This vigorous sketch, which has only re-
cently come to light, resembles in theme
and style the various versions of *La tem-
pête* (see nos. 116 and 117 of this catalog),
and like them it appears to date from 1822-
1823.

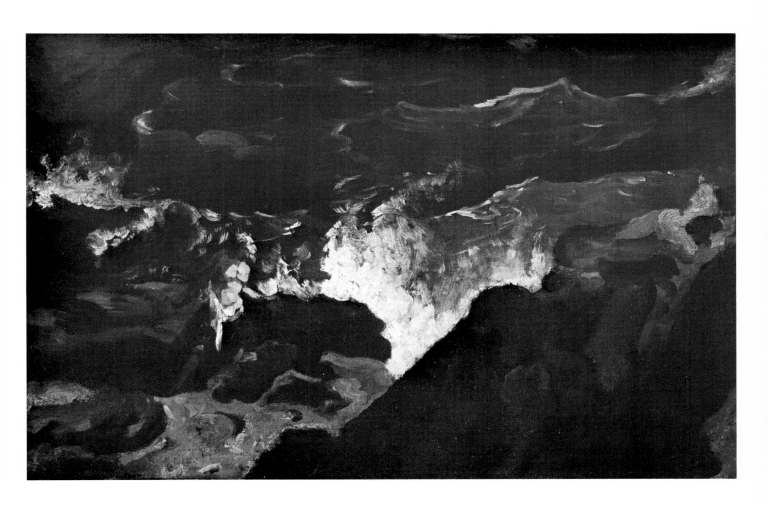

## Liberation of the Prisoners of the Spanish Inquisition

Black and red chalk on paper
16½ x 22⅞ in. (419 x 581 mm.)
Collections: Alexandre Colin; Binder;
Pierre Dubaut; private collection, Paris.

At the very end of his life Géricault returned to his old ambition of casting vital, contemporary subjects in monumental forms. He regretted the time and energy he had spent on work of small scale and dreamt of painting on immense walls "with buckets of paint and brushes the size of brooms." One of the subjects which he had in mind was the opening of the prisons of the Inquisition by French troops, an episode of the Napoleonic Wars in the Spanish peninsula. According to his earliest biographer, Louis Batissier, he "intended to paint this scene on an enormous canvas, making of it a kind of panorama showing the crowds of unfortunates escaping from the prisons of the Holy Hermandad."

The theme had a topical, political meaning in 1822-1823. At the time Géricault projected his composition, a French conservative government had sent troops into Spain to quell a popular rising and to shore up the tottering Bourbon monarchy. In representing French soldiers in their earlier role, as liberators, he doubtless meant to castigate the present invasion of Spain for the profit of a repressive king and clergy.

Several other drawings related to this project are known; a pen drawing of the composition, formerly in the Lagrange Collection (*Gazette des Beaux-Arts,* XXII, 1867, p. 469); a smaller compositional drawing in pencil in the Dubaut Collection, Paris (Centenary, no. 292), and several figure studies in the Besançon Museum (D-2121, 2123). On the verso of a drawing for yet another compositional project of 1822-1823, *The Surrender of Parga,* in the Dubaut Collection, Paris, there is a further compositional sketch for the *Liberation of the Prisoners of the Inquisition* (Centenary, no. 294).

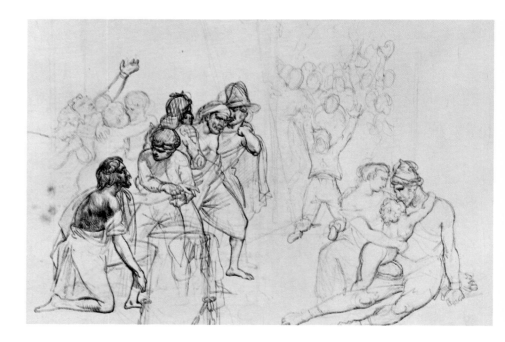

## The African Slave Trade

Black and red chalk on paper
12 1/16 x 17 3/16 in. (306 x 436 mm.)
Collections: His de La Salle
(stamp, Lugt 1332); Ecole des Beaux-
Arts (inv. 982), Paris.

The abolition of the slave trade in the African colonies was one of the popular, liberal causes of the 1820s. Among Géricault's friends, in the circle of Horace Vernet, there were men actively engaged in the polemic surrounding this issue, notably the publisher Alexandre Corréard, one of the survivors of the Medusa. It is possible that Géricault's relationship with these men gave him the idea for the *African Slave Trade,* one of the projects which occupied him in the months of his final illness. Only a few drawings of this project survive: a pen drawing in Bayonne (inv. 2055; Clément, Dessins, 160; sketches in the Dubaut Coll., Paris; tracings in the former Dollfus Collection).

The drawing in the Ecole des Beaux-Arts is the most developed design for the project. It shows that the composition, if carried out, would have been dominated by monumentally conceived figures, nude or partially nude, as in *The Raft of the Medusa.* Its structure, however, would have been looser and its elements more dispersed in contrast to the tight convergence of the figures of the earlier picture. On the whole, this drawing, inconclusive as it may be, gives a strong hint that Géricault's further development as a monumental painter would have continued more closely in the direction pointed by the *Medusa* than the intervening five years, filled with work of very different character, had given reason to suppose. There are, nevertheless, many signs of stylistic change. The heavily muscled bodies of the *Medusa* have given way to a new figure type, more slender and flexible, long-limbed and thin-jointed. The execution of the drawing illustrates the suppleness of Géricault's late manner. The figures are less sharply contoured, their forms are more natural, their poses less academic. But Géricault's fundamental desire for solidity and definition is still evident despite the nervous looseness of the execution.

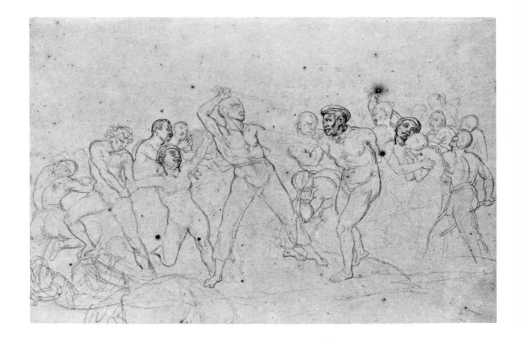

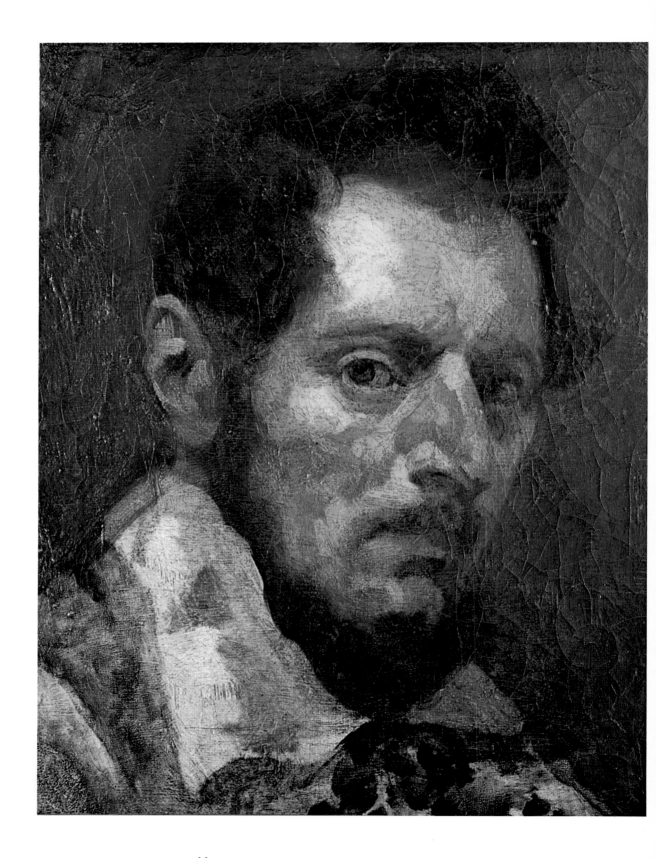

## Self-portrait

Oil on canvas (re-backed)
14¾ x 10¾ in. (374 x 272 mm.)
Collections: L. Colombier (sold,
1901); Musée des Beaux-Arts, Rouen.

The emaciated face, somewhat more fully bearded than it appeared in the earlier self-portrait (see no. 70 of this catalog), suggests that this was painted in his last years, probably 1822-1823. Géricault was then thirty-one or thirty-two years old. Drawing on the recollections of Géricault's friends, Clément describes his appearance as follows: "He was blond, his beard even had a pronounced reddish tinge. His head was well formed, regular, of great nobility. The masculine energy of the face was tempered and embellished by a marked expression of gentleness...Tall rather than short, he had a strong and slender body. He was remarkably well-built. Vernet used to say that he had never seen a more handsome man. His legs in particular were superb, like those of the horse tamer in the center of the *Race of the Barberi,* as M. Dorcy tells me. He dressed carefully, and followed the fashion, not without a certain affectation: he was a man of the world, and equal to the best horsemen of the period..." (Clément, p. 266).

**122**

*Portrait of
an Insane Man
("Kidnapper")*

Oil on canvas
25½ x 21¼ in. (647 x 540 mm.)
Collections: Dr. Georget; Dr. Lachèze,
Baden-Baden (sold, 1868);
Charles Jacque; R. Goetz (sale,
1922); Duc de Trévise (sale, 1938);
Leo Gerstle, Zürich; Museum of
Fine Arts, Springfield (The James
Philip Gray Collection).

This is one of five surviving portraits of insane men and women which Géricault probably painted in the winter of 1822-1823. Very little is known of their history. Clément, the only source, merely reports that Géricault painted them for his friend Dr. Georget, a medical officer of the Salpetrière, an institution which harbored both criminals and mental patients. According to Clément the ten portraits were painted in the years following Géricault's return from England. When Dr. Georget died, not long after Géricault, five of the pictures were sold to a Dr. Maréchal who took them to Brittany; nothing has been heard of them since. The other five were bought by a Dr. Lachèze and have since passed through various hands into their present collections. They represent victims of five different delusions or "monomanias" for the identification of which we must rely on Clément: a man suffering from delusions of military command (Reinhart Coll., Winterthur; Clément, Peintures, 155-a), a compulsive kidnapper (Springfield Museum; Clément, 156-b), a kleptomaniac (Ghent Museum; Clément, 157-c), a woman afflicted with the mania of gambling (Louvre; Clément, 158-d), and a woman suffering from compulsive envy (Lyon Museum; Clément, 159-e).

The actual purpose for which they were painted can only be guessed; possibly Géricault had been asked to document particular cases in the doctor's care as a kind of physiognomic record. It is apparent that the disorders represented in the five portraits are of a character that verges on the criminal; possibly all of the original ten portraits were connected by this common theme. The ultimate purpose of the pictures may have been to furnish models for illustrations of a projected publication by Georget. The psychiatrist Esquirol, Georget's teacher, had compiled two hundred portrait drawings of his patients over a period of time and eventually used reproductions of twenty-seven of these to illustrate his collected papers, published in 1838 under the title *Des maladies mentales.*

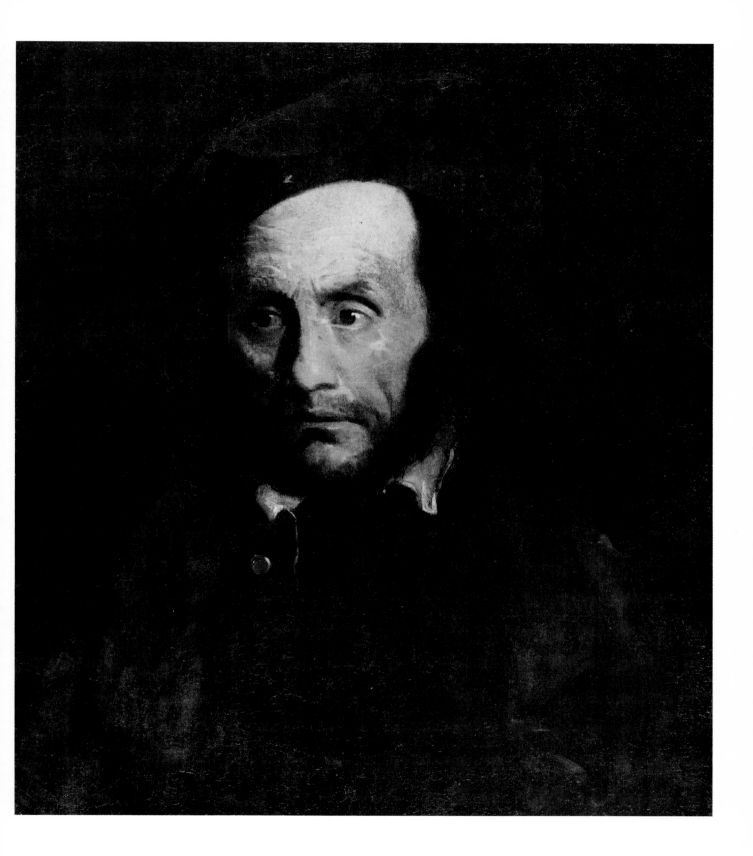

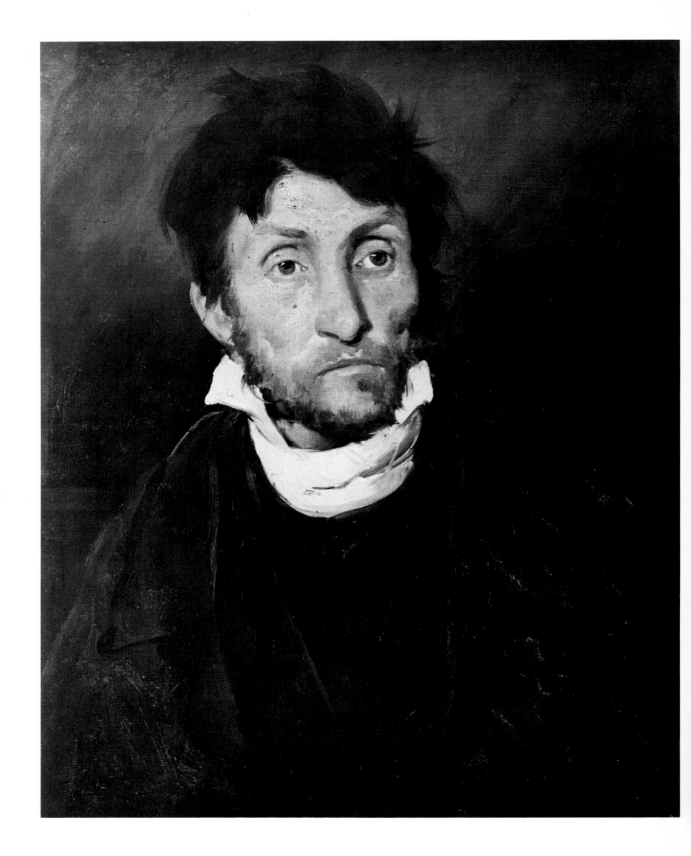

*Portrait of an
Insane Man
("Kleptomaniac")*

Oil on canvas
23⅝ x 19¾ in. (600 x 501 mm.)
Collections: Dr. Georget; Dr. Lachèze,
Baden-Baden (1868); Charles
Jacque; A. Chéramy (sale, 1908);
Museum voor Schone Kunsten, Ghent.

Concerning the history and nature of Géricault's series of ten portraits of insane patients, painted for the psychiatrist Dr. Georget, see the preceding entry. In their severe objectivity Géricault's portraits depart not only from the earlier tradition of representing the insane as men possessed by the devil, as raving lunatics, or as grotesque buffoons, they also contrast sharply with the melodramatic or sentimental treatment given to insanity in most romantic art and literature. They are "normal" portraits of disturbed individuals, rather than dramatizations of madness. It is misleading, to be sure, to compare Géricault's portraits, painted for the use of a medical scientist, with works of a different purpose; had he used the theme of insanity for a Salon painting, he would have given it quite different expression (as the staring crazed sailor among the figures of the *Medusa* proves). It is fortunate that the nature of Dr. Georget's interest relieved Géricault of the need for explanatory embroidering and enabled him to concentrate on observation. Psychiatry had just begun to show that madness was not a formless accident, but a natural process, expressing itself in visible, characteristic symptoms. In their attempt to classify and record these symptoms practitioners of the new science, like Dr. Georget, found it useful to ally themselves with artists. The objectivity of the portraits, thus, was not entirely a matter of Géricault's choice, but it was a requirement that perfectly suited him. He had earlier proven his ability to respond to emotion-charged reality with undimmed clarity of vision, most strikingly perhaps in the studies of severed heads and dissected limbs (cf. nos. 88-92 of this catalog) which in many ways parallel the portraits of the insane. His attentive coolness in the presence of disturbing subjects did not stem from emotional detachment. The macabre studies and the portraits are by no means flatly descriptive; there is no doubt that his feelings were fully engaged while he painted them. Biographical facts have recently been published (Denise Aimé-Azam, *Mazeppa,*

*Géricault et son temps,* Paris, 1956, p. 216 ff.) which throw new light on the background of Dr. Georget's commission. After the completion of *The Raft of the Medusa* in the autumn of 1819, Géricault, suffering from extreme fatigue, had exhibited symptoms of mental disturbance. It is very probable that he sought medical help at this time, perhaps from Dr. Georget. In painting the series of portraits about three years later, he may have been discharging a debt of gratitude. At any event, the fact that he had himself passed through an episode of "madness" undoubtedly goes far in explaining his interest in this unusual project. It also illuminates the quality of his artistic objectivity. His feelings, even when most deeply and immediately engaged, found release in concentrated observation and disciplined representation, not in free self-expression.

A curious parallel can be drawn between Géricault's romantic realism and that of John Constable whose experimental cloud studies (exactly contemporary with Géricault's portraits of the insane) also probe the underlying natural law in forms that had previously been considered accidental. Constable as an artist profited from the diagnostic insights into nature which the new science of meteorology offered, in much the same way as Géricault found stimulation in the observations of psychiatrists. His portraits of particular clouds, like Géricault's highly individual portraits of mental patients, are documents of the connection which once existed between romantic art and empirical science.

*Portrait of an
Insane Woman
("Mania of Gambling")*

Oil on canvas
30¼ x 25¼ in. (768 x 641 mm.)
Collections: Dr. Georget;
Dr. Lachèze, Baden-Baden (1868);
Charles Jacque (1920); Duc de Trévise
(sale, 1938); Musée du Louvre
(RF 1938:51), Paris.

For an account of the series of portraits of the insane, see catalog numbers 122 and 123 The style of the portraits shows a development beyond the stage reached by Géricault in his English work and hints at what his future direction might have been. They indicate a reaction against the brilliance and colorism of his paintings of the English stay and the period immediately following. The first impression they give is of a rather uniform, warm somberness. They are, in fact, rich in color, but this richness is concealed. What appears to be a muted harmony of dark browns, ochres, tans, and yellowish whites is in reality a far more complex mixture of hues. The flesh tones are shot through with accents of green, purplish red, and blueish grey. Even the seemingly plain backgrounds and garments are actually composed of contrasting and, occasionally, fairly intense colors which partially neutralize one another, but at the same time produce a depth and vibrancy which could not have been achieved by other means. Except for a scattering of impasto highlights, the paint is stroked or wiped on in thin, almost transparent layers. The touches, small and deftly fitted in the faces, become larger and freer in the backgrounds and garments. Compared to the brutal impasto, the heavy crusts or hatchings of opaque paint found in the works of Géricault's middle period, the handling in these portraits shows the suppleness which had become apparent in his paintings since 1820. But there is also evidence of his return to a broader and simpler manner. The technical dexterity which had threatened to overwhelm expression in his more finished, late watercolors and paintings, here in paintings of larger scale and freer execution becomes subordinated once more to a masterful directness and unity of effect.

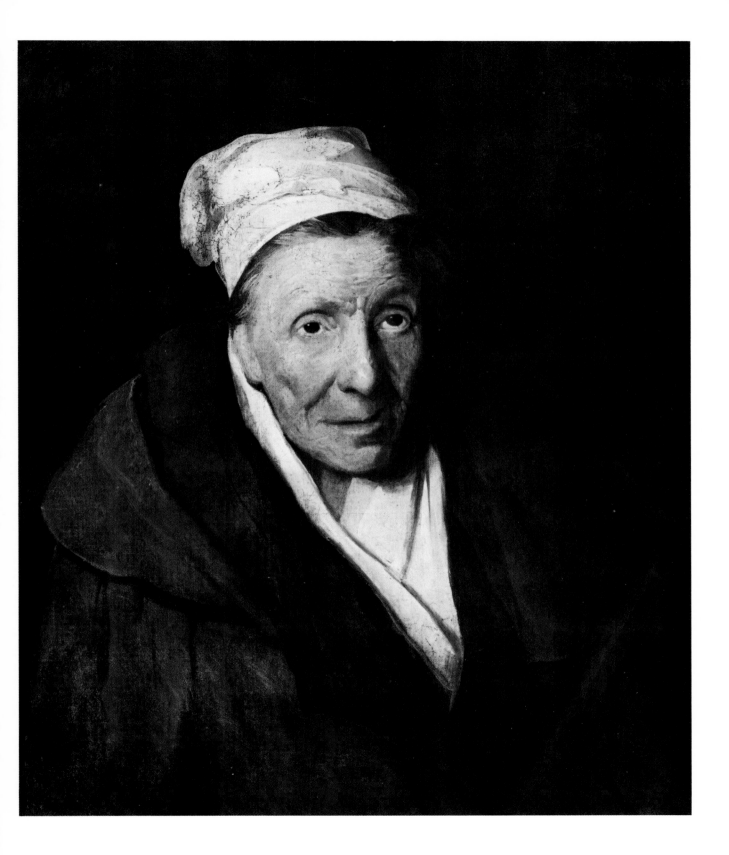

## *The Left Hand of Géricault*

Pencil, black and red chalk on paper
9¼ x 11¾ in. (235 x 298 mm.)
Collections: Lehoux;
Musée du Louvre (RF 1397), Paris.

Géricault's pupil Montfort, who cared for him during his last illness, reports that on his death bed Géricault made several drawings of his own left hand (Clément, p. 260). At the Centenary exhibition in Paris, 1924, the plaster cast of Géricault's hand was shown. The dying artist had inscribed upon it, "A tous ceux que j'aime. Adieu!"

Inscribed at the top of the sheet in the handwriting of Géricault's pupil Lehoux is, *"Géricault"* and at the bottom, *"The hand of Géricault. He made this drawing in bed, during his last illness. The pencil line was drawn by following the contours of the hand put flat against the bare paper."*

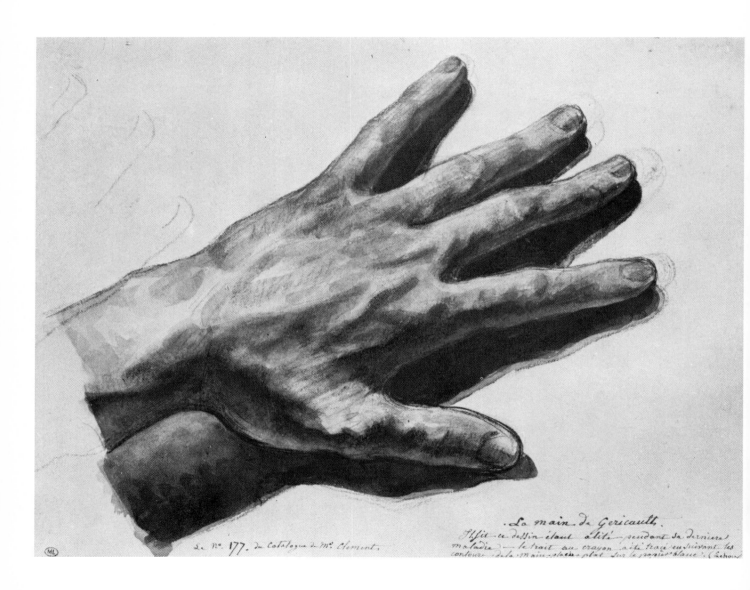

*Literature
and
Exhibitions*

1  *Self-portrait*

Literature:

C. Clément, Paris, 1867, Peintures, 1.

L. Rosenthal, *Géricault,* Paris, 1905, p. 166, ill. opp. p. 8.

D. Aimé-Azam, *La passion de Géricault,* Paris, 1970, p. 26 ff.

F. H. Lem, "Géricault portraitiste," *L'Arte* (January-June, 1963), p. 65.

Exhibitions:

Atelier Delacroix, 1963.

Aubry, 1964, no. 1.

2  *Portrait of Simeon Bonnesoeur de la Bourginière*

Literature:

C. Clément, Paris, 1867, Peintures, 65.

Sale Catalog, Hôtel Drouot, Paris, December 22, 1922, no. 84.

*Revue de L'Avranchin,* XXXVII (September, 1956), pp. 191-212, ill. p. 213.

*Revue de L'Avranchin,* XXXVIII (September, 1957), p. 329, ill. p. 330.

*Connoisseur,* CXLI (June, 1958), p. 248, ill.

F. H. Lem, "Géricault portraitiste," *L'Arte* (January-June, 1963), p. 66.

*The Minneapolis Institute of Arts Bulletin,* LIV (1965), p. 57, cover ill.

*Gazette des Beaux-Arts, La Chronique des Arts,* LXVII (April, 1966), p. 5.

*Art Quarterly,* XXIX (1966), p. 72.

Exhibitions:

Centenary, Paris and Rouen, 1924, no. 230.

Bernheim-Jeune, Paris, 1937, no. 48.

"The Inner Circle," Milwaukee Art Center, 1966, no. 38, ill.

3  *Portrait of a Gentleman*

Literature:

C. Clément, Paris, 1867, Peintures, 121.

F. H. Lem, "Géricault portraitiste," *L'Arte* (January-June, 1963), p. 68.

Exhibition: Winterthur, 1953, no. 92.

4  *St. Martin Dividing His Coat (after Van Dyck)*

Literature:

Sale Catalog, Eugène Delacroix coll., 1864, no. 232.

C. Clément, Paris, 1867, Peintures, 185.

Fierens-Gevaert, *La peinture au Musée Ancien de Bruxelles,* p. 108, pl. CLXI.

Lee Johnson, "A Copy after Van Dyck by Géricault," *Burlington Magazine* (December, 1970), pp. 793-797, ill.

Exhibition: Winterthur, 1953, no. 37.

5  *Equestrian Portrait of Francisco de Moncada (after Van Dyck)*

Literature:

"Vente Ary Scheffer," *Gazette des Beaux-Arts,* II (1859), p. 47.

Lee Johnson, "A Copy after Van Dyck by Géricault," *Burlington Magazine* (December, 1970), p. 793 ff., ill.

Exhibitions:

"Fodor 100 Jaar," Fodor Museum, Amsterdam, 1963, no. 14 (as by Delacroix).

"Delacroix," Kunsthalle, Bremen, 1964, no. 22 (as by Delacroix).

6  *The Entombment of Christ (after Titian)*

Literature: C. Clément, Paris, 1867, Peintures, 165.

Exhibitions:

Bernheim-Jeune, Paris, 1937, no. 15.

Winterthur, 1953, no. 21.

7  *Study of a Nude Model in Back View*

Literature:

L. Eitner, "Oeuvres inconnus de Géricault," *Bulletin,* Musées Royaux des Beaux-Arts de Belgique, Brussels (June, 1953), pp. 55-64.

Exhibition: Winterthur, 1953, no. 3.

8  *Sketch for the Charging Chasseur*

9  *Charging Chasseur (sketch)*

Literature:

C. Clément, Paris, 1867, Peintures, 41.

V. N. Prokofiev, *Théodore Géricault,* Moscow, 1963.

C. Sterling and H. Adhemar, *La peinture au Musée du Louvre, Ecole Française,* I, Paris, 1959, no. 932, pl. 332.

Exhibitions:

"Fransk malerkunst," Copenhagen, 1928, no. 81, Oslo, no. 75.

"Gros, ses amis et ses élèves," Paris, 1936.

"Delacroix et les maîtres de la couleur," Paris, 1952, no. 11.

Winterthur, 1953, no. 54.

"Delacroix," Bordeaux, 1963, no. 280.

"Napoléon et son époque," Tokyo, Nagoya, Osaka, no. 555.

Exposition Universelle, Montreal, 1967.

"Le romantisme dans la peinture française," Moscow, Leningrad, 1968-69, no. 55.

10  *Charging Chasseur (sketch)*

Literature: C. Clément, Paris, 1867, Peintures, 45.

Exhibition:

"Rendez-vous à cheval," Schloss Jegenstorf, 1970, no. 77, pl. II.

11  *The Charging Chasseur (sketch)*

Literature:

Sale Catalog, Coutan-Hauguet coll., Paris, December 16-17, 1889, no. 13.

Sale Catalog, P. A. Chéramy coll., G. Petit, Paris, Ma 5-7, 1908, no. 95.

*Burlington Magazine,* XIII (June, 1908), p. 180.

L. Eitner, "Reversals of Direction in Géricault's Compo sitional Projects," *Stil und Ueberlieferung in der Kun des Abendlandes,* III (Berlin, 1967), p. 126 ff.

Exhibitions:

Centenary, Paris and Rouen, 1924, no. 17.

Bernheim-Jeune, Paris, 1937, no. 23.

12  *"The Horse of Napoleon"*

Literature: C. Clément, Paris, 1867, Peintures, 56.

Exhibition:

"The John Hay Whitney Collection," Tate Galler London, December 16, 1960-January 29, 1961, no. 3

13  *Sketchbook Page*

Literature:

L. Eitner, *Géricault, an Album of Drawings in the A Institute of Chicago,* Chicago, 1960, p. 40.

14  *Sketchbook Page*

Literature:

L. Eitner, *Géricault, an Album of Drawings in the A Institute of Chicago,* Chicago, 1960, p. 41.

15  *Lancer Standing Beside His Horse*

Exhibitions:

"Master Drawings," Golden Gate International Exp sition, Palace of Fine Arts, San Francisco, 1940, no. 3

Lyman Allyn Museum, New London, Conn., 1942.

"Master Drawings from Midwestern Museums," Detro Institute of Arts, Detroit, 1950, no. 17.

16  *Wounded Cuirassier*

Literature:

C. Clément, Paris, 1867, Peintures, 53-*bis.*

R. Regamey, *Géricault,* Paris, 1926, pl. 4.

R. Huyghe, "La génèse du cuirassier blessé de Géricault *Amour de l'art,* 1931, pp. 68-73.

C. G. Heise, *La pittura francese dell'ottocento,* Mila 1944, pl. IX.

L. Eitner, "Géricault's Wounded Cuirassier," *Burlingt Magazine,* XCVI (August, 1964), p. 237 ff.

L. Johnson, "Some Unknown Sketches for the Wound Cuirassier, and a Subject Identified," *Burlington Mag zine,* XCVII (March, 1955), p. 78 ff.

C. Sterling and H. Adhemar, *La peinture française Musée du Louvre, Ecole Française, le XIXe siècle,* Par 1959, no. 934, pl. 333.

V. N. Prokofiev, *Théodore Géricault,* Moscow, 1963, p 77, 78, 80, 81.

H. Kogina, *La bataille romantique,* Leningrad, 196 ill. p. 33.

17 *Wounded Cuirassier*

Literature:

C. Clément, Paris, 1867, Peintures, 53.

R. Huyghe, "La génèse du cuirassier blessé de Géricault," *Amour de l'art*, 1931, p. 65 ff.

W. Pach, "Géricault in America," *Gazette des Beaux-Arts*, XXVII (April, 1945), p. 235, ill. p. 228.

H. Wegener, "A Study by Géricault," *Brooklyn Museum Bulletin*, XI, Winter, 1950, 2, p. 11 ff.

L. Eitner, "Géricault's Wounded Cuirassier," *Burlington Magazine*, XCVI (August, 1954), p. 237 ff.

L. Johnson, "Some Unknown Sketches for the Wounded Cuirassier, and a Subject Identified," *Burlington Magazine*, XCVII (March, 1955), p. 78 ff.

18 *Portrait of a Carabinier*

Literature:

C. Clément, Paris, 1867, Peintures, no. 54.

G. Brière, *Catalogue des peintures du Musée du Louvre, Ecole Française*, Paris, 1924, no. 343.

M. Gauthier, *Géricault*, collection *Les Maîtres*, Paris, 1935, pl. 20.

R. Regamey, *Géricault*, Paris, 1926, pl. 21.

C. Sterling and H. Adhemar, *La peinture au Musée du Louvre, Ecole Française*, Paris, 1959, no. 936, pl. 334.

V. N. Prokofiev, *Théodore Géricault*, Moscow, 1963, p. 85.

Exhibitions:

"Géricault," Galerie Charpentier, no. 25.

"Gros, ses amis et ses élèves," Petit Palais, Paris, 1936, no. 837.

"Art français," Belgrade, 1939.

"La peinture française de David à nos jours," Buenos Aires, 1939, no. 62.

"French Art," Wildenstein Gallery, New York, 1954.

"Cinq siècles d'art français," Stockholm, 1958, no. 113.

"The Romantic Movement," Tate Gallery, London, 1959, no. 175.

19 *Head of a White Horse*

Literature:

C. Clément, Paris, 1867, Peintures, 31.

M. Gauthier, *Géricault*, Paris, 1935, pl. 15.

L. Eitner, "Oeuvres inconnus de Géricault," *Bulletin*, Musées Royaux des Beaux-Arts de Belgique, Brussels (June, 1953), p. 61.

C. Sterling and H. Adhemar, *La peinture au Musée du Louvre, Ecole Française*, I, Paris, 1959, no. 928, pl. 331.

V. N. Prokofiev, *Théodore Géricault*, Moscow, 1963, p. 70.

Exhibitions:

"Géricault," Galerie Charpentier, Paris, 1924, no 180.

"Peinture Française de David à Cézanne," Warsaw, Moscow, Leningrad, 1956, no. 66.

20 *Trumpeter of the Hussars*

Literature:

C. Clément, Paris, 1867, Peintures, 61-*bis*.

A. Wolff, *Les cent chefs-d'oeuvres des collections parisiennes*, Paris, 1884, ill.

Sale Catalog, Defoer coll., May 22, 1886, G. Petit, Paris, p. 61, no. 57.

Sale Catalog, G. Lutz coll., May 26-27, 1902, G. Petit, Paris, no. 68.

R. Regamey, *Géricault*, Paris, 1926, pl. 50.

S. Lane Faison, *A Guide to the Art Museums of New England*, New York, 1958, p. 169, ill.

F. Daulte, "Des Renoirs et des chevaux," *Connaissance des Arts* (September, 1960), ill. p. 31.

Exhibitions:

"Exposition des cent chefs-d'oeuvres," Galeries G. Petit, Paris, 1883, no. 22.

"Nineteenth Century French Painters," Knoedler & Co., London, June 26-July 21, 1923, no. 18.

"Peinture de l'ecole française du 19e siècle," Knoedler & Co., Paris, May, 1924, no. 9.

"Exhibition of French Art, 1200-1900," Royal Academy, London, 1932, no. 368.

21 *Portrait of an Adolescent*

Literature:

C. Clément, Paris, 1867, Peintures, 117.

Sale Catalog, Dollfus coll., G. Petit, Paris, March 2, 1912, no. 41.

F. H. Lem, "Géricault portraitiste," *L'Arte* (January-June, 1963), p. 65.

Exhibitions:

Centenary, Paris and Rouen, 1924, no. 240.

"La jeunesse des romantiques," Maison Victor Hugo, Paris, 1927, no. 1262.

Bernheim-Jeune, Paris, 1937, no. 53.

Marlborough, London, 1952, no. 19.

Winterthur, 1953, no. 5.

Aubry, Paris, 1964, no. 30.

22 *Portrait of a Young Woman*

Literature:

C. Clément, Paris, 1867, Peintures, 116.

*Catalogue des peintures*, Musée de Beziers, n.d., p. 25, no. 76.

F. H. Lem, "Géricault portraitiste," *L'Arte* (January-June, 1963), p. 77.

Exhibitions:

Winterthur, 1953, no. 90.

Rouen and Charleroi, 1963, no. 17.

23 *Portrait of Alfred Dedreux Seated in a Landscape*

Literature:

C. Clément, Paris, 1867, Peintures, no. 14.

Sale Catalog, Eugène Delacroix coll., February 17-19, 1864, no. 225.

Sale Catalog, Sequestre Goetz coll., February 23, 1922, no. 142.

Sale Catalog, Duc de Trévise coll., May 19, 1938, no. 30.

W. Pach, *Gazette des Beaux-Arts*, XXVII (1945), p. 237, ill. p. 229.

K. Berger, *Géricault and His Work*, 1955, p. 81.

F. H. Lem, Géricault portraitiste," *L'Arte* (January-June, 1963), p. 67.

Exhibitions:

Centenary, Paris and Rouen, 1924, no. 248.

"La jeunesse des romantiques," Maison Victor Hugo, 1927.

Bernheim-Jeune, Paris, 1937, no. 47.

"Gros, Géricault, Delacroix," Knoedler & Co., New York, 1938, no. 26.

"French Romantic Artists," San Francisco Museum of Art, 1939, no. 20.

24 *Portrait of a Man Wearing a Police Cap*

Literature:

K. Berger, *Géricault*, Vienna, 1952, pl. 13.

D. Aimé-Azam, *Mazeppa, Géricault et son temps*, Paris, 1956, p. 218.

F. H. Lem, "Géricault portraitiste," *L'Arte* (January-June, 1963), p. 72.

Exhibitions:

Centenary, Paris and Rouen, 1924, no. 244.

"Gros, ses amis et ses élèves," Petit Palais, Paris, 1936, no. 278.

"Exposition de portraits français," Hôtel Charpentier, Paris, 1945, no. 51.

"Portraits d'homme," Rochas, 1949.

Winterthur, 1953, no. 64.

"Cent chefs-d'oeuvres," Hôtel Charpentier, Paris, 1957,

25 *Assassination in a Boat (The Murder of Pompey?)*

Exhibition:

"Exhibition of Early Drawings," Christopher Powney, London, 1968, no. 52.

26 *Three Dramatic Figure Compositions*

Exhibitions:

"Gros, ses amis et ses élèves," Petit Palais, Paris, 1936 (not in the catalog).

Bernheim-Jeune, Paris, 1937, no. 108.

Bignou, Paris, 1950, no. 27.

Marlborough, London, 1952, no. 45.

Winterthur, 1953, no. 156.

"Gros, Géricault, Delacroix," Bernheim-Jeune, Paris, 1954, no. 44.

27 *Nude Prisoner Battling with a Serpent*

Exhibition: Bernheim-Jeune, Paris, 1937, no. 9.

28  *Satyr Approaching a Sleeping Woman
(Jupiter and Antiope)*

Literature:
R. Regamey, *Géricault,* Paris, 1926, pl. 39.

Exhibitions:
Prague, 1923.
"De David à Manet," Galerie Balzac, Paris, 1924, no. 128.
Centenary, Paris and Rouen, 1924, no. 84.
Bignou, Paris, 1950, no. 35.
Marlborough, London, 1952, no. 35.
Winterthur, 1953, no. 121.
"Gros, Géricault, Delacroix," Bernheim-Jeune, Paris, 1954, no. 37.
Aubry, Paris, 1964, no. 47.

29  *The Deluge*

Literature:
C. Clément, Paris, 1867, Peintures, 133 and p. 72 ff.
L. Eitner, "Two Rediscovered Landscapes by Géricault and the Chronology of His Early Work," *Art Bulletin,* XXXVI (June, 1954), p. 134, pl. 6.
C. Sterling and H. Adhemar, *La peinture au Musée du Louvre, Ecole Française,* I, Paris, 1959, no. 948, pl. 340.
R. Lebel, "Géricault, ses ambitions monumentales et l'inspiration italienne," *L'Arte,* XXV (October-December 1960), pp. 333, 335.
V. N. Prokofiev, *Théodore Géricault,* Moscow, 1963, p. 89, repr. p. 90.
A. Jouan, "Notes sur quelques radiographies," *Bulletin du laboratoire du Louvre* (1966), no. 11, pl. 17-19.
P. Granville, "L'une des sources de Géricault," *La revue du Louvre* (1968), no. 3, p. 139-146.
H. Kogina, *La bataille romantique,* Leningrad, 1969, ill. p. 34.

30  *Heroic Landscape with Fishermen*

C. Clément, Paris, 1867, Dessins, 5 (listing two drawings, one of which is presumably this in the Fogg Museum).
B. Holme, *Master Drawings,* New York, 1943, no. 98.
A. Mongan and P. Sachs, *Drawings in the Fogg Museum of Art,* Cambridge, 1940, no. 692.
K. Berger, *Géricault's Drawings and Watercolors,* New York, 1946, no. 1.
L. Eitner, "Two Rediscovered Landscapes by Géricault," *Art Bulletin,* XXXVI (June, 1954), p. 135.
M. Huggler, "Two Unknown Landscapes by Géricault," *Burlington Magazine,* XCVI (August, 1954), p. 234.
R. Lebel, "Géricault, ses ambitions monumentales et l'inspiration italienne," *L'Arte,* XXV (October-December, 1960), p. 329.

Exhibitions:
Gobin, Paris, 1935, no. 28.
Bernheim-Jeune, Paris, 1937, no. 92.
Brooklyn Museum, 1939.
Detroit, 1951, no. 43, ill.
"Memorial Exhibition: Works of Art from the Collection of Paul J. Sachs," Fogg Art Museum, Cambridge,

November, 1965-January, 1966; Museum of Modern Art, New York, December, 1966-February, 1967, no. 41, ill.

31  *Landscape with an Aqueduct*

Literature:
C. Clément, Paris, 1867, p. 72 and 280.
L. Eitner, "Two Rediscovered Landscapes by Géricault and the Chronology of His Early Work," *Art Bulletin,* XXXVI (June, 1954), p. 131 ff., pl. 2.
M. Huggler, "Two Unknown Landscapes by Géricault," *Burlington Magazine,* XCVI (August, 1954), p. 234 ff.
R. Lebel, "Géricault, ses ambitions monumentales et l'inspiration italienne," *L'Arte,* XXV (October-December, 1960), p. 327 ff.

Exhibitions:
Winterthur, 1953, no. 70.
"Paintings from the Collection of Walter P. Chrysler, Jr.," Portland Art Museum, 1956, no. 72 (also shown at the museums of Seattle, San Francisco, Los Angeles, Minneapolis, St. Louis, Kansas City, Detroit, and Boston during 1956-1957.
"Paintings from Private Collections," The Metropolitan Museum of Art, New York, Summer 1958.

32  *Landscape with a Roman Tomb*

Literature: Cf. no. 31.

Exhibitions: Cf. no. 31.

33  *The Triumph of Silenus*

Literature:
C. Clément, Paris, 1867, Dessins, 82.
L. Rosenthal, *Géricault,* Paris, 1905, p. 66, ill. p. 41.
K. Berger, *Géricault,* Vienna, 1952, pl. 22.

Exhibitions:
Centenary, Paris and Rouen, 1924, no. 78.
Bernheim-Jeune, Paris, 1937, no. 115.
Bignou, Paris, 1950, no. 28.
"French Drawings from Fouquet to Gauguin," The Arts Council, London, 1952, no. 76.
"French Drawings," Washington, D.C., Cleveland, St. Louis, Fogg Art Museum, The Metropolitan Museum of Art, 1952-53, no. 120.
"Französische Zeichnungen," Hamburg, Cologne, Stuttgart, 1958, no. 132.

34  *Centaur Abducting a Nymph*

35  *Centaur Abducting a Nymph*

Literature:
C. Clément, Paris, 1867, Dessins, No. 92.
Guiffrey and Marcel, *Inventaire général illustré des dessins du Louvre, Ecole Française,* V, Paris, 1910, p. 123, no. 4159.
C. Martine, *Cinquante-sept dessins de Théodore Géricault,* Paris, 1928, pl. 14.

Exhibitions:
"Dessins français," Brussels, 1936, no. 75, pl. 44.

"Géricault, peintre et dessinateur," Galerie Bernheim-Jeune, 1937, no. 114.

36  *Italian Peasant with His Son*

Literature:
C. Martine, *Cinquante-sept dessins de Théodore Géricault,* Paris, 1928, pl. 49.

Exhibitions:
Centenary, Paris and Rouen, 1924, no. 98.
"David, Ingres, Géricault et leur temps," Ecole des Beaux-Arts, Paris, 1934.

37  *Worshippers at the Portal of a Church
("Prière à la Madone")*

Literature:
C. Clément, Paris, 1867, Dessins, 76.
L. Rosenthal, *Géricault,* Paris, 1905, p. 67 ff.
C. Martine, *Cinquante-sept dessins de Théodore Géricault,* Paris, 1928, pl. 35.
K. Berger, *Géricault,* Vienna, 1952, pl. 21.

Exhibitions:
Centenary, Paris and Rouen, 1924, no. 99.
"David, Ingres, Géricault et leur temps," Ecole des Beaux-Arts, Paris, 1934.

38  *Roman Groom Leading a Horse*

Literature:
C. Clément, Paris, 1867, Peintures, 86.
*Gazette des Beaux-Arts* (July-December, 1867), no. 81, p. 283.

Exhibition:
"Berlioz and the Romantic Imagination," The Arts Council of Great Britain, Victoria and Albert Museum, London, 1969, no. 182.

39  *Sketch for the Race of
The Barberi Horses*

Literature:
C. Clément, Paris, 1867, Dessins, 62.
*L'Art,* V, 1876, p. 238.
M. Delâcre and P. Lavallée, *Dessins des maîtres anciens,* Paris, 1927, pl. 46.

Exhibitions:
Centenary, Paris and Rouen, 1924, no. 110 (?).
"An Exhibition of Drawings from the Alfred A. de Pass Collection Belonging to the Royal Institution of Cornwall, Truro," The Arts Council of Great Britain, London, 1957.

40  *Study for the Race of
the Barberi Horses*

41  *Men Struggling with Horses
and Other Sketches*

42  *Sketch of an Ephebe Holding
a Running Horse*

43 *Four Ephebes Holding a Running Horse*

Literature:

C. Clément, Paris, 1867, Peintures, 87.

L. Rosenthal, *Géricault,* Paris, 1905, p. 73.

J. Meier-Graefe, *Delacroix und Géricault (Mappe der Maresgesellschaft,* XIV), Munich, 1914 (the drawing in the Meyer-Huber Collection).

R. Regamey, *Géricault,* Paris, 1926, p. 25.

H. Focillon, *La peinture au* XIX *siècle,* Paris, 1927, p. 185.

R. Schneider, *L'art français; XIX siècle,* Paris, 1929, p. 52.

G. Oprescu, *Géricault,* Paris, 1927, p. 73.

G. Bazin, "Course des chevaux libres," *Amour de l'art* (1932), p. 217 ff.

M. Gauthier, *Géricault,* Paris, 1935, p. 31.

N. Wynne, "Géricault's Riderless Racers," *Magazine of Art,* XXXI (1938), p. 209 ff.

K. Berger, *Géricault,* Vienna, 1952, pl. 29.

R. Lebel, "Géricault, ses ambitions monumentales et l'inspiration italienne," *L'Arte,* XXV (October-December, 1960), p. 327 ff.

L. Eitner, "Reversals of Direction in Géricault's Compositional Projects," *Stil und Ueberlieferung in der Kunst des Abendlandes,* III (Berlin, 1967), p. 130, pl. III/23-2.

Exhibitions:

"Exposition Centennale," Paris, 1900.

Centenary, Paris and Rouen, 1924, no. 113-b.

Bernheim-Jeune, Paris, 1937, no. 34.

"Chefs-d'oeuvres de l'art français," Paris, 1937, no. 334.

"De David a nuestros días," Buenos Aires, 1939.

"Mostra dei capolavori della pittura francese dell'ottocento," Rome and Florence, 1955, no. 49.

"L'Italia vista dei pittori francesi del XVIII e XIX secolo," Rome, 1962, no. 162.

44 *Sketch for the Start of the Race of the Barberi Horses*

Literature: C. Clément, Paris, 1867, Dessins, 61.

Exhibition:

"An Exhibition of Drawings from the Alfred A. de Pass Collection Belonging to the Royal Institution of Cornwall, Truro," The Arts Council of Great Britain, London, 1957.

45 *Study of a Nude Man Holding a Rearing Horse*

Literature:

Sale Catalog, Michel-Levy coll., G. Petit, Paris, May 12-13, 1919, no. 83.

Sale Catalog, Duc de Trévise coll., Charpentier, Paris, May 19, 1938, no. 7.

*Apollo,* XXVIII (June, 1938), p. 32.

Shoolman and Slatkin, *Six Centuries of French Master Drawing in America,* Oxford University Press, New York, 1950.

*Academic Tradition,* Indiana University Art Museum, Bloomington, 1968, p. 24, pl. 57, no. 57.

Exhibitions:

Centenary, Paris and Rouen, 1924, no. 108.

"La jeunesse des romantiques," Maison Victor Hugo, Paris, 1927, 1292.

Bernheim-Jeune, Paris, 1937, no. 110.

"Gros, Géricault, Delacroix," Knoedler & Co., New York, 1938, no. 36.

"From David to Courbet," Detroit Institute of Arts, February-March, 1950, no. 29.

"Old Master Drawings from Midwestern Museums," Detroit Institute of Arts, no. 16.

"The Nineteenth Century: One Hundred Twenty-Five Master Drawings," University Gallery, University of Minnesota, Minneapolis, and the Solomon R. Guggenheim Museum, New York, 1962, no. 47.

"The Nude in Art," Vancouver Art Gallery, November, 1964, no. 58.

"Academic Tradition," Indiana University Art Gallery, Bloomington, June-August, 1968, no. 57.

46 *Start of the Race of the Barberi Horses*

Literature:

M. Huggler, "Die Bemuehung Géricault's um die Erneuerung der Wandmalerei, *Walraf-Richartz Jahrbuch,* XXXII (Cologne, 1970), p. 151 ff.

Concerning the general development of the project of the *Race of the Barberi Horses,* cf.:

L. Rosenthal, *Géricault,* Paris, 1905, p. 70 ff.

R. Regamey, *Géricault,* Paris, 1926, p. 25 ff.

G. Oprescu, *Géricault,* Paris, 1927, p. 68 ff.

G. Bazin, "Course des chevaux libres," *Amour de l'art* (1932), p. 217 ff.

N. Wynne, "Géricault's Riderless Racers," *Magazine of Art,* XXXI (1938), p. 209 ff.

R. Lebel, "Géricault, ses ambitions monumentales et l'inspiration italienne," *L'Arte,* XXV (October-December, 1960), p. 327 ff.

L. Eitner, "Reversals of Direction in Géricault's Compositional Projects," *Stil und Ueberlieferung in der Kunst des Abendlandes,* III (Berlin, 1967), p. 129 ff.

47 *Sketchbook Page: The Interior of the Temple of Poseidon at Paestum*

Literature:

H. A. Lüthy, "Géricault's 'Zuercher Skizzenbuch'," *Neue Zuercher Zeitung* (September 18, 1966), Sonntagsausgabe, p. 4.

48 *Entrance to a Park*

Literature: C. Clément, Paris, 1867, Dessins, 158.

49 *Nude Horseman*

50 *Three Studies of a Female Model*

Literature:

R. Regamey, *Géricault,* Paris, 1926, pl.

C. Martine, *Cinquante-sept dessins de Théodore Géricault,* Paris, 1928, pl. 41.

Exhibitions:

Centenary, Paris and Rouen, 1924, no. 94.

Winterthur, 1953, no. 116.

51 *Mameluke Horsemen in Battle*

52 *Mameluke Unhorsed by Attacking Grenadiers ("Episode de la Campagne d'Egypte")*

Literature:

C. Clément, Paris, 1867, Dessins, 38.

Guiffrey and Marcel, *Inventaire général illustré des dessins du Louvre, Ecole Française,* V, Paris, 1910, p. 123, no. 4163.

C. Martine, *Cinquante-sept dessins de Théodore Géricault,* Paris, 1928, pl. 4.

K. Berger, *Géricault,* Vienna, 1952, pl. 4.

Exhibitions:

"Fransk Malerkunst, David-Courbet," Copenhagen, Stockholm, Oslo, 1928.

"Gloires militaires," Musée des Arts Décoratifs, 1935, no. 762.

"Gros, ses amis et ses élèves," Petit-Palais, Paris, 1936, no. 586.

"De David à Millet," Kunsthaus, Zurich, 1937, no. 117.

"Bonaparte en Egypte," Orangerie, Paris, 1938, no. 129.

"Exp. Franco-Egyptienne," Arts Décoratifs, Paris, 1949, no. 454.

53 *Portrait of a Young Man*

Literature:

F. H. Lem, "Géricault portraitiste," *L'Arte* (January-June, 1963, p. 59 ff. (here mistakenly identified with Clément, Peintures, 129).

Exhibitions:

Centenary, Paris and Rouen, 1924, no. 241.

Bernheim-Jeune, Paris, 1937, no. 50.

"Gros, Géricault, Delacroix," Knoedler & Co., New York, 1938, no. 25.

"French Romantic Artists," San Francisco Museum of Art, 1939, no. 19.

"Master Drawings," Golden Gate Exposition, San Francisco, 1940, no. 269.

"French Paintings 1789-1929 from the Collection of Walter P. Chrysler, Jr.," The Dayton Art Institute, Dayton, 1960, no. 13.

"Nineteenth and Twentieth Century French Masters," Finch College Museum of Art, New York, 1962, no. 21.

54 *Portrait of a Boy*

Literature:

C. Clément, Paris, 1867, Peintures, 124.

Sale Catalog, Hôtel Drouot, Paris, December 22, 1920, no. 83.

Sale Catalog, Duc de Trévise coll., Charpentier, Paris, May 19, 1938, no. 31.

F. H. Lem, "Géricault portraitiste," *L'Arte* (January-June, 1963), p. 78.

Exhibitions:

Centenary, Paris and Rouen, 1924, no. 239.

"La jeunesse des romantiques," Maison Victor Hugo, Paris, 1927, no. 1273.

Bernheim-Jeune, Paris, 1937, no. 49.

"Gros, Géricault, Delacroix," Knoedler & Co., New York, 1938, no. 27.

Aubry, Paris, 1964, no. 29.

55  *Portrait Study of a Youth*

Literature: C. Clément, Paris, 1867, Peintures, 129.

Exhibitions:

"Delacroix, ses maîtres, ses amis, ses élèves," Musée des Beaux-Arts, Bordeaux, 1963, no. 286.

Aubry, Paris, 1964, no. 28.

"Géricault to Courbet," Roland, Browse and Delbanco, London, 1965, no. 25.

56  *Portrait of a Young Man in an Artist's Studio*

Literature:

Sale Catalog, A. Vollon coll., Hôtel Drouot, Paris, May 20-23, 1901, no. 164.

R. Bouyer, "Géricault jugé par Delacroix," *Le Figaro artistique* (January 17, 1924), repr. p. 1.

U. Moussali, "Un faux Géricault au Musée du Louvre?" *Figaro littéraire* (January 3, 1959).

G. Bazin, "Non, ce jeune homme n'est pas Géricault," *Arts* (January 14-20, 1959).

L. Eitner, "The Sale of Géricault's Studio in 1824," *Gazette des Beaux-Arts* (February, 1959), pp. 123-124, note 7.

J. Siegfried, "The Romantic Artist as a Portrait Painter," *Marsyas*, VIII (1959), p. 32, fig. 6.

C. Sterling and H. Adhémar, *La peinture au Musée du Louvre, Ecole Française,* I, Paris, 1959, no. 927, pl. 329.

P. Courthion, *Le romantisme,* ed. Skira, 1961, p. 22.

V. N. Prokofiev, *Théodore Géricault,* Moscow, 1963, pp. 169, 170, repr. p. 166.

F. H. Lem, "Géricault portraitiste," *L'Arte* (January-June, 1963), p. 59 ff.

Exhibitions:

"Exposition Centennale," Paris, 1889.

"Gros, ses amis et ses élèves," Petit Palais, Paris, 1936, no. 274.

"Delacroix et les compagnons de sa jeunesse," Atelier Delacroix, Paris, 1947, no. 36.

"Berlioz and the Romantic Imagination," The Arts Council of Great Britain, Victoria and Albert Museum, London, 1969, no. 161.

57  *The Plotting of the Murder of Fualdès ("la Réunion de la Saint-Martin")*

Literature:

Concerning the Fualdès project in general, cf. Clément, p. 364, no. 165, and Duc de Trévise, "Géricault, peintre d'actualités," *Revue de l'art ancien et moderne,* XLIX (1924), p. 102 ff.

Exhibitions:

"Exhibition of Early Drawings," Christopher Powney, London, 1968, no. 31.

"Dessins et aquarelles du XIX *siècle,*" L'Oeil, Galerie d'Art, Paris, 1970, no. 30.

58  *The Assassins Carrying Fualdès' Body to the River*

Literature:

C. Clément, Paris, 1867, Dessins, 165, describes a pencil drawing on "papier de couleur," 220 x 290 mm., in the Lehoux Collection, which may, despite these discrepancies, be identical with the drawing in Lille.

K. Berger, *Géricault,* Vienna, 1952, pl. 57.

59  *Sketches of Horsemen*

Exhibition:

"Exhibition of Early Drawings," Christopher Powney, London, 1968, no. 39.

60  *Sheet of Sketches*

Literature: C. Clément, Paris, 1867, Dessins, 19.

Exhibitions:

Browse, London, 1943.

"A Selection of French Drawings from the Witt Collection," Courtauld Institute Galleries, London, 1962, no. 62.

Swansea, 1962, no. 65.

Nottingham University, 1966.

61  *Field Artillery During a Battle*

Literature:

Guiffrey and Marcel, *Inventaire général des dessins du Musée du Louvre, Ecole Française,* v, Paris, 1910, no. 4165.

C. Martine, *Cinquante-sept dessins de Théodore Géricault,* Paris, 1928, pl. 6.

K. Berger, *Géricault Drawings and Watercolors,* New York, 1946, pl. 7.

Exhibitions:

"Gloires militaires," Musée des Arts Décoratifs, Paris, 1935, no. 1200.

"Gros, ses amis et ses élèves," Petit Palais, Paris, 1936, no. 589.

Bernheim-Jeune, Paris, 1937, no. 100.

62  *General Kléber at Saint-Jean d'Acre*

Literature:

*The Arts* (October, 1927), p. 187.

M. Gauthier, *Géricault,* Paris, 1935, pl. 21.

Exhibitions:

Centenary, Paris and Rouen, 1924, no. 51.

"Chefs-d'oeuvres des musées de province," Orangerie, Paris, 1933, no. 153.

"Deux siècles de gloire militaire," Musée des Arts Decoratifs, Paris, 1935, no. 616.

Bernheim-Jeune, Paris, 1937, no. 103.

"Von David zu Millet," Kunsthaus, Zurich, 1937, no. 139.

"Bonaparte en Egypte," Orangerie, Paris, 1938, np. 377.

"150e anniversaire de la revolution française," Carnavalet, Paris, 1939, not in catalog.

Bignou, Paris, 1950, no. 21.

"French Drawings," The Arts Council of Great Britain, London, 1952, no. 75.

Winterthur, 1953, no. 143.

"Gros, Géricault, Delacroix, "Galerie Bernheim-Jeune, Paris, 1954, no. 43-bis.

Rouen and Charleroi, 1963, no. 28.

63  *Mounted Carabinier Leading an Attack*

Literature:

C. Clément, Paris, 1867, Dessins, 26 and p. 414 (mention of a lithograph after this drawing, by Tayler).

Guiffrey and Marcel, *Inventaire général des dessins du Musée du Louvre, Ecole Française,* v, Paris, 1910, no. 4175.

C. Martine, *Cinquante-sept dessins de Théodore Géricault,* Paris, 1928, pl. 12.

M. Gauthier, *Géricault,* Paris, 1935, pl. 17.

Exhibitions:

"Aquarelles de 1400 à 1900," Orangerie, Paris, 1936, no. 75.

"Chefs-d'oeuvres de l'art français," Paris, 1937, no. 658.

"D'Ingres à Cézanne," Lyon, 1938, no. 30.

"L'aquarelle romantique en France et en Angleterre," Musée de Calais, 1961, no. 58.

64  *Groom Holding a Rearing Horse ("Le Dressage")*

Literature:

Guiffrey and Marcel, *Inventaire général des dessins du Musée du Louvre, Ecole Française,* v, Paris, 1910, 4170.

C. Martine, *Cinquante-sept dessins de Théodore Géricault,* Paris, 1928, pl. 13.

M. Gauthier, *Géricault,* Paris, 1935, pl. 37.

G. Oprescu, *Géricault,* Paris, 1927, opp. p. 156.

Exhibitions:

Lyon, Venice, 1935.

"Gros, ses amis et ses élèves," Petit Palais, Paris, 1936, no. 294.

"Art français," Belgrade, 1939, no. 131.

"Gravures, dessins et aquarelles français du 19e siècle," Prague, 1955, no. 10.

"Le romantisme dans la peinture française," Moscow, 1968, no. 63.

65  *Horses Battling in a Corral*

Literature:

H. S. Francis, "A Drawing by Théodore Géricault," *The Bulletin of the Cleveland Museum of Art,* XX (July, 1933), p. 111 ff.

K. Berger, *Géricault Drawings and Watercolors,* New York, 1946, no. 24, pl. 24.

L. Eitner, "Géricault at Winterthur," *Burlington Magazine,* XCVI (August, 1954), p. 259.

L. Eitner, *Géricault, An Album of Drawings in the Art Institute of Chicago,* Chicago, 1960, fols. 20 and 21, repr. p. 105.

I. Moskowitz, ed., *Great Drawings of All Time,* III, New York, 1962, no. 727.

Exhibitions:

"Pictures, Drawings, and Sculpture of the French School of the Last 100 Years," Burlington Fine Arts Club, London, 1922, no. 52.

"19th Century French Drawings," California Palace of the Legion of Honor, San Francisco, 1947, no. 22.

"Watercolors by the Masters, Dürer to Cézanne," Minneapolis Institute of Arts, 1952, no. 35.

"De David à Toulouse-Lautrec, chefs-d'oeuvres des collections americaines," Orangerie, Paris, 1955, no. 75, ill. pl. 12.

"The Nineteenth Century: One Hundred Twenty-Five Master Drawings," University Gallery, University of Minnesota, Minneapolis, and Solomon R. Guggenheim Museum, New York, 1962, no. 48, ill. pl. 18.

"The Artist and the Animal," Knoedler & Co., New York, 1968, no. 72, ill.

---

66 *Sketchbook Page:*
   *Munitions Cart Drawn by Two Horses*

Literature:

L. Eitner, *Géricault, an Album of Drawings in the Art Institute of Chicago,* Chicago, 1960, folio 4 recto and p. 23.

---

67 *Sketchbook Page:*
   *Seven Sketches of Pairs of*
   *Boxers and Wrestlers*

Literature:

L. Eitner, *Géricault, an Album of Drawings in the Art Institute of Chicago,* Chicago, 1960, folio 14 recto and p. 26.

---

68 *General Letellier After His Suicide*

Literature:

C. Clément, Paris, 1867, Dessins, 176.

Duc de Trévise, "Gèricault, peintre d'actualités," *Revue de l'art ancien et moderne,* XLV (1924), p. 303.

D. Aimé-Azam, *Mazeppa, Géricault et son temps,* Paris, 1956, p. 176.

P. Dubaut, "Géricault, cet ami," *Jardin des Arts* (December, 1958).

F. H. Lem, "Géricault portraitiste," *L'Arte* (January-June, 1963), p. 80.

Exhibitions:

Centenary, Paris and Rouen, 1924, no. 237.

Bernheim-Jeune, Paris, 1937, no. 136.

Bignou, Paris, 1950, no. 25.

Winterthur, 1953, no. 189.

Aubry, Paris, 1964, no. 63.

---

69 *Sketch of a Reclining Woman*

---

70 *Self-portrait*

---

71 *Portrait of a Young Woman*

---

72 *Portrait of a Boy*

Literature:

*Catalogue, Musée du Mans,* Le Mans, 1932, p. 33, no. 144.

M. Gauthier, *Géricault,* Paris, 1935, pl. 32.

Exhibitions:

Centenary, Paris and Rouen, 1924, no. 261-*bis.*

"Les chefs-d'oeuvres des musées de province," Musée Carnevalet, Paris, 1933.

Rouen and Charleroi, 1963, no. 16.

---

73 *Portrait of a Man*

Literature:

C. Clément, Paris, 1867, Peintures, 119.

*The Arts,* XII (1927), no. 4, p. 190.

K. Berger, *Géricault,* Vienna, 1952, pl. 35.

F. H. Lem, "Géricault portraitiste," *L'Arte* (January-June, 1963), p. 78.

Exhibitions:

Centenary, Paris and Rouen, 1924, no. 243.

Bernheim-Jeune, Paris, 1937, no. 29.

"Goya, Bonington, Géricault, Delacroix," Galerie Dubourg, Paris, 1951, no. 33.

Winterthur, 1953, no. 65.

---

74 *The Rescue of the Survivors*
   *of the Raft of Medusa*

Literature:

C. Clément, Paris, 1867, Dessins, 112.

A. del Guercino, *Géricault,* Milan, 1963, pl. 56.

Exhibitions:

Bernheim-Jeune, Paris, 1937, no. 126.

Bignou, Paris, 1950, no. 45.

Marlborough, London, 1952, no. 49, ill.

Winterthur, 1953, no. 173.

"Gros, Géricault, Delacroix," Bernheim-Jeune, Paris, 1954, no. 53.

Aubry, Paris, 1964, no. 68, ill.

---

75 *The Mutiny on the Raft*

Literature:

*Beschrijving der schilderijen, teekeningen, etc. in het Museum Fodor te Amsterdam,* Amsterdam, 1863, no. 823.

C. Clément, Paris, 1867, Dessins, 109.

R. Huyghe, *Le dessin français au* XIX *siècle,* Lausanne, 1948, pl. 16.

K. Berger, *Géricault,* Vienna, 1952, pl. 46.

J. Q. van Regteren Altena, "Het vlot van de Medusa," *Openbaar Kunstbezit,* V (1961), no. 10, ill.

L. Eitner, "Reversals of Direction in Géricault's Compositional Projects," *Stil und Ueberlieferung in der Kunst des Abendlandes,* III (Berlin, 1967), p. 132, pl. III/23-3.

---

Exhibitions:

"Teekeningen van Fransch Meesters," Gemeentemusea, Amsterdam, 1946, no. 102.

"Die Handschrift des Kuenstlers," Staedtische Kunsthalle, Recklinghausen, 1959, no. 109.

"Polaritaet, das Apollinische und das Dionysische," Staedtische Kunsthalle, Recklinghausen, 1961, no. D-95, ill.

"Idee und Vollendung," Staedtische Kunsthalle, Recklinghausen, 1962, no. 20-B, ill.

Rouen and Charleroi, 1963, no. 31.

"Fodor 100 Jaar," Fodor Museum, Amsterdam, 1963, no. 74, ill.

---

76 *Fall of the Rebel Angels*
   *(After Rubens)*

Literature:

*Fac-similes extraits des livres de croquis de Géricault,* Paris, 1825, pl. 15 (lithographic reproduction of the drawing by Deveria; cf. Clément, p. 420).

L. Eitner, "Dessins de Géricault d' après Rubens et la génèse du Radeau de la Meduse," *Revue de l'art* (1971).

Exhibition:

"Master Drawings in Californian Collections," University Gallery, University of California, Berkeley, 1968, no. 84.

---

77 *The Survivors on the Raft Hailing*
   *an Approaching Rowboat*

Literature:

P. Gonse, *Chefs-d'oeuvres des musées de France,* II, Paris, 1904, p. 318.

P. Lafond, *Le Musée de Rouen,* n.d., p. 78.

M. Delâcre and P. Lavallée, *Dessins de maîtres ançiens,* Paris, 1927, p. 94.

R. Regamey, *Géricault,* Paris, 1926, pl. 17.

G. Oprescu, *Géricault,* Paris, 1927, p. 97.

J. Knowlton, "Stylistic Origins of Géricault's Raft of the Medusa," *Marsyas* II (1942), p. 133.

W. Friedlaender, *David to Delacroix,* Cambridge, 1952, fig. 60.

Exhibitions:

"Exposition Centennale," Paris, 1900.

"Fransk Malerkunst," Copenhagen, 1914, no. 286.

Centenary, Paris and Rouen, 1924, no. 121.

Bernheim-Jeune, Paris, 1937, no. 125.

"David à Millet," Kunsthaus, Zurich, 1937, no. 141-A.

"Meisterzeichnungen aus Frankreichs Museen," Vienna, 1950, no. 147.

Winterthur, 1953, no. 174.

"Gros, Géricault, Delacroix," Bernheim-Jeune, Paris, 1954, no. 53-*bis.*

"French Drawings," Chicago, Minneapolis, Detroit, San Francisco, 1955, no. 111 (1), pl. 22.

"Franzoesische Zeichnungen," Hamburg, Cologne, Stuttgart, 1958, no. 133 (1).

"Idee und Vollendung" Staedtische Kunsthalle, Recklinghausen, 1962, no. 200.

Rouen and Charleroi, 1963, no. 32.

78  *The Sighting of the Rescue Ship*

Literature:

Sale Catalog, Jules Boilly coll., March 19-20, no. 118, ill.

*Catalogue, Dessins,* Musée Wicar, Lille, 1887, p. 310, no. 1391.

Pluchart, *Catalogue du Musée Wicar,* Lille, 1899, no. 1391.

J. Knowlton, "Stylistic Origins of Géricault's Raft of the Medusa," *Marsyas,* II (1942), p. 133, pl. XLVI, fig. 16.

L. Eitner, "Reversals of Direction in Géricault's Compositional Projects," *Stil und Ueberlieferung in der Kunst des Abendlandes,* III (Berlin, 1967), p. 132, pl. III/24-2.

Exhibitions:

"Idee und Vollendung," Staedtische Kunsthalle, Recklinghausen, 1962, no. 20-J.

Rouen and Charleroi, 1963, no. 36, ill.

79  *The Sighting of the Rescue Ship*

Literature:

*Catalogue, Musées des Beaux-Arts,* Rouen, 1890, no. 773.

P. Gonse, *Chefs-d'oeuvres des musées de France,* II, Paris, 1904, p. 318.

*Catalogue, Musées des Beaux-Arts,* Rouen, 1911, no. 1385.

P. Lafond, *Le Musée de Rouen,* Rouen, n.d., p. 78.

M. Delâcre and P. Lavallée, *Dessins des maîtres anciens,* Paris, 1927, p. 194, pl. 47.

J. Knowlton, "Stylistic Origins of Géricault's Raft of the Medusa," *Marsyas,* II (1942), p. 133, pl. XLVI, fig. 17.

K. Berger, *Géricault, Drawings and Watercolors,* New York, 1946, pl. 27.

W. Friedlaender, *David to Delacroix,* New York, 1952, pl. 59.

L. Eitner, "Reversals of Direction in Géricault's Compositional Projects," *Stil und Ueberlieferung in der Kunst des Abendlandes,* III (Berlin, 1967), p. 133, pl. III/24-4.

Exhibitions:

"Idee und Vollendung," Staedtische Kunsthalle, Recklinghausen, 1962.

Rouen and Charleroi, 1963, no. 33.

80  *The Raft of the Medusa*

Literature:

C. Clément, Paris, 1867, Peintures, 98.

K. Berger, *Géricault,* Vienna, 1952, pl. 42.

L. Eitner, "The Sale of Géricault's Studio in 1824," *Gazette des Beaux-Arts,* I (1959), pp. 117-118.

C. Sterling and H. Adhémar, *La peinture au Musée du Louvre, Ecole Française,* I, Paris, 1959, no. 945, pl. 338.

V. N. Prokofiev, *Théodore Géricault,* Moscow, 1963, pl. 136.

L. Eitner, "Reversals of Direction in Géricault's Compositional Projects, *Stil und Ueberlieferung in der Kunst des Abendlandes,* III (Berlin, 1967), p. 133.

Exhibitions:

Centenary, Paris and Rouen, no. 135.

"Fransk Malerkunst, David-Courbet," Copenhagen, Stockholm, Oslo, 1928, no. 77.

"Gros, ses amis et ses élèves," Petit Palais, Paris, 1936, no. 843.

"Fransk Kunst," Copenhagen, 1938, no. 83.

"Art français," Belgrade, 1939, no. 56.

"De David a nuestros dias," Buenos Aires, 1939, no. 64.

"Delacroix et les compagnons de sa jeunesse," Paris, 1947, no. 40.

Winterthur, 1953.

"Idee und Vollendung," Staedtische Kunsthalle, Recklinghausen, 1962, no. 20-K.

Rouen and Charleroi, 1963, no. 3, ill.

"Delacroix," Bordeaux, 1963, no. 284.

"Le romantisme dans la peinture française," Moscow, Leningrad, 1968-1969, no. 58.

"The Past Re-Discovered," Minneapolis Institute of Arts, 1969, no. 40.

81  *The Raft of the Medusa*

Literature: C. Clément, Paris, 1867, Dessins, 115.

Exhibition:

Aubry, Paris, 1964, no. 77, ill.; verso, no. 76, ill.

82  *Studies of a Reclining Male Nude; a Seated Figure*

Literature:

L. Eitner, "Dessins de Géricault d'après Rubens, et la génèse du Radeau de la Méduse," *Revue de l'art* (1971).

83  *Study of the "Father" for the Raft of the Medusa*

Literature:

C. Clément, Paris, 1867, Dessins, 126.

Pluchart, *Catalogue, Notice des Dessins,* Musée Wicar, Lille, p. 310, no. 1393.

Exhibitions:

"Idee und Vollendung," Staedtische Kunsthalle, Recklinghausen, 1962, no. 20-C.

Rouen and Charleroi, 1963, no. 41 (the verso).

84  *Study of a Kneeling Man Reaching Forward with Both Arms*

85  *Study for the Body of a Dead Youth*

Literature:

*Catalogue des tableaux, dessins et sculptures du Musée d'Alençon,* Alençon, 1862, p. 16, no. 50.

*Catalogue du Musée d'Alençon,* Alençon, 1909, p. 11, no. 44.

*Peintures du Musée d'Alençon,* Alençon, 1938, p. 33, no. 87.

86  *Study of a Nude Man Lying on His Back*

Literature:

C. Clément, Paris, 1867, Dessins, 125.

W. Hausenstein, *Der Koerper des Menschen in der Geschichte der Kunst,* Munich, 1916, p. 585, fig. 535.

Exhibitions:

"Von David zu Millet," Kunsthaus, Zurich, 1937, no. 136, pl. 5.

"De Watteau à Cézanne," Musée d'Art et d'Histoire, Geneva, 1951, no. 130.

Winterthur, 1953, no. 178.

Rouen and Charleroi, 1963, no. 42.

"Franzoesische Zeichnungen," Freiburg im Breisgau, May-June, 1963.

"Précurseurs de l'art moderne," Ornans, August-September, 1964.

87  *Study of a Nude Man Lying on His Back*

Literature: C. Clément, Paris, 1867, Dessins, 124.

88  *Four Studies of the Severed Head of a Man*

Literature: C. Clément, Paris, 1867, Dessins, 132.

Exhibitions:

Winterthur, 1953, no. 185.

Rouen and Charleroi, 1963, no. 47.

89  *Four Studies of the Severed Head of a Man*

Literature: C. Clément, Paris, 1867, Dessins, 135.

Exhibitions:

Centenary, Paris and Rouen, 1924, no. 133.

Bernheim-Jeune, Paris, 1937, no. 133.

Bignou, Paris, 1950, no. 51.

Marlborough, London, 1952, no. 54.

Winterthur, 1953, no. 184.

Aubry, Paris, 1964, no. 71.

90  *Study of the Severed Head of a Man*

Literature:

A. del Guercino, *Géricault,* Milan, 1963, p. 65.

Exhibitions:

Centenary, Paris and Rouen, 1924, no. 132.

"Gros, ses amis et ses élèves." Petit Palais, Paris, 1936, (not listed in the catalog).

Bernheim-Jeune, Paris, 1937, no. 43.

Marlborough, London, 1952, no. 24.

Winterthur, 1953, no. 81.

Aubry, Paris, 1964, no. 25.

91  *Study of Two Severed Legs and an Arm*

Literature:

L. Eitner, "Géricault in Winterthur," *The Burlington Magazine,* XCVI (August, 1954), p. 254 ff., pl. 25.

Exhibitions:

Centenary, Paris and Rouen, 1924, no. 118 (also listed under no. 130).

Bernheim-Jeune, Paris, 1937, no. 42.

Marlborough, London, 1952, no. 25.

Winterthur, 1953, no. 83.

"Quatre siècles de natures mortes françaises," Museum Boymans-van Beuningen, Rotterdam, 1954, no. 68, ill. p. 37.

"Natures mortes de Géricault à nos jours," Musée de St.-Etienne, 1955, no. 2.

Aubry, Paris, 1964, no. 24, ill.

___

92 *After Death*
*(Study of the Head of a Corpse)*

Literature:

M. Gauthier, *Géricault,* Paris, 1935, pl. 59.

K. Berger, *Géricault,* Vienna, 1952, p. 72, pl. 52.

W. Friedlaender, *David to Delacroix,* Cambridge, 1952, p. 97 ff., pl. 57.

D. Aimé-Azam, *Mazeppa, Géricault et son temps,* Paris, 1956, p. 216.

*Catalogue: Art Institute of Chicago,* Chicago, 1961, p. 173, ill. p. 232.

A. del Guercino, *Géricault,* Milan, 1963, p. 66.

Exhibitions:

"Gros, ses amis et ses élèves," Petit Palais, Paris, 1936, no. 279.

Bernheim-Jeune, Paris, 1937, no. 44, ill.

"Night Scenes," Wadsworth Atheneum, Hartford, 1940, no. 43.

"De David à Toulouse-Lautrec, chefs-d'oeuvres des collections americaines," Orangerie, Paris, 1955, no. 31, pl. 9.

"1965 Fogg Museum Course Exhibition," Fogg Art Museum, Cambridge, 1965.

"Berlioz and the Romantic Imagination," The Arts Council of Great Britain, Victoria and Albert Museum, London, 1969, no. 43, p. 18.

___

93 *Study of the Head of a Young Man*

Exhibitions:

Centenary, Paris and Rouen, 1924, no. 129.

"Festival Européen," Saarbrücken, 1954, no. 93.

Rouen and Charleroi, 1963, no. 8.

___

94 *Study for the Head of a Dead Man*

Exhibitions:

Centenary, Paris and Rouen, 1924, no. 119.

"Géricault to Courbet," Roland, Browse and Delbanco, London, 1965, no. 26, ill.

___

95 *A Hanging in London*

Literature:

C. Clément, Paris, 1867, Dessins, 140.

R. Huyghe, *Le dessin français au* XIX *siècle,* Lausanne, 1948, pl. 17.

K. Berger, *Géricault,* Vienna, 1952, pl. 68.

D. Aimé-Azam, *Mazeppa, Géricault et son temps,* Paris, 1956, opp. p. 240.

Exhibitions:

Centenary, Paris and Rouen, 1924 (not listed in the catalog).

___

Bernheim-Jeune, Paris, 1937, no. 138.

"Von David zu Millet," Kunsthaus, Zurich, 1937, no. 142

Bignou, Paris, 1950, no. 55.

"Meisterzeichnungen aus Frankreichs Museen," Berlin and Vienna, 1950, no. 166.

Winterthur, 1953, no. 208.

"Gros, Géricault, Delacroix," Bernheim-Jeune, Paris, 1954, no. 64-*bis*.

"Französische Zeichnungen," Hamburg, Cologne, Stuttgart, 1958.

Rouen and Charleroi, 1963, no. 52.

___

96 *London Sketches: Lavender Seller,*
*Male Head, Head of a Horse, Two Hands*

Exhibitions:

Bernheim-Jeune, Paris, 1937, no. 150.

Bignou, Paris, 1950, no. 60.

Aubry, Paris, 1964, no. 79.

___

97 *English Horse Race*

Literature:

C. Martine, *Cinquante-sept dessins de Théodore Géricault,* Paris, 1928, pl. 27.

S. Lodge, "Géricault in England," *Burlington Magazine,* CVII (December, 1965), p. 616 ff.

Exhibitions:

Centenary, Paris and Rouen, 1924, no. 142.

"David, Ingres, Géricault et leur temps," Ecole des Beaux-Arts, Paris, 1934.

___

98 *Groom Leading a Thoroughbred*
*("Pur Sang")*

Literature:

Guiffrey and Marcel, *Inventaire général des dessins du Musée du Louvre, Ecole Française,* V, Paris, 1910, no. 4181.

R. Regamey, *Géricault,* Paris, 1926, pl. 34.

C. Martine, *Cinquante-sept dessins de Théodore Géricault,* Paris, 1928, pl. 10.

M. Gauthier, *Géricault,* Paris, 1935, pl. 10.

Exhibitions:

Galerie Charpentier, 1925.

Maisons-Lafitte, 1926.

"La jeunesse des romantiques," Maison Victor Hugo, Paris, 1927.

Winterthur, 1953, no. 200.

___

99 *Woman in a Riding Costume on*
*a Dappled Grey Horse*

Literature:

R. Hoetink, *Franse teekeningen uit de 19e Eeuw,* Museum Boymans-van Beuningen, Rotterdam, 1968, no. 141.

Exhibitions:

"Ein Jahrhundert Franzoesischer Zeichnung," P. Cassirer, Berlin, 1929-1930, no. 62.

"Teekeningen van Ingres tot Seurat," Museum Boymans-van Beuningen, Rotterdam, 1933-34, no. 65.

___

"Meisterzeichnungen französischer Künstler von Ingres bis Cézanne," Kunsthalle, Basel, 1935, no. 18.

"Teekeningen van Ingres, Delacroix, Géricault, Daumier, etc.," Museum Boymans-van Beuningen, Rotterdam, 1935-1936, no. 42.

"Chefs-d'oeuvres de l'art français," Palais National des Arts, Paris, 1937, no. 657.

"Fransche Meesters uit de 19e Eeuw," Paul Cassirer, Amsterdam, 1938, no. 69.

"Teekeningen van Fransche Meesters, 1800-1900," Stedelijk Museum, Amsterdam, 1946, no. 106.

"Dessin du 15e au 19e siècle," Museum Boymans-van Beuningen, Rotterdam; Bibliothèque Nationale, Paris, 1952, no. 101.

Winterthur, 1953, no. 196.

"Europäische Meister 1790-1910," Kunstmuseum, Winterthur, 1955, no. 196.

Franse teekeningen uit de 19e Eeuw," Museum Boymans-van Beuningen, Rotterdam, 1968, no. 141.

___

100 *Four Sketches of an Oriental*
*Horseman Attacked by a Tiger*

___

101 *Lion and Lioness*

Literature: C. Clément, Paris, 1867, Dessins, 52.

Guiffrey and Marcel, *Inventaire général des dessins du Musée du Louvre, Ecole Française,* V, Paris, 1910, no. 4185.

M. Gauthier, *Géricault,* Paris, 1935, pl. 45.

K. Berger, *Géricault,* Vienna, 1952, pl. 38.

Exhibition: Winterthur, 1953, no. 152.

___

102 *Lion Attacking a White Horse*

Literature:

C. Clément, Paris, 1867, Dessins, 101.

H. R. Hoetink, *Franse teekeningen uit de 19e Eeuw,* Museum Boymans-van Beuningen, Rotterdam, 1968, no. 140.

Exhibitions:

Centenary, Paris and Rouen, 1924, no. 215.

"Teekeningen van Ingres tot Seurat," Museum Boymans-van Beuningen, 1933-34, no. 66.

"Teekeningen van Ingres, Delacroix, Géricault, Daumier uit de verzameling Koenigs," Museum Boymans-van Beuningen, Rotterdam, 1935-36, no. 43.

"Zeichnungen französischer Meister," Kunsthaus, Zurich, 1937, no. 153.

"Teekeningen van Fransche Meesters, 1800-1900," Stedelijk Museum, Amsterdam, 1946, no. 105.

"Franse teekeningen uit de 19e Eeuw," Museum Boymans-van Beuningen, Rotterdam, 1968, no. 140.

___

103 *Sketches of Horses*

Literature:

*Yale University Gallery Bulletin* (April 1, 1959), p. 23.

S. Longstreet, *The Horse in Art,* Alhambra, California, 1966.

K. H. Spencer, *The Graphic Art of Géricault,* Yale University Art Gallery, New Haven, 1969, p. 26 ff.

European Drawings and Watercolors in the Yale University Art Gallery, Yale University Art Gallery, New Haven, 1970, no. 127, pls. 48 and 49.

Exhibitions:

"Great Master Drawings of Seven Centuries," M. Knoedler & Co., New York; Allen Memorial Art Museum, Oberlin, 1959, no. 65.

"French Masters, Rococo to Romanticism," UCLA Art Galleries, Los Angeles, 1961, no. 70.

"The Graphic Art of Géricault," Yale University Art Gallery, New Haven, 1969, no. 28.

## 104 A Beer Cart in an Inn Yard ("Le Haquet")

Literature:

C. Clément, Paris, 1867, Peintures, 96.

Catalogue des tableaux composant la galerie Delessert, Paris, March 17-18, 1869, p. 70, no. 151.

Sale Catalog, Delessert coll., Hôtel Drouot, Paris, May, 11, 1911, no. 27.

Museum Notes, Rhode Island School of Design, II, no. 3 (March, 1944).

Art News, XLIII, no. 18 (January 1-14, 1945), p. 23, ill.

Gazette des Beaux-Art (April, 1945), pp. 232, 239, fig. 9.

Art News, XLVIII (March, 1950), ill.

K. Berger, Géricault, Vienna, 1952, no. 77.

Exhibitions:

Galerie Lebrun, Rue des Jeuneurs, Paris, 1826.

Kronprinz Palais, Berlin, 1928-1933.

Kunsthaus, Zurich.

"The 19th Century Heritage," Paul Rosenberg & Co., New York, 1950, no. 9.

"The Romantic Circle," Wadsworth Atheneum, Hartford, 1952, no. 20.

Paul Rosenberg & Co., New York, 1957.

## 105 The Village Forge

Literature:

A. Jal, L'artiste et le philosophe, entretiens critiques sur le Salon de 1824, Paris, 1824, p. 186.

Revue critique du Salon de 1824, Paris, 1825, p. 103.

C. Blanc, Histoire des peintres français au 19e siècle, I, Paris, 1845, p. 439.

C. Blanc, Histoire des peintres — Ecole Française, III, Paris, 1863, p. 12.

C. Clément, Paris, 1867, Peintures, 142, and p. 226.

C. Cunningham, "Village Forge by J. L. A. Théodore Géricault," Wadsworth Atheneum Bulletin, second series, n. 12 (December, 1959), p. 1, ill.

Exhibitions:

Salon of 1824, no. 760.

Centenary, Paris and Rouen, 1924, no. 186.

"Rehabilitation du sujet," Galerie A. Seligman, Paris, 1934.

Bernheim-Jeune, Paris, 1937, no. 62.

"Chevaux et cavaliers," Charpentier, Paris, 1938, no. 66.

"The Romantic Circle," Wadsworth Atheneum, Hartford, 1952, no. 22.

## 106 Two Posthorses at the Entrance of a Stable

Literature:

C. Clément, Paris, 1867, Peintures, 143.

M. Gauthier, Géricault, Paris, 1935, pl. 47.

C. Sterling and H. Adhemar, La peinture au Musée National du Louvre, Ecole Française, I, Paris, 1959, no. 949.

Exhibitions:

"Exposition au profit des Grecs," Galerie Lebrun, Paris, 1826, no. 87.

"Delacroix et les compagnons de sa jeunesse," Atelier Delacroix, Paris, 1947, no. 39.

## 107 Dappled Draught Horse Being Shod

Exhibitions:

"Chevaux et Cavaliers," Galerie Charpentier, Paris, 1948.

Bignou, Paris, 1950, no. 73.

"De Watteau à Cézanne," Geneva, 1951, no. 132.

"Early Lithography: 1800-1840," Annmary Brown Library, Brown University, Providence, 1968.

"The Graphic Art of Géricault," Yale University Art Gallery, New Haven, 1969, no. 37, ill.

## 108 Study of a Farrier

## 109 Stallion Covering a Mare ("La Monte")

Exhibition:

"100 chefs-d'oeuvres de l'art français," Charpentier, Paris, 1957.

Aubry, Paris, 1964, no. 83.

## 110 Study of an Oriental

Exhibitions:

Centenary, Paris and Rouen, 1924, no. 266.

Bernheim-Jeune, Paris, 1937, no. 157.

"Un siècle d'aquarelle," Charpentier, Paris, 1942.

Bignou, Paris, 1950, no. 66.

Marlborough, London, 1952, no. 43.

Winterthur, 1953, no. 214.

"Gros, Géricault, Delacroix," Bernheim-Jeune, Paris, 1954, no. 65.

Aubry, Paris, 1964, no. 87.

## 111 Negro Soldier Holding a Lance

Literature:

C. Clément, Paris, 1867, Dessins, 175-bis.

Sale Catalog, Marmontel coll., Hôtel Drouot, Paris, January 25-26, 1883, no. 116.

Sale Catalog, Marmontel coll., Hôtel Drouot, Paris, March 28 -29, 1898, no. 134.

Apollo, St. Petersburg, 1912, p. 23.

Société de reproductions des dessins de maître, IV, 1912, pl. 1.

Sale Catalog, Beurdeley coll., G. Petit, Paris, June 2-4, 1920, no. 167.

Leporini, Die Künstlerzeichnung, Berlin, 1928, pl. 127.

A. Mongan and P. Sachs, Drawings in the Fogg Collection, Cambridge, 1940, no. 694, fig. 365.

K. Berger, Géricault Drawings and Watercolors, New York, 1946, p. 33, pl. 46.

K. Berger, Géricault, Vienna, 1952, pl. 82.

C. G. Heise, Grosse Zeichner des XIX Jahrhunderts, Berlin, 1959, p. 84, no. 64.

F. H. Lem, "Le thème du nègre dans l'oeuvre de Géricault," L'Arte (January-June, 1962), p. 29.

A. del Guercino, Géricault, Milan, 1963, pp. 86, 151, pl. 89.

Exhibitions:

"Exposition Centennale," Paris, 1900, no. 984.

"Exposition centennale de l'art français," St. Petersburg, 1912, no. 276.

"Exposition centennale de l'art français," Geneva, 1918.

"Géricault," Smith College, Northampton, 1929, no. 15.

"French Painting of the XIX Century, Fogg Art Museum, Cambridge, 1929, no. 77.

"Exhibition of French Art, 1200-1900," Royal Academy, London, 1932, no. 900.

City Art Museum, St. Louis, 1932.

The Brooklyn Museum, 1938.

"19th Century French Drawings," California Palace of the Legion of Honor, San Francisco, 1947, no. 25.

"De David à Toulouse-Lautrec, chefs-d'oeuvres des collections americaines," Orangerie, Paris, 1955, no. 76, pl. 11.

"French Drawings from American Collections," Museum Boymans-van Beuningen, Rotterdam; Orangerie, Paris; The Metropolitan Museum of Art, New York, 1958-59, no. 123, pl. 112.

"Works of Art from the Collection of Paul J. Sachs," Fogg Art Museum, Cambridge, 1965, no. 42, ill.

## 112 Portrait of a Negro

Literature:

L. H. Lem, "Le thème du nègre dans l'oeuvre de Géricault," L'Arte (January-June, 1962), p. 17.

K. Berger and D. C. Johnson, "Art and Confrontation: the Black Man in the Work of Géricault," The Massachusetts Review (Spring, 1969).

Exhibitions:

"Exposition Coloniale," Paris, 1931.

"Unbekannte Schoenheit," Zurich, 1956, no. 118.

"Portraits français de Largillière à Manet," Copenhagen, 1960, no. 19; Rome, 1961, no. 98.

## 113 Portrait Study of a Negro

Literature:

Kunst und Kuenstler, 1913, p. 279.

A. Michel, Histoire de l'art, VIII, Ie partie, Paris, 1925, p. 119.

R. Regamey, Géricault, Paris, 1926, pl. 29.

K. Berger, Géricault, Vienna, 1952, pp. 57, 77, pl. 89.

Art Digest, vol. 27, no. 4 (November 15, 1952), p. 9.

The Art Quarterly, XVI, no. 2 (Summer, 1953), p. 163 ill. p. 164.

*Gallery Notes,* Albright Gallery, XVII, no. 1, p. 8, ill. p. 17.

K. Berger and D. C. Johnson, "Art and Confrontation: the Black Man in the Work of Géricault," *The Massachusetts Review* (Spring, 1969).

Exhibitions:

"Millenaire Normand," Rouen, 1911.

"Exposition centennale de l'art français," St. Petersburg, 1912, no. 13.

Nye-Carlsberg Glyptothek, Copenhagen, 1919.

Kunstmuseum, Basel, 1925-26.

"The Romantic Circle," Wadsworth Atheneum, Hartford, 1952, no. 16.

"Paintings and Sculptures from the Albright Art Gallery," Yale University Gallery, New Haven, 1961, no. 25.

"Inaugural Exhibition," Museum of Fine Arts, St. Petersburg, Florida, 1965.

---

114 *Scene of the Plague at Missolunghi*

Literature:

C. Clément, Paris, 1867, Peintures, 149.

J. Meier-Graefe and E. Klossowski, *La collection Chéramy,* Munich, 1908, no. 107.

M. Gauthier, *Géricault,* Paris, 1935, pl. 51.

K. Berger, *Géricault,* Vienna, 1952, p. 85, pl. 78.

*European Art in the Virginia Museum of Fine Arts,* Richmond, n.d., p. 43, ill.

Exhibitions:

"La réhabilitation du sujet," Galerie A. Seligman, Paris, 1934, no. 103.

"Chefs-d'oeuvres de l'art français," Palais National des Arts, Paris, 1937, no. 337.

"Selected French Paintings of the XIX and XX Century," Lefevre Gallery, London, 1953, no. 7.

"French Masters, Rococo to Romanticism," UCLA Art Galleries, Los Angeles, 1961, p. 36, ill.

---

115 *Sea Coast with Fishermen*

Literature:

C. Clément, Paris, 1867, Peintures, 17.

*Die Sammlung eines Sueddeutschen Kunstfreundes,* Cassirer & Helbig, March 3-4, 1925, pl. 21 (the appearance of the picture before removal of the over-painting).

L. Eitner, "Géricault's *'La Tempête',*" *Museum Studies,* 2, The Art Institute of Chicago (Chicago, 1967), p. 10 ff., figs. 6-7.

T. Brachett, "Beobachtungen an einem Gemaelde von Géricault," *Maltechnik,* LXXIII (1967), Heft 2, p. 33.

---

116 *The Body of a Woman Discovered on a Beach by a Monk ("La Tempête")*

Literature:

L. Eitner, "Géricault's *'La Tempête',*" *Museum Studies,* 2, The Art Institute of Chicago (Chicago, 1967), p. 7 ff.

---

117 *The Body of a Woman and Child on a Rocky Beach ("La Tempête")*

Literature:

C. Clément, Paris, 1867, Peintures, 67.

---

Fierens-Gevaert, *Catalogue de la peinture ancienne,* Musées Royaux des Beaux-Arts de Belgique, Brussels, 1922, p. 107, no. 735.

R. Regamey, *Géricault,* Paris, 1927, pl. 158.

P. Courthion, *Géricault, raconté par lui-même et par ses amis,* Vézenas-Geneva, 1947, p. 160.

G. Oprescu, *Géricault,* Paris, s.d., 1958.

L. Eitner, "Géricault's *'La Tempête',*" *Museum Studies,* 2, The Art Institute of Chicago (Chicago, 1967), p. 7 ff., fig. 2.

Exhibitions:

Centenary, Paris and Rouen, 1924, no. 176.

"Gros, ses amis et ses élèves," Petit Palais, Paris, 1936, no. 286.

Marlborough Gallery, London, October-November, 1952.

Winterthur, 1953, no. 112.

Rouen and Charleroi, 1963, no. 2.

"Marines, vues de port et paysages fluviaux, Brussels, November-December, 1960, no. 29.

---

118 *Shipwrecked Man on a Beach*

---

119 *Liberation of the Prisoners of the Spanish Inquisition*

Literature:

C. Clément, Paris, 1867, Dessins, 161.

P. Courthion, *Géricault, raconté par lui-même et par ses amis,* Vézenas-Geneva, 1947, p. 321.

K. Berger, *Géricault,* Vienna, 1952, pl. 85.

Exhibitions:

Centenary, Paris and Rouen, 1924, no. 293.

"Gros, ses amis et ses élèves," Petit Palais, Paris, 1936 (not listed in the catalog).

Bernheim-Jeune, Paris, 1937, no. 161.

Bignou, Paris, 1950, no. 71.

Winterthur, 1953, no. 224.

"Gros, Géricault, Delacroix," Galerie Bernheim-Jeune, Paris, 1954, no. 70.

Aubry, 1964, no. 92.

---

120 *The African Slave Trade*

Literature:

C. Clément, Paris, 1867, Dessins, 159, and pp. 232, 261.

L. Rosenthal, *Géricault,* Paris, 1905, opp. p. 160.

C. Martine, *Cinquante-sept dessins de Théodore Géricault,* Paris, 1928, pl. 36.

M. Gauthier, *Géricault,* Paris, 1935, pl. 60.

K. Berger, *Géricault, Drawings and Watercolors,* New York, 1946, pl. 48.

K. Berger, *Géricault,* Vienna, 1952, pl. 87.

K. Berger and D. C. Johnson, "Art and Confrontation: the Black Man in the Work of Géricault," *The Massachusetts Review* (Spring, 1969).

Exhibitions:

Centenary, Paris and Rouen, 1924, no. 291.

Winterthur, 1953, no. 222.

---

121 *Self-portrait*

Literature:

R. Regamey, *Géricault,* Paris, 1926, pl. 1.

P. Courthion, *Géricault, raconté par lui-même et par ses amis,* Vézenas-Geneva, 1947, opp. p. 7.

*Burlington Magazine* (August, 1954), p. 258.

Exhibitions:

Centenary, Paris and Rouen, 1924, no. 295.

Bernheim-Jeune, Paris, 1937, no. 46.

Winterthur, 1953, no. 87.

Rouen and Charleroi, 1963, no. 19.

---

122 *Portrait of an Insane Man ("Kidnapper")*

Literature:

C. Clément, Paris, 1867, Peintures, 156- (b).

M. Hamal, *Gazette des Beaux-Arts,* XXXV, p. 256.

L. Rosenthal, *Géricault,* Paris, 1905, p. 141.

M. G., "A propos de Géricault," *Le Progrès Médical* (Paris, 1920), no. 20.

G. Oprescu, *Géricault,* Paris, 1927, p. 162 ff.

Cadinouche, *La médecine dans l'oeuvre de Géricault,* dissertation, Paris, 1927.

Sale Catalog, Duc de Trévise coll., Charpentier, Paris, 1938, p. 35, no. 35.

M. Miller, "Géricault's Paintings of the Insane," *Journal of the Warburg and Courtauld Institutes,* IV (1940-41), p. 151 ff.

K. Berger, *Géricault,* Vienna, 1952, pl. 92.

D. Aimé-Azam, *Mazeppa, Géricault et son temps,* Paris, 1956, opp. p. 248.

Exhibition:

"French Masters, Rococo to Romanticism," UCLA Art Galleries, Los Angeles, 1961, p. 34, ill.

---

123 *Portrait of an Insane Man ("Kleptomaniac")*

Literature:

C. Clément, Paris, 1867, Peintures, 157-(c).

J. Meier-Graefe and E. Klossowski, *La collection Chéramy,* Munich, 1908, p. 79, no. 108.

D. Aimé-Azam, *La passion de Géricault,* France, 1970.

Cf. the items listed under no. 123 of this catalog.

Exhibitions:

Centenary, Paris and Rouen, 1924, no. 263.

"The Past Re-Discovered," Minneapolis Institute of Arts, 1969, no. 41.

---

124 *Portrait of an Insane Woman ("Mania of Gambling")*

Literature:

C. Clément, Paris, 1867, Peintures, 158-(d).

Sale Catalog, Duc de Trévise coll., Charpentier, Paris, 1938, p. 34, no. 34.

M. Florisoone, "La folle de Géricault," *Bulletin des Musées de France,* X (1938), no. 6.

N. Miller, "Géricault's Paintings of the Insane," *Journal of the Warburg and Courtauld Institutes* (1940-1941), pp. 150-163.

K. Berger, *Géricault,* Vienna, 1952, pp. 38-40 and p. 78, no. 93, pl. 93.

C. Sterling and H. Adhémar, *La peinture au Musée National du Louvre, Ecole Française,* I, Paris, 1959, no. 957.

V. N. Prokofiev, *Théodore Géricault,* Moscow, 1963, p. 174.

Cf. the items listed under no. 123 of this catalog.

Exhibitions:

Centenary, Paris and Rouen, 1924, no. 264.

"La jeunesse des romantiques," Maison Victor Hugo, Paris, 1927, no. 1275.

"Art Français," Copenhagen, Stockholm, Oslo, 1928.

"Cent ans de portraits français, 1800-1900," Bernheim-Jeune, Paris, 1934, no. 37.

"Gros, ses amis et ses élèves," Petit Palais, Paris, 1936, no. 272.

Bernheim-Jeune, Paris, 1937, no. 75.

"Chefs-d'oeuvres de l'art français," Paris, 1937, no. 336.

"Les peintures du Ier Empire," Galerie Drouin, Paris, 1942, no. 21.

"Dons des amis du Louvre," Orangerie, Paris, 1953, no. 37.

Rouen and Charleroi, 1963, no. 20.

"Le romantisme dans la peinture française," Moscow, 1968; Leningrad, 1969, no. 60.

---

125 *The Left Hand of Géricault*

Literature:

C. Clément, Paris, 1867, Dessins, 177.

Guiffrey and Marcel, *Inventaire général des dessins du Musée du Louvre, Ecole Française,* v, Paris, 1910, no. 4187.

C. Martine, *Cinquante-sept dessins de Théodore Géricault,* Paris, 1928, pl. 8.

Exhibitions:

Maison Victor Hugo, 1927.

"Gros, ses amis et ses élèves," Petit Palais, Paris, 1936, no. 292.

"De David à Millet," Kunsthaus, Zurich, 1937, no. 124.

189

*The catalog was designed in Los Angeles*
*by Ken Parkhurst & Associates, Inc.*
*All text was set in Linotype Garamond*
*by Ad Compositors, Los Angeles,*
*and the catalog printed on Lustro Enamel*
*Dull paper by Homer H. Boelter*
*Lithography, Los Angeles.*